ART OF
THE BOOT

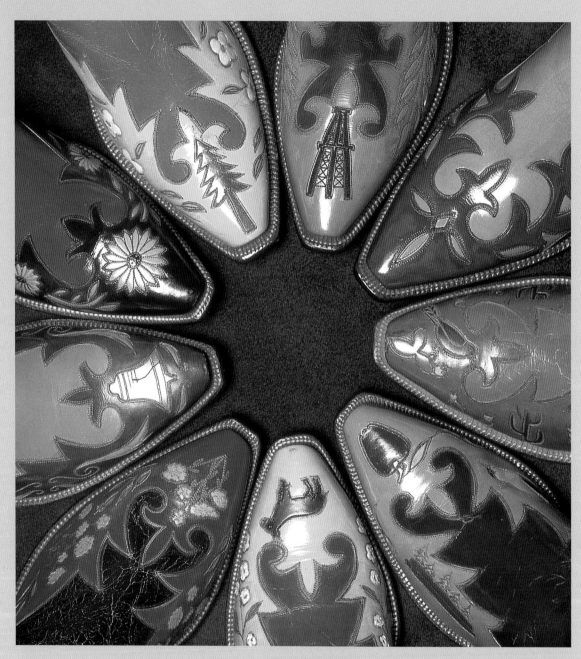

Toes courtesy Lucchese Boot Company, Mark Hooper, and Gary van der Meer.

ART OF
THE BOOT

TYLER BEARD

PHOTOGRAPHS
BY **JIM ARNDT**

GIBBS·SMITH
PUBLISHER

SALT LAKE CITY

06 05 04 03 8 7 6 5

Published by
Gibbs Smith, Publisher
P.O. Box 667
Layton, Utah 84041
Orders: (800) 748-5439
www.gibbs-smith.com

K.Y.O.H.2.N.W.H.M.T.80,W.H.? W.G.W.T.B!

Design by Steven R. Jerman—Jerman Design Incorporated, Salt Lake City, Utah
Printed in China

Library of Congress Cataloging-in-Publication Data

Beard, Tyler, 1954–
 Art of the boot / Tyler Beard : photographs by Jim Arndt — 1st ed
 p. cm.
 ISBN 0-87905-919-2
 1. Cowboy boots—United States. 2. Shoemakers—United States.
3. Footwear industry—United States—History. I. Arndt, Jim.
II. Title
TS1020.B347 1999
685' .31—dc21 99-26514
 CIP

Two men

Two American legends

Heroes to millions around the world

They put smiles on our faces,

dreams in our minds,

songs in our hearts,

faith in our souls,

wings on our spirits,

and boots on our feet.

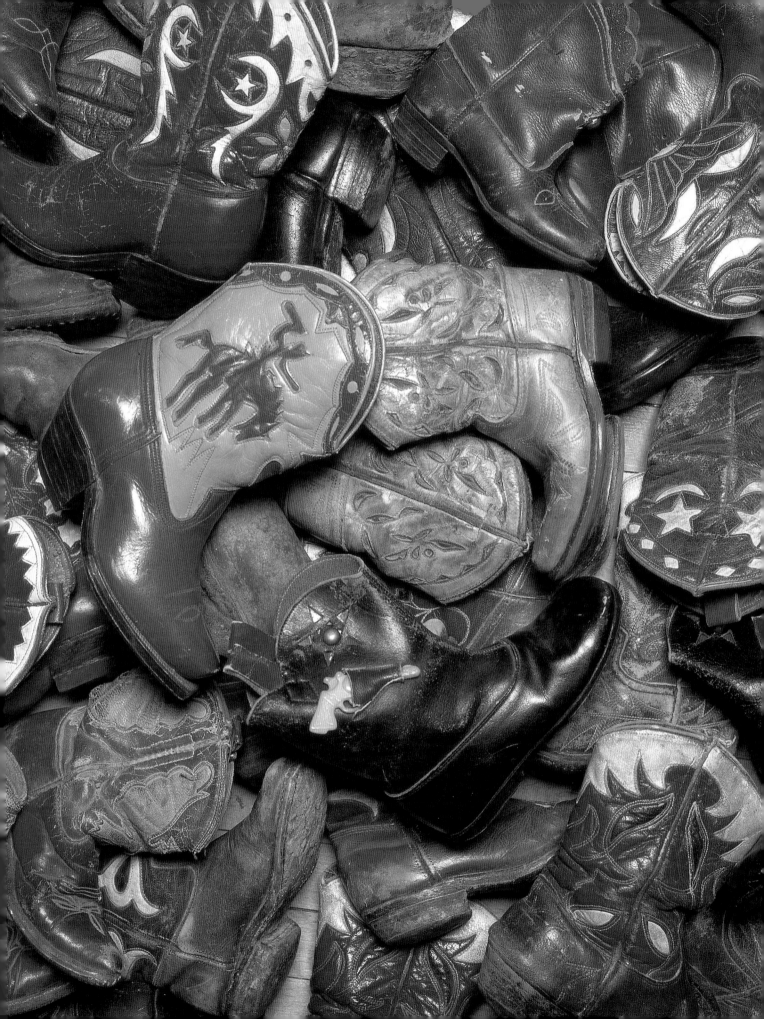

CONTENTS

ACKNOWLEDGMENTS

I bow to my fellow bootists Jim Arndt, Mark Hooper, Jack Pressler, John Tongate, Gary van der Meer, and Evan Voyles (let's pass the torch). I am beholden to the Kimmels, the Littles, Nathalie Kent, and Jennifer June for their boundless cowboy boot benevolence and enthusiasm. Thanks to Steve Jerman for his design eye.

Special thanks to Mr. Camera, my boot buddy and friend, Jim Arndt.

I am blessed with Debra Jane, Betty, Bill, Patti, René, Francois, Isabella, Madeleine, Gus, Dr. Anderson, Dr. Gonzales, Dr. Studey, Dr. White, my friend and editor extraordinaire, Madge Baird, and last but never least, my sweet squirrel girl, Teresa Lynn, my wife for life.

Tyler Beard

This project involved many, many people. Without all the bootmakers, collectors, and museums who gave up their boots for the photos, this would have never happened. A thank you to all of them, and to the publisher and editor, Madge, for going along with Tyler and me on another boot book.

Thanks to Tyler for his enthusiasm—always finding another pair of boots, researching them, and just being the "boot dude." Thanks for that and your friendship.

There are also the people who helped with the photography. Tyler was always "stylin'." But with enormous help on the stylin' part was the always stylish Nathalie Kent, who also knows her boots. And thanks to Bruce Eldridge from the Museum of the Horse for helping me set up backgrounds and always making sure we wore our white museum gloves.

A special thanks to Dave Little for going above and beyond to make up the logo boots especially for this book.

Back at my studio, a thanks to Todd Overland and Matt Seefeldt for helping me with the photos. And my gratitude to my studio manager and friend Craig Gjerness for his never-ending support and dedication.

Even with the help of all these people, the enthusiasm for me to keep going with this project came from the most supportive person I know, my best friend Nathalie—and I cannot thank her enough.

Although this book is dedicated to Gene and Roy, my own personal dedication is to my father, Don, who passed away while I was working on this book. I know it was his support, understanding, and love that got me here—otherwise this would have been impossible.

Jim Arndt

A COWBOY BOOT BIOGRAPHY

Cowboy boots can be a narcotic for the neophyte cowboy wanna-be. Boots from the dawn of high-heeled footwear have always evoked a certain sensual connotation that extends to sexuality. The beauty of cowboy boots is that they are genderless. They can be worn by anyone, with anything, for any occasion—or "with nothing at all." . . . And so this love affair with the "soul" of the American cowboy, forever ingrained in our hearts, continues into the twenty-first century.

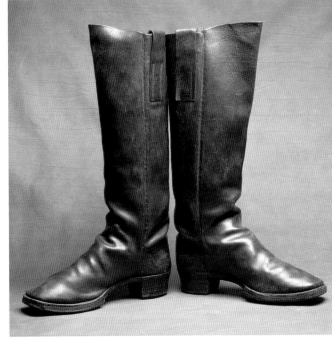

A classic pre-1890 example of what the first cowboys actually wore up the cattle trails—plain and protective, with emphasis on function not fashion. Maker unknown; courtesy Jim Arndt Collection.

After years of research, it has become clear that there was no "first" pair of cowboy boots—nowhere to begin the story of how the cowboy boot developed. As far back as we know, horsemen throughout the ages, all over the world, preferred higher-heeled boots. This represented a sign of nobility or a profession on horseback, above the ground, hence the old adage "well heeled."

For millenniums, horsemen have relied on protective footwear, from Attila the Hun in the fifth century, the Moors in the eighth, Genghis Khan in the twelfth, to Spain and Europe through the nineteenth century, man, his boots, and his horse have been inexorably linked in history, legend, myth, and our imaginations.

Cattle ranching in the United States existed as early as 1767, when Indians and Mexicans on horseback were engaged by Franciscan missionaries to work cattle in California. In Texas, cattle ranching began around 1820. Yet the legendary cowboy and his lifestyle did not set roots until the spring of 1867, when the incomplete transcontinental railroad reached Abilene, Kansas. A twenty-nine-year-old livestock trader, Joe McCoy, had purchased a large portion of Abilene for $4,250 and advertised for men in Texas to drive longhorns on the open range up to this Kansas railhead. At $40 a head, this was ten times higher than the going rate for cattle that currently existed in the hide and tallow market. By the end of this first summer, herds

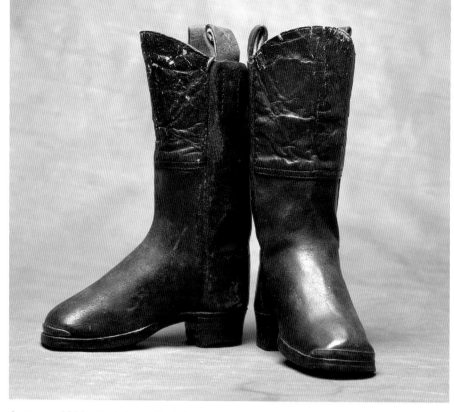

A rare pre-1890 child's boot—like father, like son.
Maker B. H. & N. Shoe and Boot Co.; courtesy Jim Arndt Collection.

of 2,000 and 3,000 head or more arrived along the Chisholm Trail. The beef industry had been established. McCoy was the first cattle king, and the cowboy boot—the single icon that best represents America around the world—was being born.

Before and after the Civil War, cowboys wore whatever they could afford or what they walked away from the war in. Early daguerreotype photographs show groups of cowboys wearing a sundry of clothing and footwear. Cowboys wore all kinds of boots, one example being the Wellington, a boot of British origin dating from 1810 and popularized by Arthur Wellsley, the first duke of Wellington, following his defeat of Napoleon at Waterloo. The Wellington boot is usually described as a plain boot, commonly in black leather or sometimes brown. Typically these boots had side seams, one-inch stacked straight heels, square or slightly rounded toes, and leather pull-on straps. There was usually no decorative stitching. The tops were either cut straight across or curved slightly higher in the front. The Wellington was basically utilitarian footwear that sprang from British influence and immigration.

Cowboys were also wearing at this time the Hessian boot, an under-the-knee boot with a V-cut in the front. This boot was introduced in England about 1785 by German dandies imitating the military footwear of the Hessian soldiers, named after the city-state of Hesse. Because Hessian soldiers fought in the American Revolutionary War, this style actually received some popu-

larity before the Wellington. Some of the original Hessian boots were distinguished by a large silk or leather tassel that hung down in the V-cut in the front of the boot. This military detail was not popular with cowboys, but its influences are still evident today in the short-top boots worn by high school and college drum majorettes and drill teams. In the most famous photograph of Billy the Kid, circa 1879, he is shown with his trousers tucked in, wearing a medium-high-heeled Hessian boot with its typical front V-cut (minus the tassel) and with pull straps flopping on the outside of the boot.

We know that by 1870 John Cubine, in Coffeyville, Kansas, had combined the Wellington and military-style boots in what is known today as the Coffeyville-style boot. The Coffeyville boot is usually described as not having a specific right or left foot; as being constructed from unlined, waxed, flesh-side out leather, usually in black; having leather pull straps, a low Cuban heel, slightly rounded square toes, a fully pegged sole; and the front of the boot, or the "graft," being considerably higher than the back. Not always but usually the graft was a different color of leather—brown or a deep red. Accounts from the time describe Coffeyville boots made for Texas cowboys with a cutout five-point lone star inlaid in the center of the graft. There is no reason to doubt that these star-styled Coffeyville boots were made; Texas cowboys were having stars put on everything. Yet not one example of this boot from the 1860s or '70s is known to exist.

An 1860s newspaper reporter described seeing the lone star emblem in the cow towns:

> Everywhere starred and shone the lone star of Texas for the cowboy. Wherever he may wander and however he may change, never spends his money or lends his presence to a concern that does not in some way recognize the emblem of his native state. So you will see in towns like New Sharon a general pandering to this sentiment. And lone stars abound of all sizes and hues, from the big disfiguring white one painted on the hotel front down to the little pink one stitched in silk on the cowboy's shilling handkerchief.

A typical pre-1920 boot, with a few rows of decorative stitching that also helped hold up those tall tops. Between 1880 and the 1920s, the obvious changes were slight and slow in coming. Maker unknown; courtesy Caroline Shapiro Collection.

One myth should be put to bed. Having looked at literally thousands of photographs of early cowboys, I have never seen one pair of boots or shoes with a pointed toe, squelching the idea that pointed toes helped the cowboy find his stirrups more easily. We cannot say there was never a cowboy who wore this style of toe design; however, no pair exists. Every single pair of cowboy boots that I have seen from the 1860s through the 1930s had either a medium-to-wide round or square toe. Not until the 1940s, when streamlining was the fashion of the day, did the cowboy boot toe dramatically change shape. The pointy, sharp, cockroach-killer variety did not appear until the late 1950s; then it remained popular as "the" toe for men, women, and children throughout the sixties and a large part of the seventies.

Throughout the 1860s and '70s, these various military-style boots continued to be copied in hundreds of variations, modified and sometimes improved upon by the gone-to-Texas southerners, who also brought with them the refined European cavalier-style ancestry of boot making, with its higher heel and finer leathers. During these times, heel shapes and boot heights varied greatly. Toes were usually of round or square duck-bill shapes that might be as wide as three inches. Stitching on the boot tops for support or decoration was actually fairly rare, and wrinkles, toe bugs, or flowers stitched on the toe tops were unheard of.

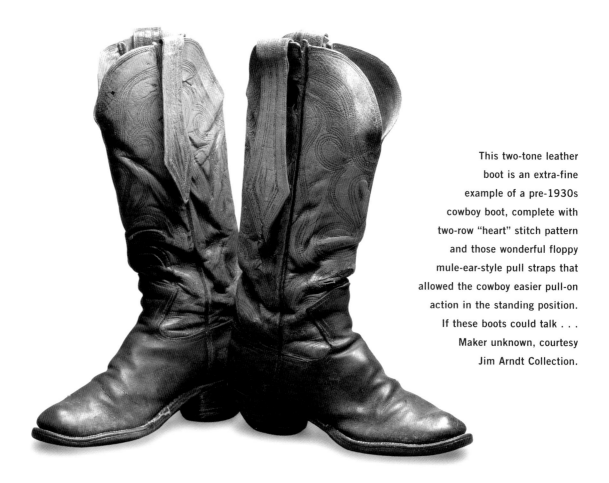

This two-tone leather boot is an extra-fine example of a pre-1930s cowboy boot, complete with two-row "heart" stitch pattern and those wonderful floppy mule-ear-style pull straps that allowed the cowboy easier pull-on action in the standing position. If these boots could talk . . . Maker unknown, courtesy Jim Arndt Collection.

In 1870 the U.S. Census recorded 121 boot- and shoe-making establishments in Kansas and 98 in Texas. Most of these shops were also making stovepipe stogie boots (work boots), ranger boots (farmers' boots), cavalry-style boots, lace-up boots and shoes, and a wide variety of footwear for the general populace. But historical photographs, newspaper advertisements, town histories, and personal diaries tell us that many of these shops were specializing in boots for cowboys and ranchers.

By the 1880s, a more characteristic boot was being developed with a four-piece construction and stovepipe top (which means the front and back of the boot were the same height). Some simple decorative stitch patterns were beginning to emerge, and the high heel was becoming much more popular.

Concerning the ongoing dispute between Kansas and Texas historians as to which state made the first pair of cowboy boots or made the most or the best—the answer is neither. The assumption that cowboys got paid at the end of the trail at the railheads in Kansas and therefore had the money to order a pair of boots is only one possible scenario. I am sure that once they reached town—this rough form of civilization with shops, home-cooked meals, saloons, gambling, soiled doves, and a virtual kaleidoscope of distractions— the last thing on many a cowboy's mind was his boots! Like anyone leaving on a trip, vacation, or adventure, it seems more feasible to me that the cowboy would have considered his boots, gear, and tools before heading north. That there were more boot, shoe, and saddle shops in Kansas at this time also reflects the fact that the Midwest had a much greater population, with trade and commerce crisscrossing the state.

The historical facts do show, however, that the most influential bootmakers in Kansas and Texas pre-1900 were primarily of German or British descent. (The Italian shoe- and boot-making influences of Tony Lama and the Lucchese family and others were felt after the turn of the century.)

That bootmakers and shoemakers were spread throughout the Great Plains as early as 1868 does not diminish the indisputable fact that Charles Hyer of Hyer Brothers Boots in Olathe, Kansas, and "Big Daddy Joe" Justin of Justin Boots in Spanish Fort, Texas, were the two most influential boot-makers of the 1880s.

A new post-Civil War America was emerging. This immigrant-based society with its newfound urbanization and industrialization were changing the face of the country. H. Dean Hyer of C. II. Hyer and Sons, founded in 1874 and one of the oldest boot-making establishments in the West, had this to say about their early customers: "We do know that we have made boots in the past for many people who had no connection with the cattle business other than being in an area where this was the main industry. In the 1870s, almost everyone still rode a horse, so it would not be uncommon at all for the U.S. marshal, stage drivers, gamblers, prospectors, and common townspeople to be buying tall-topped boots."

By the late 1880s, the general public was already reminiscing over the loss of the Old West, and by the turn of the century, the cowboy stood alone

as the most picturesque figure in the nation. His profession had changed little since the 1860s. His range, corrals, cattle pens and cow trails were far from the patted-down town roads and city pavement. Cowboys were still out there pounding dirt into dust, mud into muck, or snow into slush. A cowboy's best friends were his horse and saddle, a rope, a hat, a crackling fire to warm his work-weary feet, and his cowboy boots.

As the open ranges of the southern plains were closed and the spiny fingers of railroad tracks expanded, the American cowboy still had a job to do, but it was now within the confines of a large ranch or cattle concern. It was a long horseback ride into town—sometimes several hundred miles. But in the late 1880s, both Justin and Hyer revived nostalgic visions of their one-man shop origins along the cattle trails to help promote their mail-order line of cowboy boots, thus solving the distance problem and making it convenient for folks out on the ranch to get boots delivered right to their homes.

This rare example of a 1920s cowgirl boot was custom made for Louise Lambert, rodeo star of the 1920s and '30s. Boots by C. P. Shipley; photograph by and courtesy William Manns.

In these earliest mail-order catalogs, cowboy boot prices varied from $3 to $25. The average boot sold for $3 to $12, depending on the hide used, height of the boot, toe, heel, stitching, and any other particulars the cowboy may have requested.

One event that helped promote the mail-order cowboy boot business was that in 1896 the U.S. Congress authorized free postal delivery in rural areas (RFD), which brought the mail directly to the farmer, rancher, and cowboy. By 1911, post offices were offering personal post with a C.O.D. charge, which further simplified these transactions between the bootmaker and the cowboy.

There was no other footwear in the 1890s and early 1900s that could have provided as much safeguard and practical application as the tall-top, high-heeled cowboy boot. This boot provided year-round protection from mud, snow, gravel, brush, thorn, and horn, allowing the cowboy to always keep one thickness between his pants and his leg. Changes and improvements, for fashion or utility, were always being made. Heels went from low to high, to low, and back to high again. Toes were varying widths in square and round shapes. Some soles were thick while others were thin, and the tops were either plain or decorated with colored leather and stitching. These changes were made to satisfy the individual's vanity, a bootmaker's whimsy, or to improve safety and efficiency. The end result, given personal preference, was a perfect tool for the feet used in a very special way.

One of these decorative whimsies was the introduction of the toe wrinkle. They may not have been the first to stitch them on some boot toes, but in 1903 the Hyer Brothers catalog was the first to advertise toe wrinkles—the straight-stitch lines across the top of the toe. There is no way

The toe lines or wrinkles were later crowned by a flower, or fleur-de-lis.

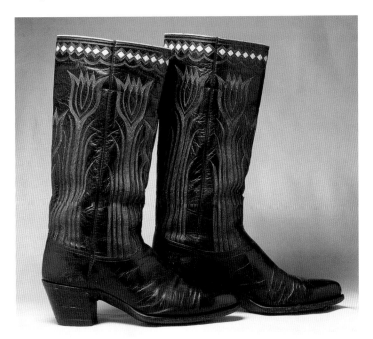

A 1920s Blucher boot made for Tom Mix. An exquisite example of flat stovepipe tops, inlaid-diamond collar work, and the ever-popular "tulip" stitch pattern. Boots by Blucher Boot Company; courtesy Tom Mix Museum.

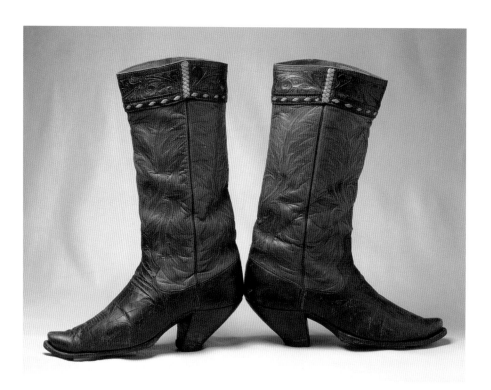

This 1920s boot made for Tom Mix shows an attractive hand-tooled and laced stovepipe collarpiece, a boxed toe, and a heel base that would barely hide a quarter! Boots by Blucher Boot Company; courtesy Tom Mix Museum.

This heel and toe would definitely give you attitude, 1930s. Maker unknown, courtesy Jim Arndt Collection.

to absolutely trace the origin of this addition to the cowboy boot, but we do know that by about 1915, most bootmakers were offering their own toe bug, wrinkle, or flower. By now a delicate curved, floral, or fleur-de-lis shape was usually added in front of the straight bar lines of the wrinkles. This personalized signature in thread, of each bootmaker's design, remains an element on most manufactured as well as custom-made boots to this day.

Cowboy boots rose to a fashion high as a byproduct of the entertainment industry's success with the cowboy hero. The 1920s and 1930s West that many of our grandparents and great-grandparents spoke about nostalgically was kept alive through radio shows and movie serials featuring the likes of Tim McCoy, William S. Hart, Bronco Billy, Jack Hoxie, Buck Jones, Ken Maynard, Hoot Gibson, Tom Mix, and the list goes on and on. None of these tough hombres would have been caught dead without his boots on. These Hollywood idols were the springboard for the fashion-vs.-function "anything goes" cowboy boot styles of the next two decades.

More than any other entertainment star, Tom Mix had the greatest influence on western wear and boots, especially as an emerging style for the masses. Tom was a sexy sight in his high-heeled inlaid boots and silver-and-jeweled spurs. He was the Tom Cruise of his time. When Mix died in a car

accident on October 12, 1940, he was wearing black patent-leather boots with a floral design stitched in red, white, and blue silk thread. This working cowboy, stuntman, and movie star had cowboy class with a capital "C."

During the next twenty-five years, cowboy boot designs became increasingly intricate and colorful. Most boot pairs were symmetrical mirror images: the outside matched the inside of the partner boot in reverse. Some of the new abstract designs that had been devised from floral images, leaves, tulips, roses, scrolls, and flame patterns were now being incorporated in ever-increasing colors and variations. Spider webs, hair-on longhorn heads, cactus pears, eagles in flight, horses, horse shoes, bucking broncs, oil derricks, decks of cards, crescent moons surrounded by stars, and endless varieties of butterflies, eagles, flowers, and vines all but replaced the simpler inlaid boots of the 1920s and early '30s.

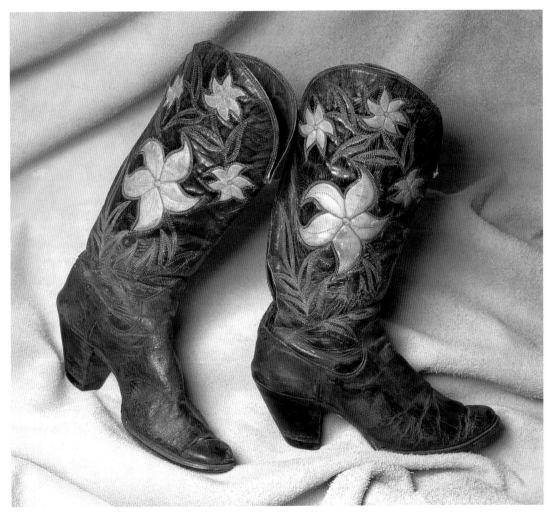

The 1920s cowgirl who wore these high-heeled floral gems rode and roped with finesse. Maker unknown; courtesy Cowgirl Hall of Fame Museum.

Lepidopteran themes were extremely popular in the 1930s and '40s.

A unique pattern of black, red, and muted yellow create a swarm of butterflies.
Boots by Jesse's Boot Shop; courtesy Evan Voyles Collection.

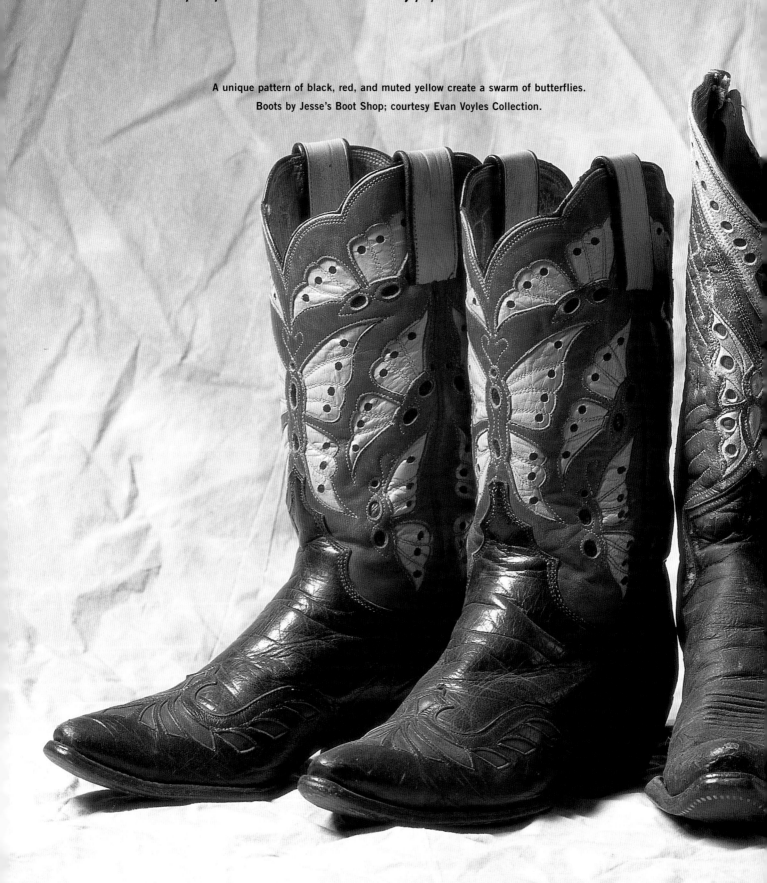

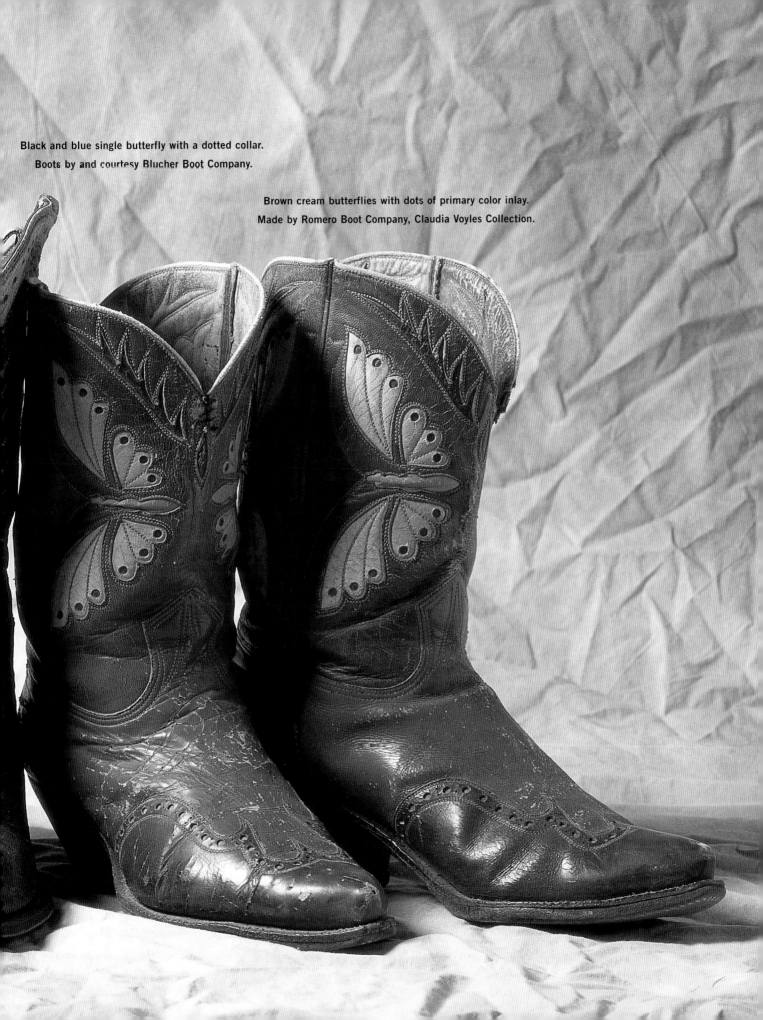

Black and blue single butterfly with a dotted collar.
Boots by and courtesy Blucher Boot Company.

Brown cream butterflies with dots of primary color inlay.
Made by Romero Boot Company, Claudia Voyles Collection.

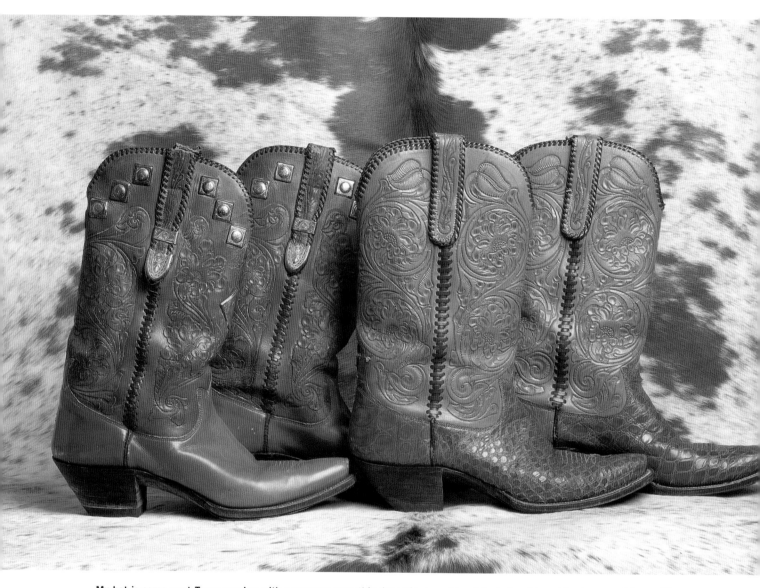

My bet is some west Texas rancher with a swagger wore this dynamic duo of hand-tooled and laced boots, one with an alligator
foot and the other capped off with sterling conchos and belt-tip-style pull straps. Wow!
Boots by Olsen-Stelzer, 1940s; courtesy Tyler and Teresa Beard Collection.

This 1930s–40s peewee with an alligator foot, hand-carved top, and sterling silver repoussé and engraving is the finest example combining metal and hides I have ever seen. Boot courtesy The High Noon Collection.

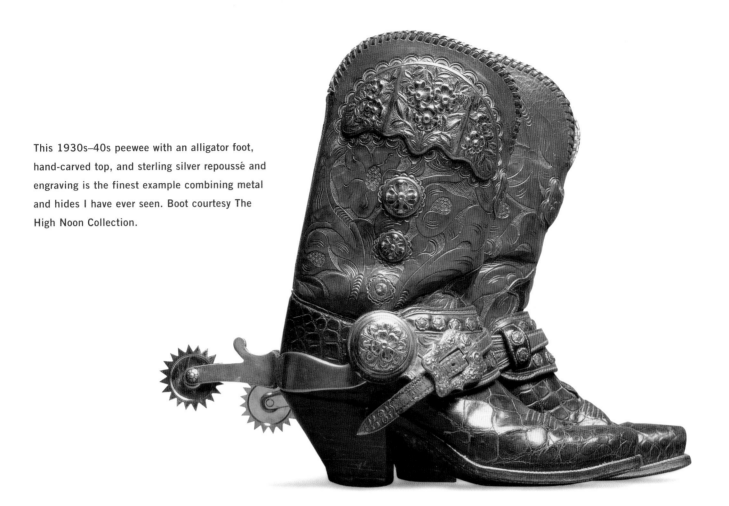

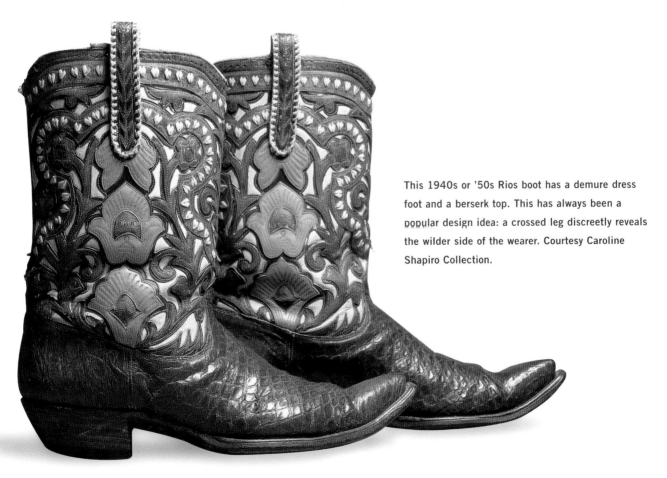

This 1940s or '50s Rios boot has a demure dress foot and a berserk top. This has always been a popular design idea: a crossed leg discreetly reveals the wilder side of the wearer. Courtesy Caroline Shapiro Collection.

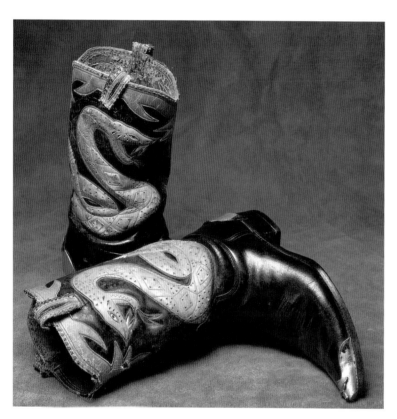

You either love or hate this coiled critter emblazoned on this killer 1950s boot. Boots by Romero Boot Company, León, Mexico; courtesy Evan Voyles Collection.

In the mid-1990s these boots were picked up for a pittance—twenty-five cents—at a garage sale in Houston. The twilight zone factor is that the man who picked them up for his son, Briggs Vest, also noticed the initials B.V. were on the back. Bear in mind, these boots were made at least 25 years before Briggs was born. I purchased the boots from the Vest family so the boy could get Dave Wheeler to make a more practical pair that fit. In a momentary boot break-down, I sold these to my friend Eddie Liptrott. They fit him!

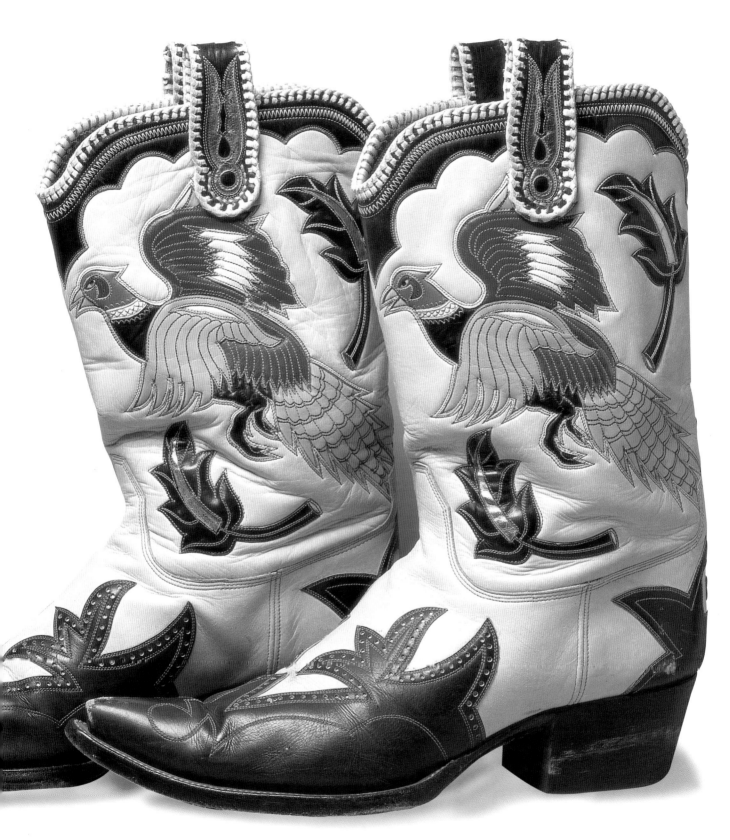

One of the finest examples of a Rios boot made in the 1940s or '50s. Padded inlay and overlay with foxing on the foot and counter (heel). Laced collar and pull straps complete this amazing "Pheasant Boot." Courtesy Eddy Liptrott Collection.

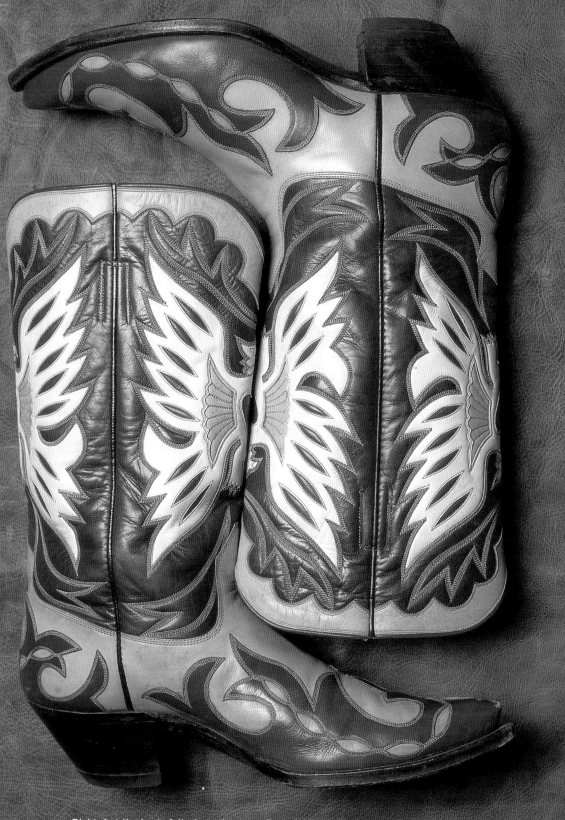

Below: Flowers and eagles are the two most common themes in the history of pictorial cowboy boot design. The symmetry and choice of color reveals a studied, artful approach and execution. A Rios boot; courtesy Gary van der Meer Collection.

Right: Let the boots fall where they may. Boots by Olsen Stelzer, Justin, Nocona, Mercer, and one unknown. Stars, crescent moons, and longhorns from Claudia Voyles; the rest courtesy Tyler and Teresa Beard & Bruce and Courtney Whitehead Collections. All 1930s–1940s.

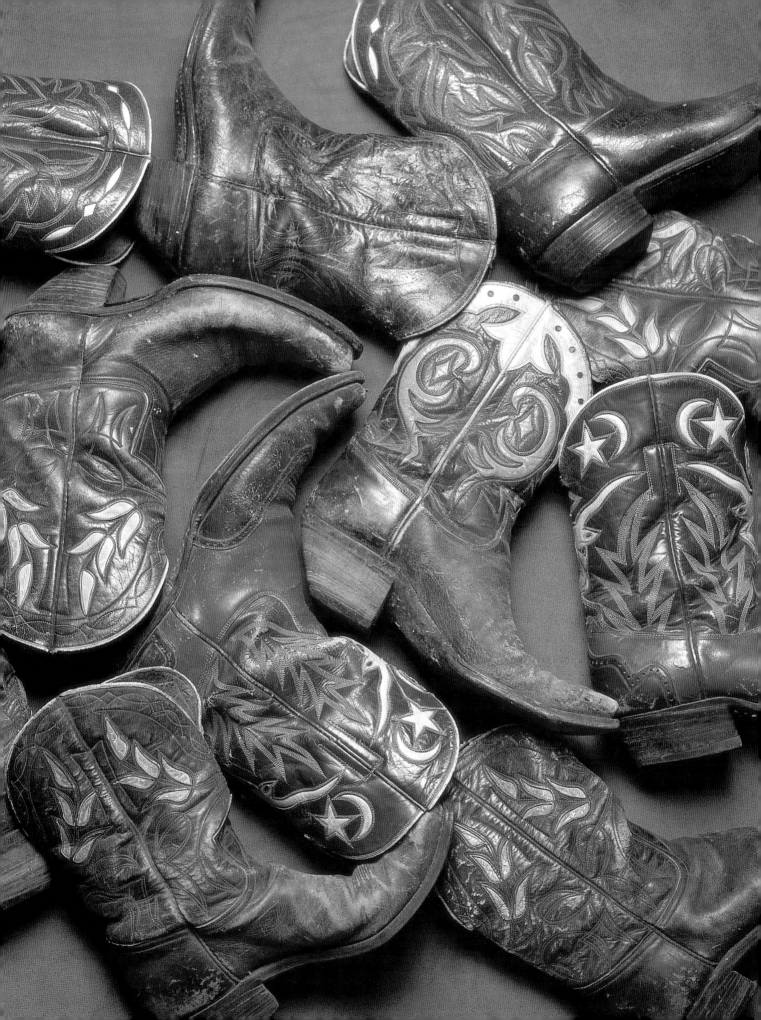

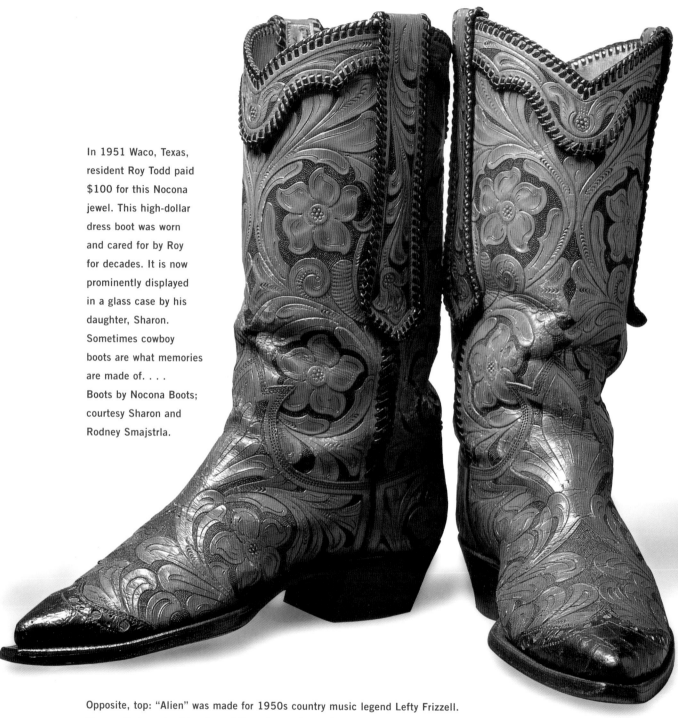

In 1951 Waco, Texas, resident Roy Todd paid $100 for this Nocona jewel. This high-dollar dress boot was worn and cared for by Roy for decades. It is now prominently displayed in a glass case by his daughter, Sharon. Sometimes cowboy boots are what memories are made of. . . .
Boots by Nocona Boots; courtesy Sharon and Rodney Smajstrla.

Opposite, top: "Alien" was made for 1950s country music legend Lefty Frizzell.
The verdigris and gold patina of these boots shaped in fluted and horned designs takes on an otherworldly aura. Boots by Dixon Boots: courtesy The Country Music Hall of Fame.

Opposite, bottom left: An L. White classic shows his flair for filagree inlay and overlay work on his unusual rough-on-rough technique, 1950s. Courtesy Evan Voyles Collection.
Right: An artistic aesthetic guided L. White through this lacelike curtain of soft kid leather laid on plush purple suede. These were made in the 1950s for rodeo cowgirl Jackie Worthington. Courtesy The Cowgirl Hall of Fame Museum.

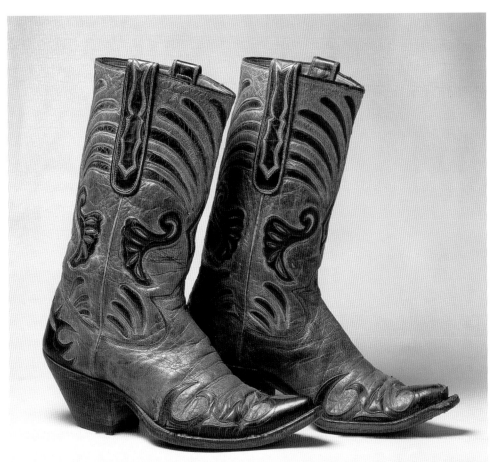

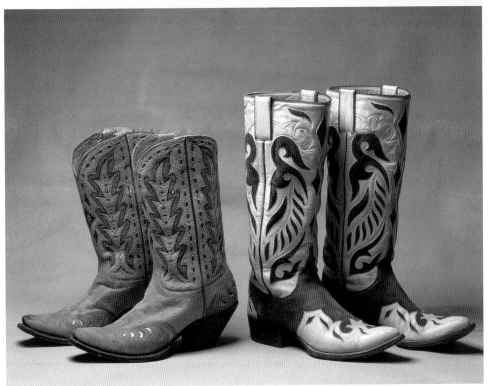

My F.B.B.I. (Federal Bureau for Boot Investigation) spent a week getting this story accurate. Cowboy boots are a science all their own. This pair of "Star-Spangled Banner Boots" were purchased at a garage sale in Oregon a few years ago. The numbering system inside the boot shaft dates them. The Hyer Boot Company in Olathe, Kansas, made these boots in 1962. A number of these were made through the years for store openings, sales promotions, rodeos, and state fair displays. This particular pair belonged to Howard Hunsaker, owner of Howard's Men's Wear in Roseburg, Oregon, now closed for nearly twenty years. Howard carried Levi's, boots, and other western wear. His sterling-silver and 24-carat gold toe tips with the initials "C.H.H." were a classy addition to mark that these boots were made by the Charles H. Hyer Boot Company. These were proudly displayed in Howard's store until his death in 1991. Courtesy Brian Lebel, Old West Antiques.

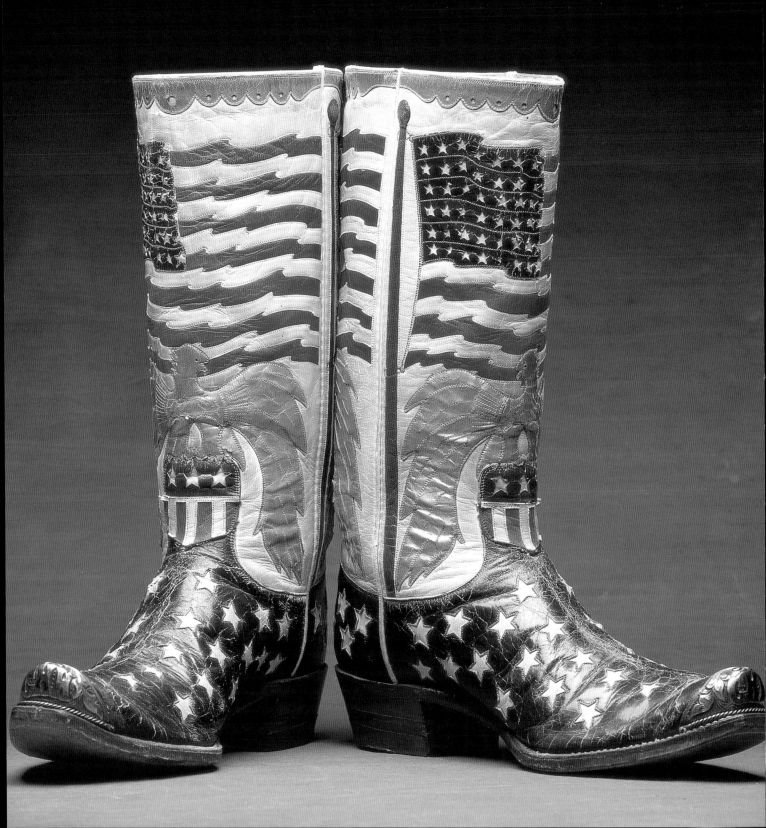

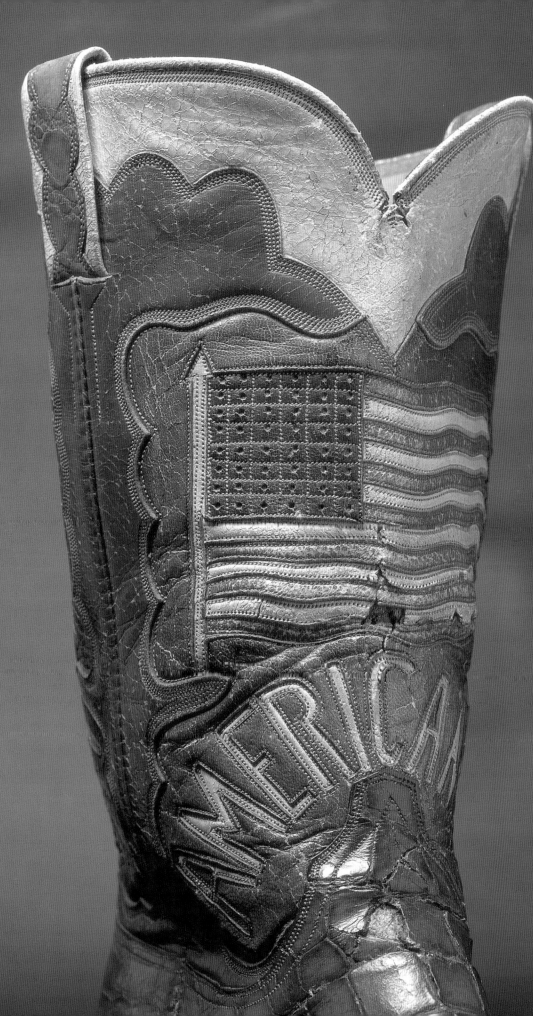

"The Americanization" boots were made to celebrate the end of World War II and were photographed for *Life* magazine in 1945. Boot by and courtesy Palace Boot Shop.

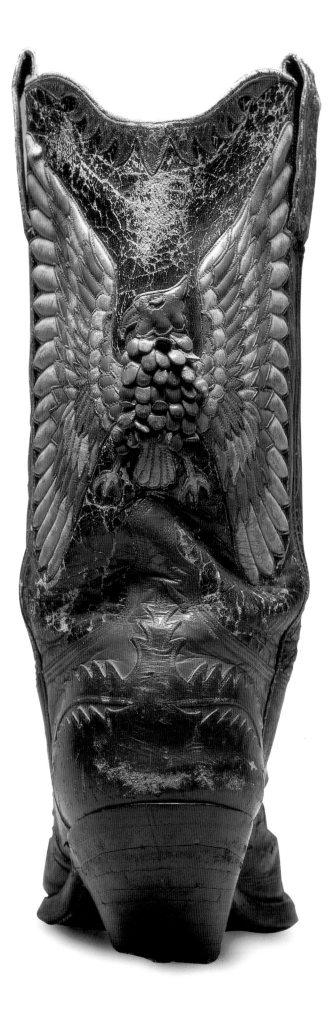

Left: A fetching feathered boot with padded plumage and ruffled chest feathers, 1940s. Maker unknown; courtesy Rocketbuster Boots Vintage Collection.

Opposite, top: In the 1950s, Texas constable Dalee Richardson must have been quite a man. When Joe Bowman related that he knew where some incredible boots might still be stashed under a bed in Louisiana, I was totally unprepared for the adrenaline rush that swept over me as I gazed into the box. This pair proved to me that there are still a few charismatic cowboy boot creations capable of catapulting our wildest footwear dreams straight into boot heaven. Amen! Boots by Joe Bowman and Sam DeGeorge, engraved silver and gold work by Nelson-Silva Co.; courtesy Joe Bowman and the Richardson family.

Opposite, bottom:
The appeal of this 1950s boot to men and women guarantees it will be one of the most copied boots from this book. Boots by Tres Caballeros; courtesy Corky Dieringer Collection.

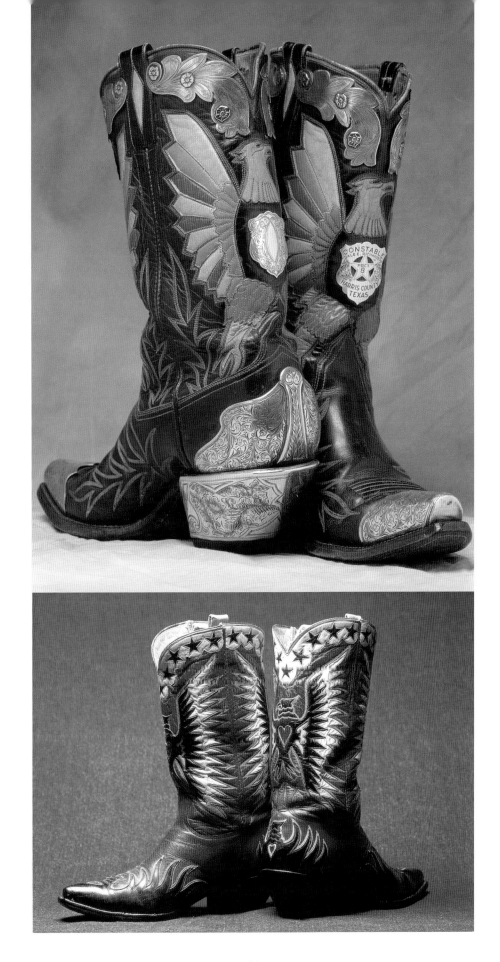

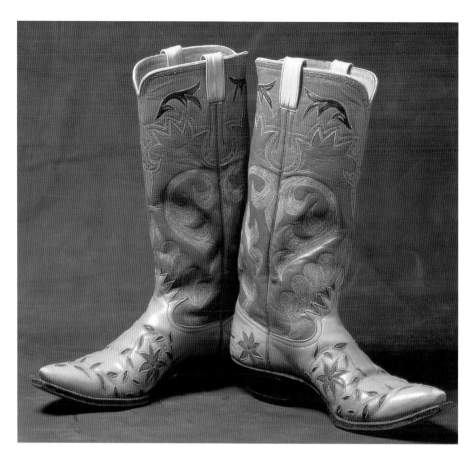

A kaleidoscope in psychedelic shades of the 1960s made by Jay Griffith for his wife. Mrs. Griffith wasn't afraid to flaunt her fantastic footwear. Courtesy Caroline Shapiro Collection.

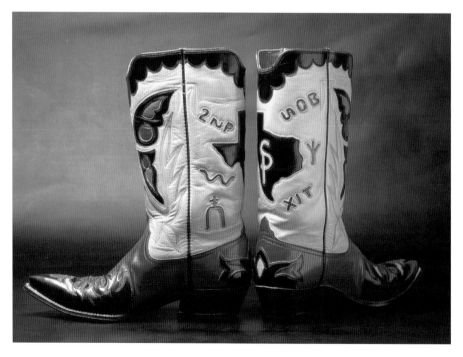

Some dude had a sense of humor when he ordered this boot! Besides the state of Texas and longhorns on the toes, check out the brands—"2 lazy-2 P" and "lazy-SOB."
Boots by Joe Bowman and Sam DeGeorge; courtesy Joe Bowman.

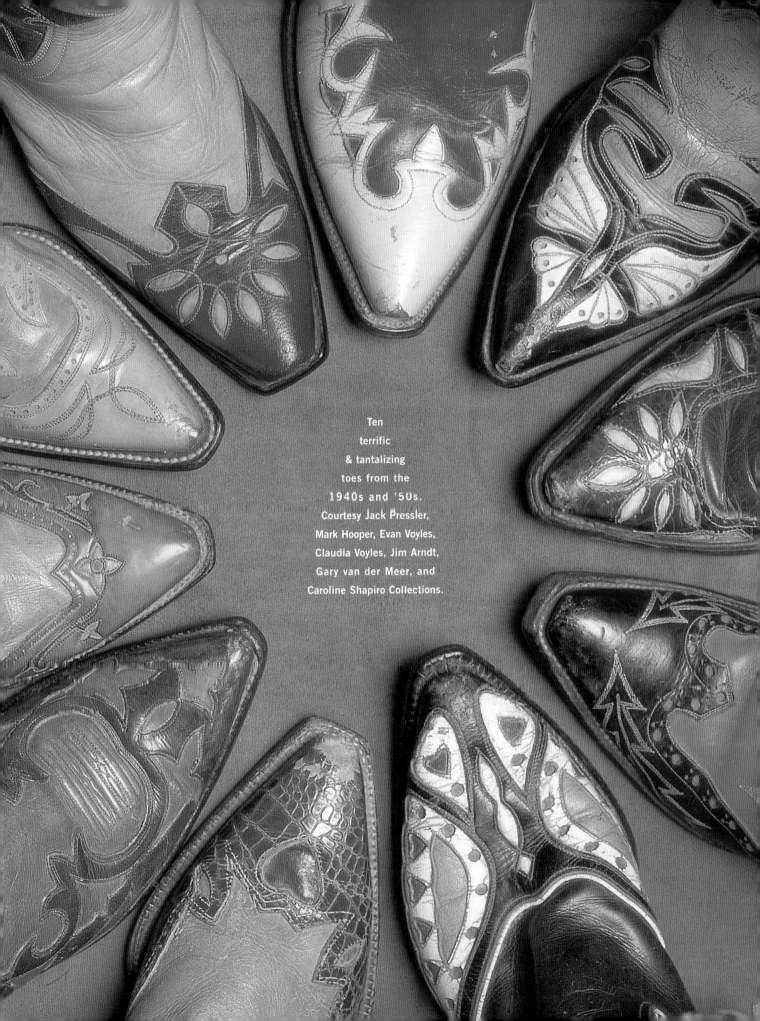

Ten
terrific
& tantalizing
toes from the
1940s and '50s.
Courtesy Jack Pressler,
Mark Hooper, Evan Voyles,
Claudia Voyles, Jim Arndt,
Gary van der Meer, and
Caroline Shapiro Collections.

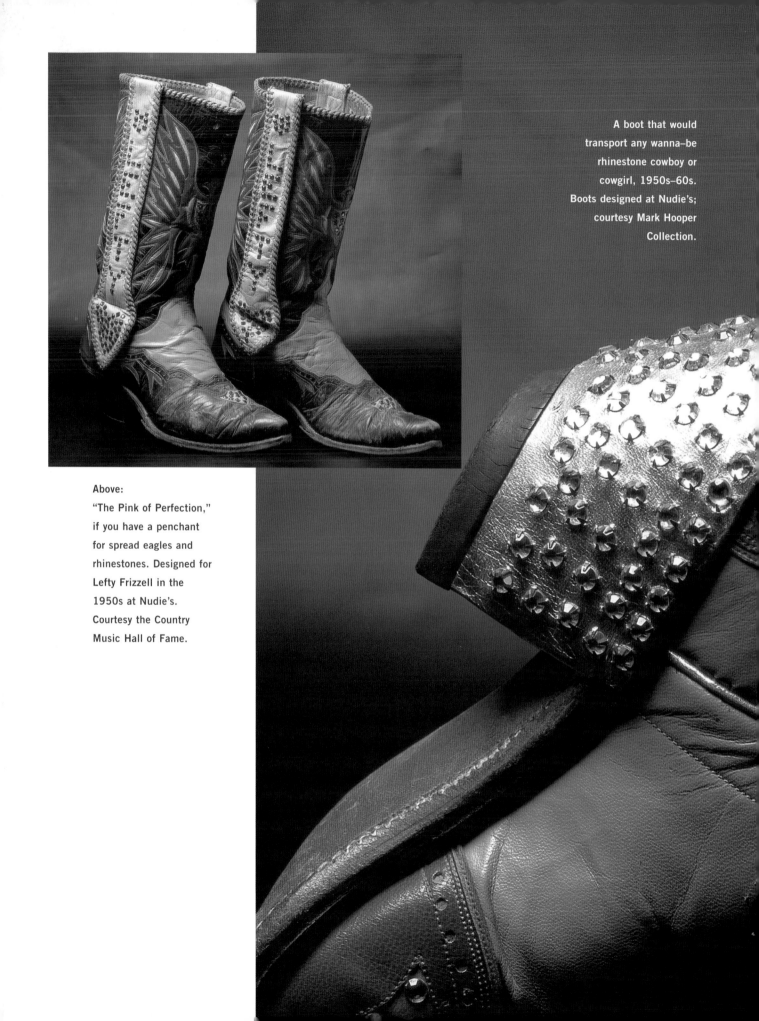

A boot that would
transport any wanna–be
rhinestone cowboy or
cowgirl, 1950s–60s.
Boots designed at Nudie's;
courtesy Mark Hooper
Collection.

Above:
"The Pink of Perfection,"
if you have a penchant
for spread eagles and
rhinestones. Designed for
Lefty Frizzell in the
1950s at Nudie's.
Courtesy the Country
Music Hall of Fame.

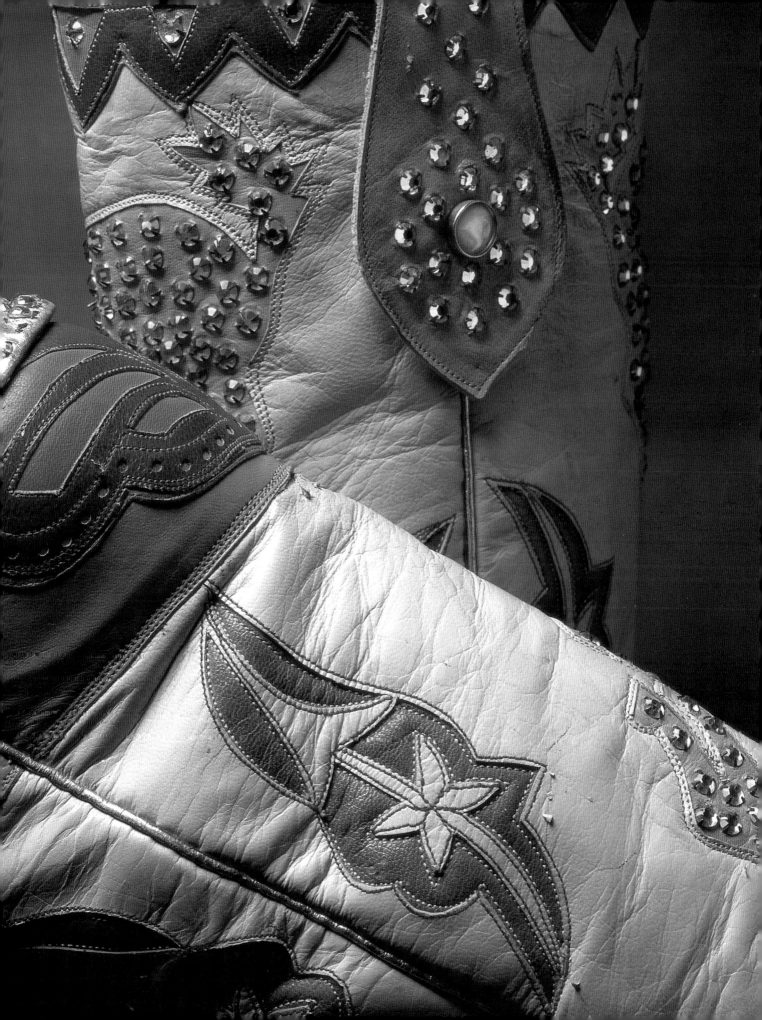

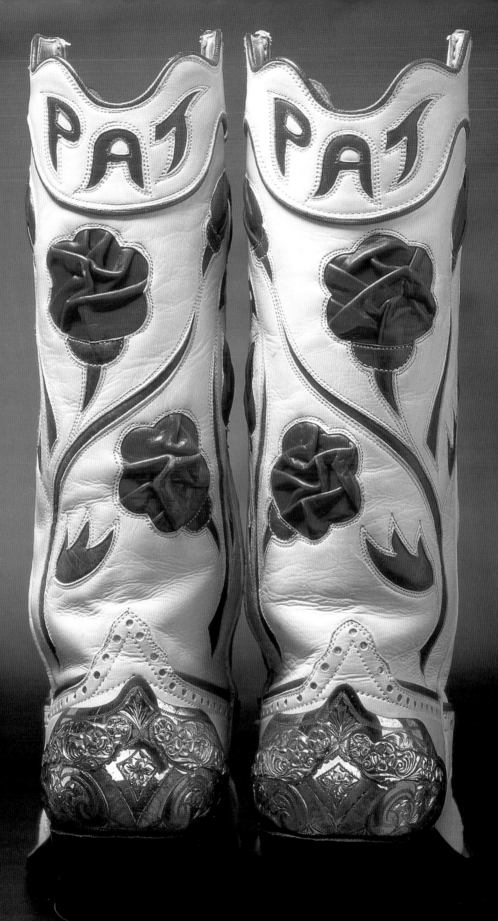

Romantically regal and rosie cowgirl bootwear, heel-capped in sterling silver and gold.

Boots by Joe Bowman and Sam DeGeorge; courtesy Joe Bowman and Linda Snedicker.

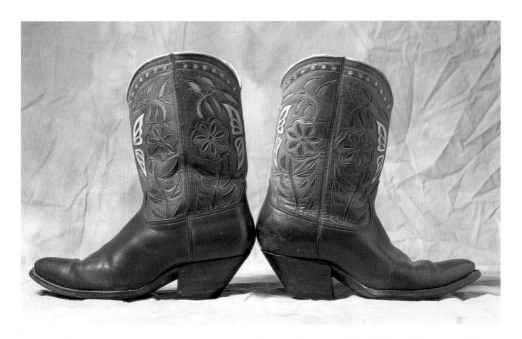

A 1940s palette of pastels, faded naturally over time to a dreamy patina. Maker unknown; courtesy Caroline Shapiro Collection.

There were three Trujillo brothers making boots in Texas. Like the Rios brothers, their styles were so similar that it's hard to distingulsh who made a specific pair. There is no doubt this floral folk art was a forte in leather work for one of the brothers. A Trujillo boot; courtesy Tyler and Teresa Beard Collection.

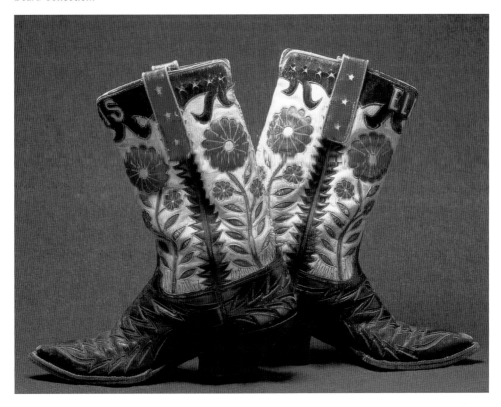

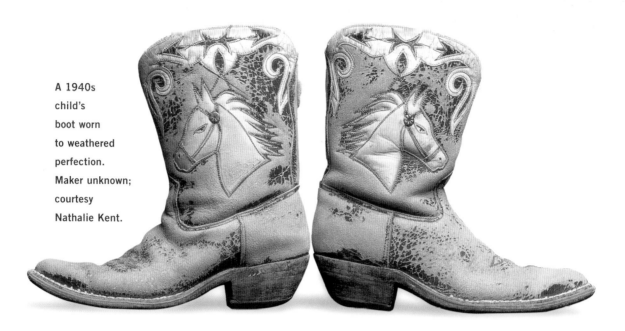

A 1940s child's boot worn to weathered perfection. Maker unknown; courtesy Nathalie Kent.

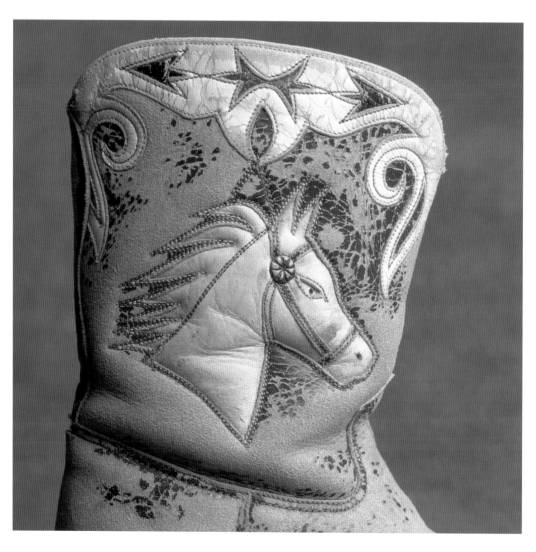

Opposite: The premier collection of children's boots, 1930s to 1950s.
Courtesy Tyler and Teresa Beard & Rodney and Sharon Smajstrla collections.

The State Boots

Without question, the most elaborate and ambitious custom boot-making project ever undertaken, "The State Boot" series were conceived in 1949 and completed in early 1951. A pair for every state, represented by the state's flag, bird, flower, capitol building, and their individual symbols of commerce, industry, and history. This herculean task was a collaborative design effort between Cosimo Lucchese and his master bootmaker and artist,

Jesus Garcia, as well as Garcia's predecessor, forty-plus-year Lucchese veteran Carlos Hernandez Sr. When Garcia left to open his own boot shop, Carlos Hernandez Jr. completed this amazing "96 feet" of boot history.

Over the next decade or so, many state governors and officials ordered copies of their particular state boot. (The originals are easily distinguished by a hole drilled in the bottom of each boot sole in order to affix them to a traveling display that toured state fairs, rodeos, and western-wear store openings.) Only eighteen of the original forty-eight pairs are still known to exist. The other thirty pairs have been stolen or

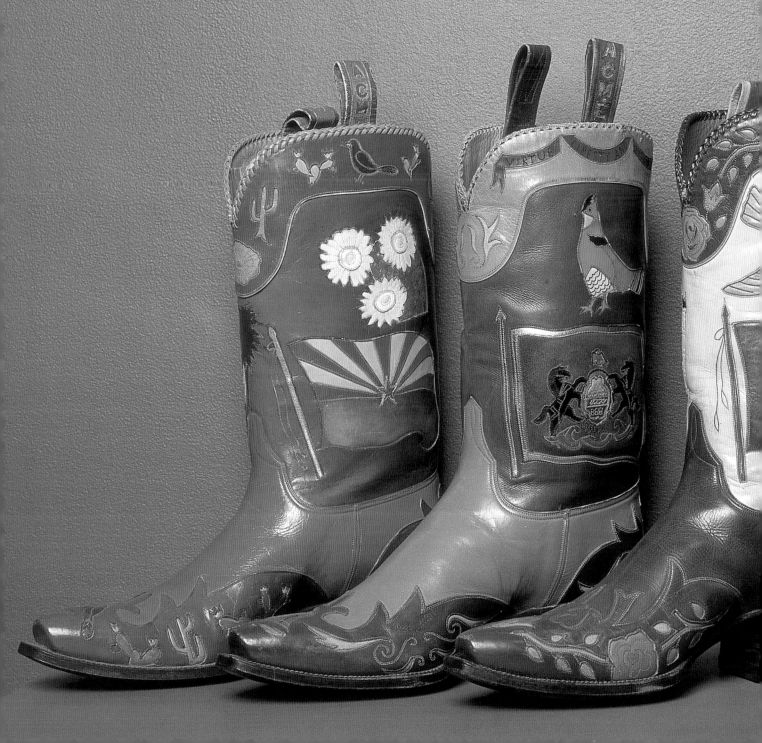

otherwise dispersed through public auctions, estate sales, and private collectors.

The great mystery surrounding these boots is why Cosimo Lucchese accepted this commission from Acme Boot Company to make this series. Each pair carries the Acme name on the pull straps, which is equivalent to building a Silver Cloud Rolls Royce, only to christen it a Ford Escort! An FBBI investigation through every Acme and Lucchese employee who has any memory of these boots has turned up nothing. The only answer that is universally agreed upon is the speculation that Cosimo was not good at money management. These boots were simply created as an order from another boot company for cash. Perhaps Mr. Lucchese found some humor and irony in this baffling business deal. If anyone has any additional information or knows the whereabouts of any more State Boots, please contact the author. All boots courtesy Lucchese Boot company unless otherwise credited.

Above: Boot counter detailing from the Arizona boot.

Left to right: Arizona (courtesy Mark Hooper), Pennsylvania and New York (courtesy Gary van der Meer), Montana, and West Virginia.

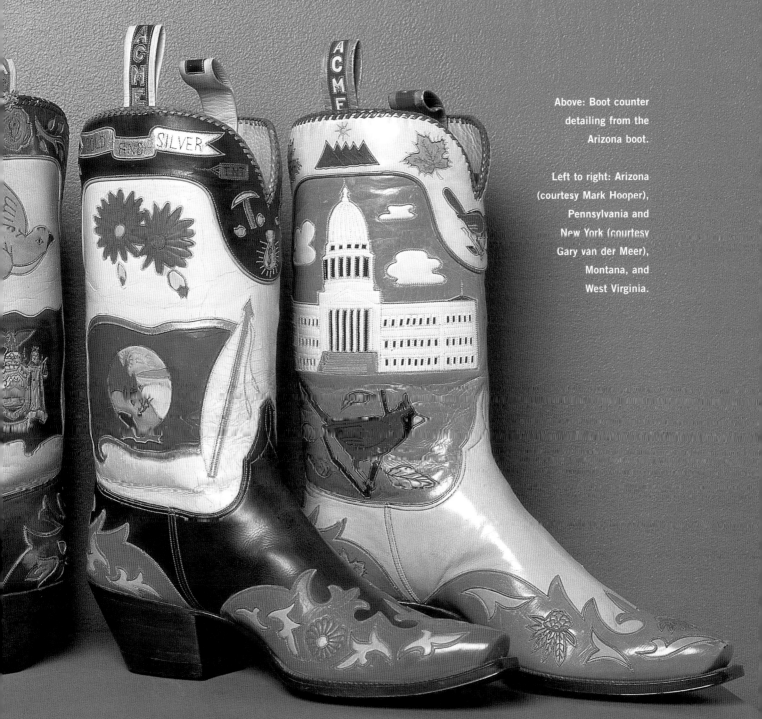

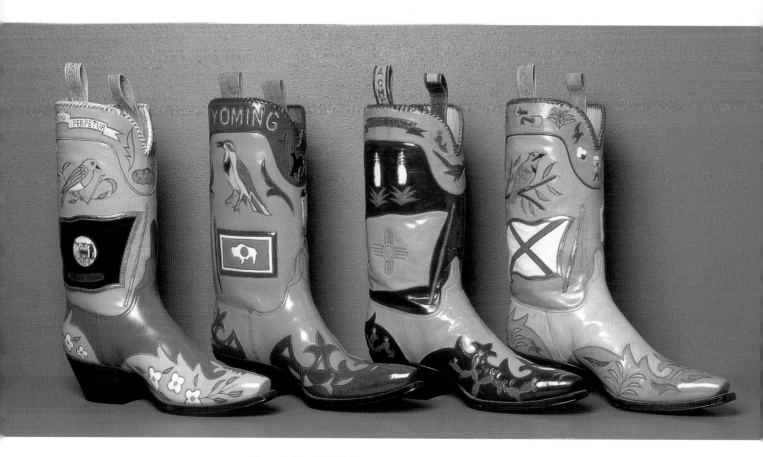

Above, left to right: Idaho, Wyoming, New Mexico, Alabama.
Below, left to right: Missouri, Washington, Nevada, Kansas, Texas.

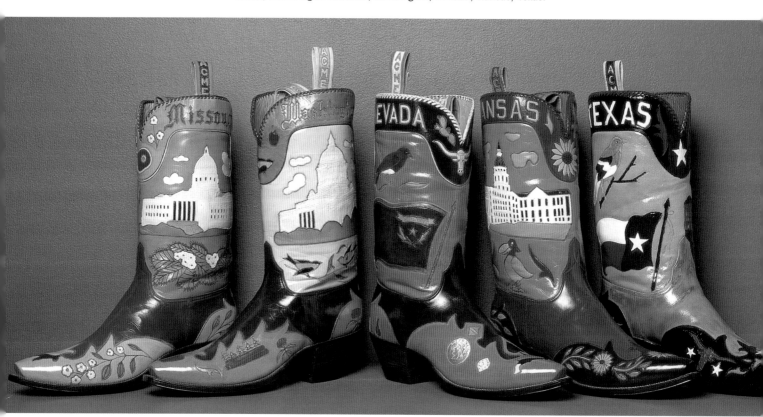

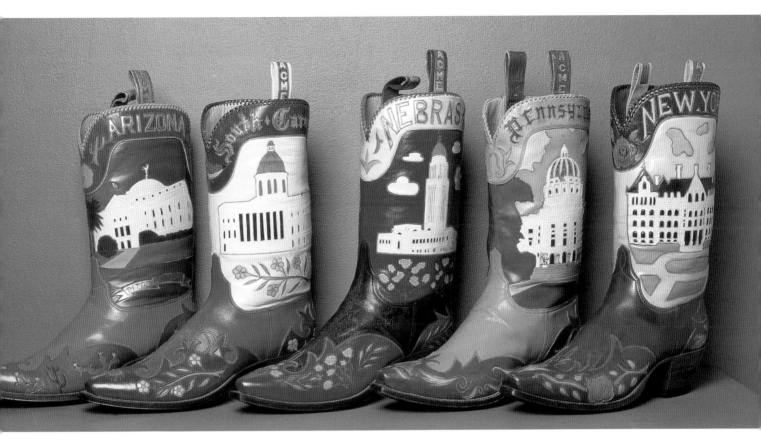

Above, left to right: Arizona, South Carolina, Nebraska, Pennsylvania, New York.
Below, left to right: Texas, Arkansas, North Dakota.

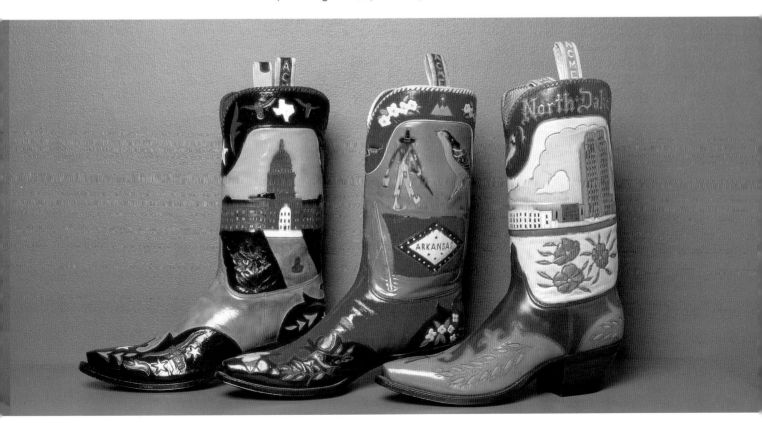

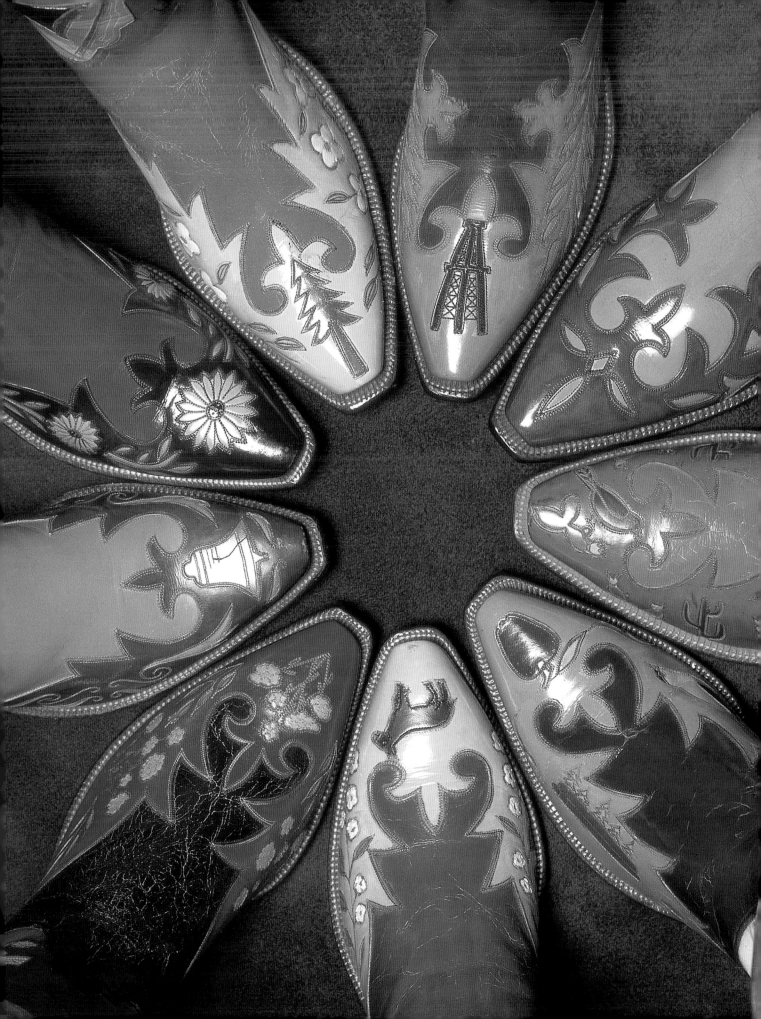

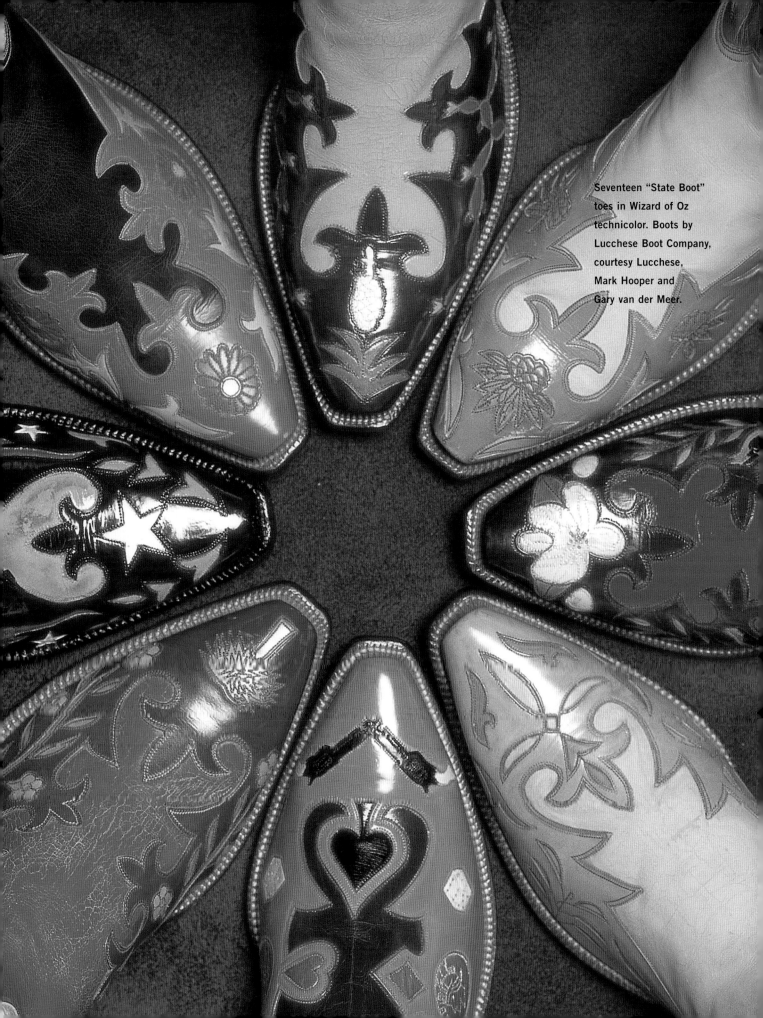

Seventeen "State Boot" toes in Wizard of Oz technicolor. Boots by Lucchese Boot Company, courtesy Lucchese, Mark Hooper and Gary van der Meer.

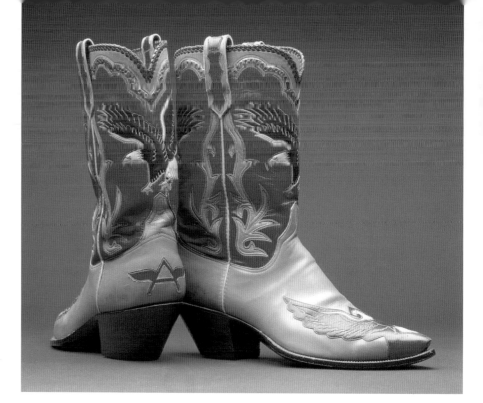

A bald eagle in flight and Gene Autry's "Flying A" brand set off this do-si-do of a dandy design in a classic red and gray color scheme. Boots by Lucchese; courtesy The Autry Museum of Western Heritage, Los Angeles. Photo by Thomas Mishima.

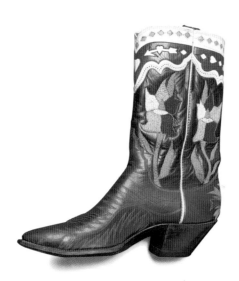

A collaboration between Charlie Garrison and Viola Grae resulted in these highly unusual embroidered boot tops and counters with sleek quilt stitching all the way down the foot. Boot embroidery has been on the endangered species list for about fifty years, but the 1990s have seen a mini-revival of this technique; courtesy The Autry Museum of Western Heritage, Los Angeles.

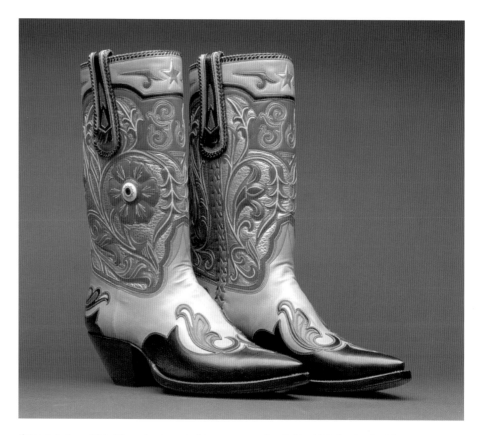

Strangely beautiful. If you had wanted to wave your freak flag high in the 1940s, these would have been the pair to wave it in. One of the few boots signed by Zeferino Rios. Note the asymmetrical design and the scrolled "GA" on the fronts of the boot shafts.
Courtesy The Autry Museum of Western Heritage, Los Angeles. Photo by Thomas Mishima.

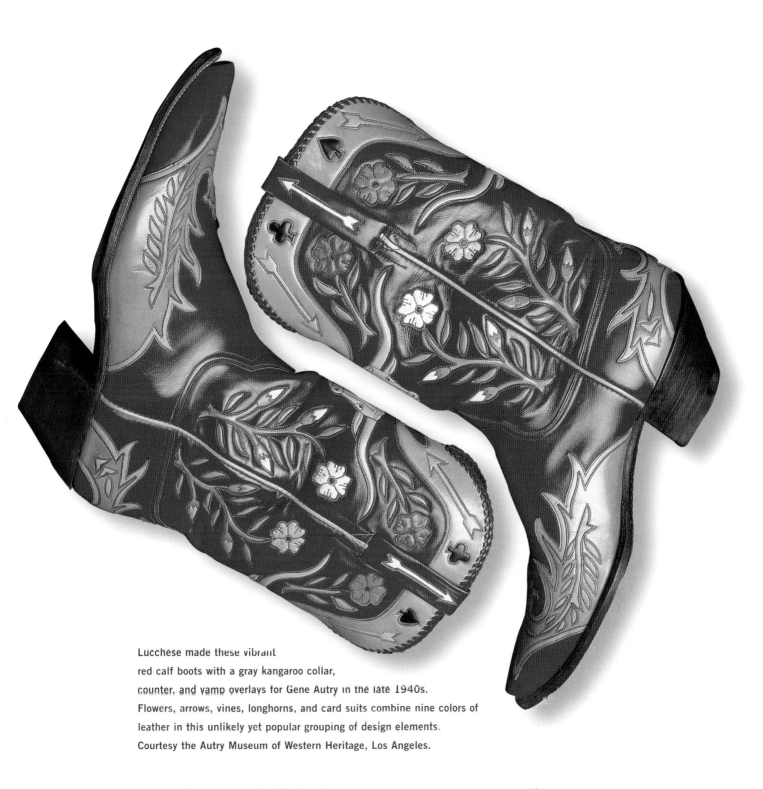

Lucchese made these vibrant
red calf boots with a gray kangaroo collar,
counter, and vamp overlays for Gene Autry in the late 1940s.
Flowers, arrows, vines, longhorns, and card suits combine nine colors of
leather in this unlikely yet popular grouping of design elements.
Courtesy the Autry Museum of Western Heritage, Los Angeles.

In the post-World War II years, entertainment was requisite for war-weary Americans. By now the Wild West shows were over, so the old-time ranch rodeos became, instead, organized town and city sporting events. Boots became much more than protection against rattlesnakes, mesquite thorns, cacti, inclement weather, saddle chafing, or even a means to hold up a pair of working spurs. This was show business. The entertainers in these events realized the need to exaggerate the styles and colors of their costumes in order to

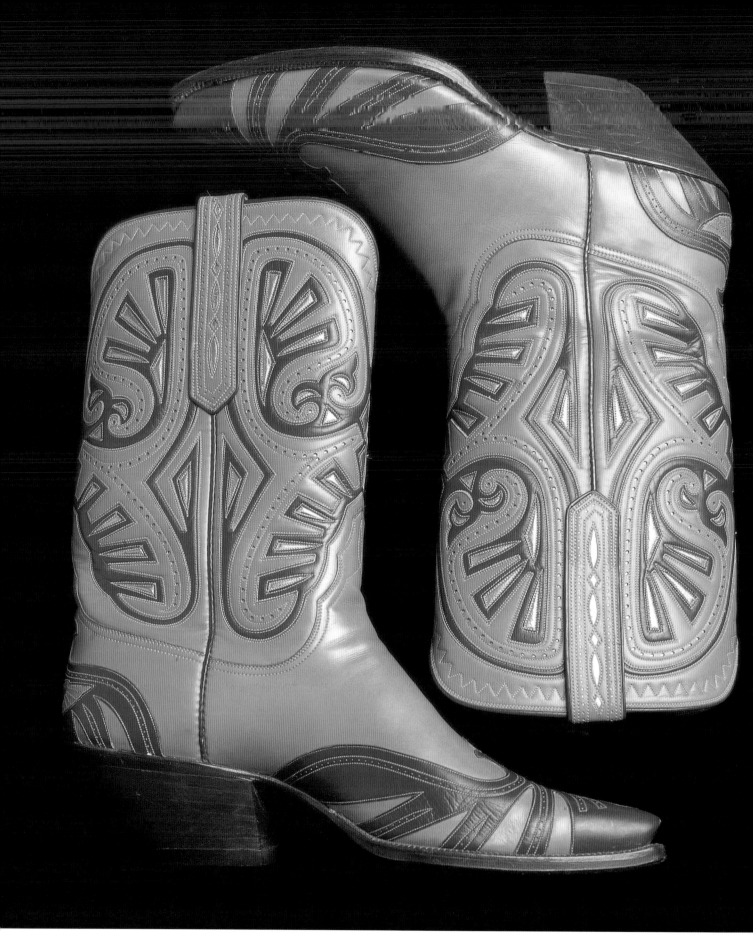

These boots shine with all the gusto of pure gold, burgundy leather, and a benedictine backdrop for some of the most ambitious geometric inlay work ever created. Boots by Lucchese; courtesy The Autry Museum of Western Heritage, Los Angeles.

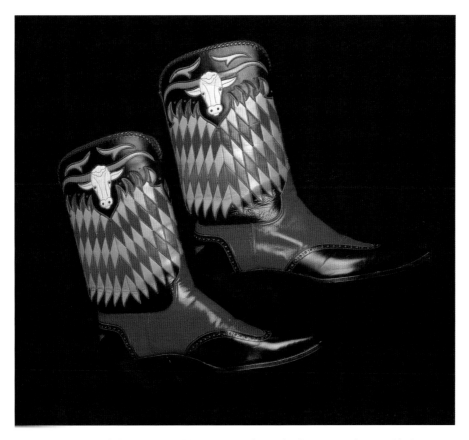

These boots have all the snap, crackle, and pop of a work of art, a puzzle, or optical illusion, all rolled into one masterpiece! Boots by Lucchese; courtesy The Autry Museum of Western Heritage, Los Angeles.

be seen from the grandstands. Styles that featured simple collars with inlaid stars, moons, hearts, card suits, diamonds, ranch brands, and simple initials were now considered "old boot." The rodeo and dude ranch phenomenon, accompanied by the impact of cowboy crooners such as Gene Autry, Roy Rogers and Dale Evans, along with the Nashville country music scene, were keys to the mass appeal that put cowboy boots on the feet of people of all ages, in all states, in all professions.

The Big Five—Justin, Tony Lama, Nocona, Hyer, and Acme—began to crank out millions of pairs to satisfy this first wave of national cowboy-boot mania.

Looking back, it is logical to consider 1940 to 1965 as the golden age of boot making. This was the time when bootmakers pushed all the limits of their imagination and skill. During this period, western clothing crossed all gender boundaries more than in any decade previous. Boots were being made in a variety of shapes, colors, styles and leathers unimaginable only a generation before.

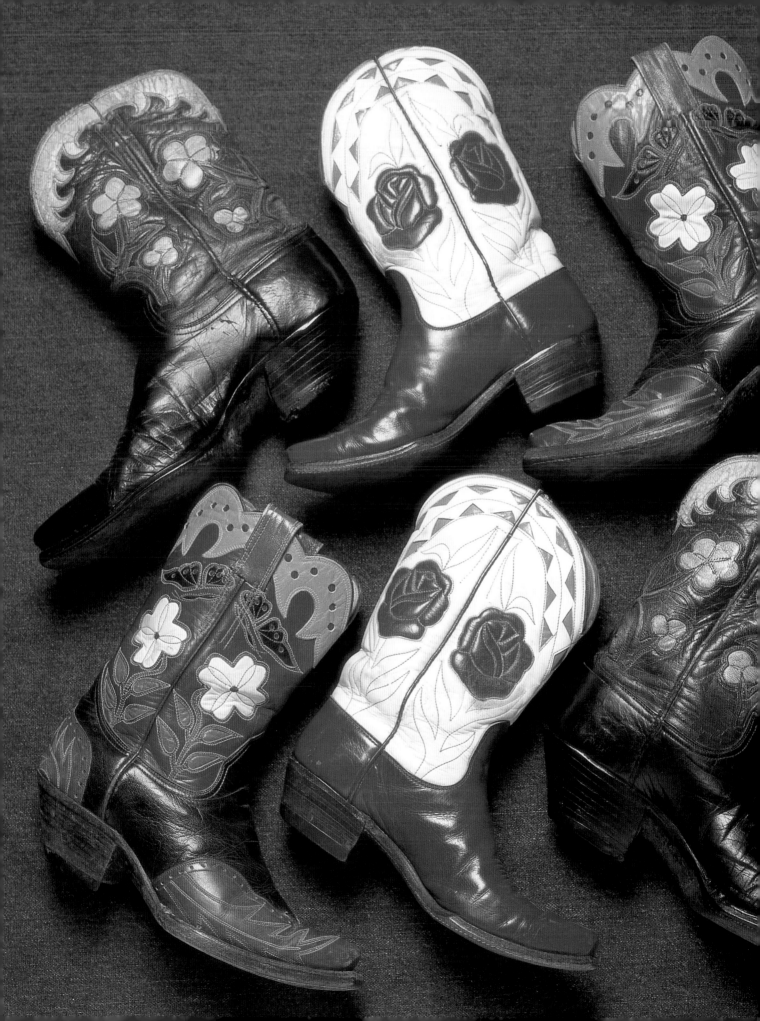

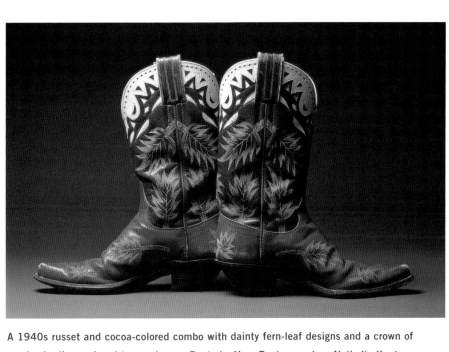

A 1940s russet and cocoa-colored combo with dainty fern-leaf designs and a crown of overlay in diamond and tepee shapes. Boots by Hyer Boots; courtesy Nathalie Kent.

A 1940s beauty! Burgundy and crimson with a "lace"-style inlaid collar. Boots by Olsen-Stelzer; courtesy Gary van der Meer.

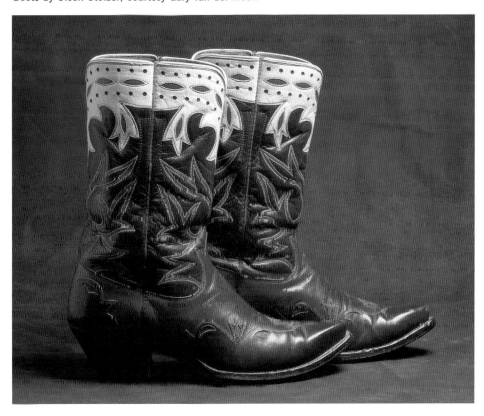

Opposite: A triad of sweetie pies—1940s butterflies and flowers. The one with a scalloped gingerbread collar on top is courtesy Rocketbuster Boots Vintage Collection, maker unknown. Rose boot by Justin, courtesy Corky Dieringer Collection. Floral plum and black boot courtesy Caroline Shapiro Collection, maker unknown.

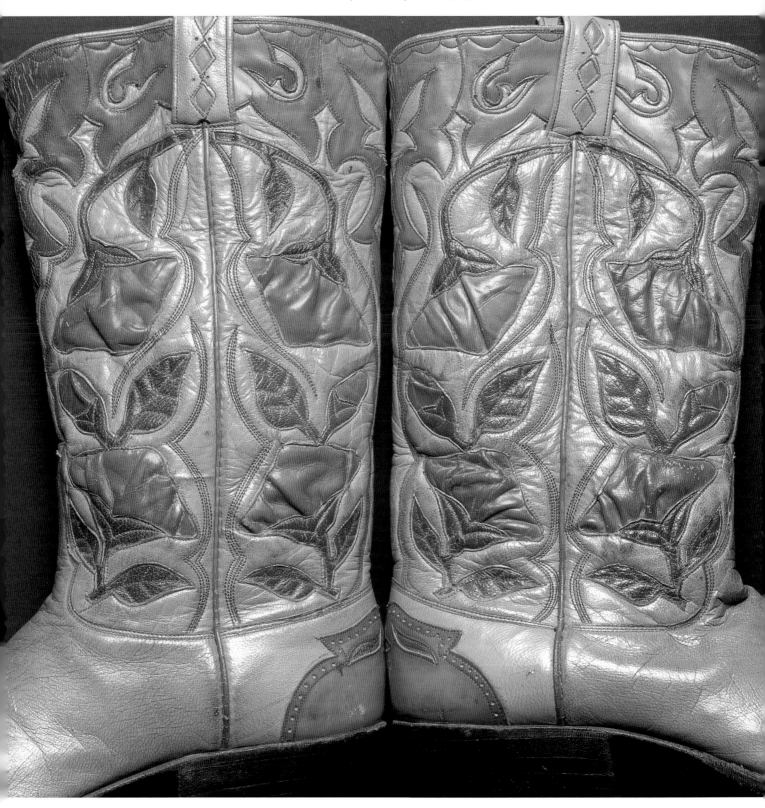

A 1940s parade of pinched roses is a very atypical pair of boots by L. White, Ft. Worth, Texas.
Courtesy Mark Hooper collection.

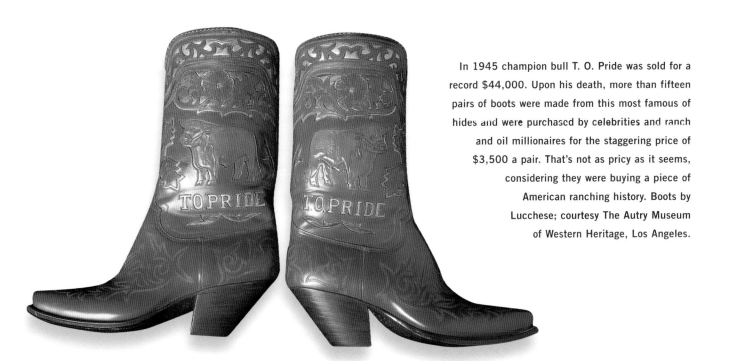

In 1945 champion bull T. O. Pride was sold for a record $44,000. Upon his death, more than fifteen pairs of boots were made from this most famous of hides and were purchased by celebrities and ranch and oil millionaires for the staggering price of $3,500 a pair. That's not as pricy as it seems, considering they were buying a piece of American ranching history. Boots by Lucchese; courtesy The Autry Museum of Western Heritage, Los Angeles.

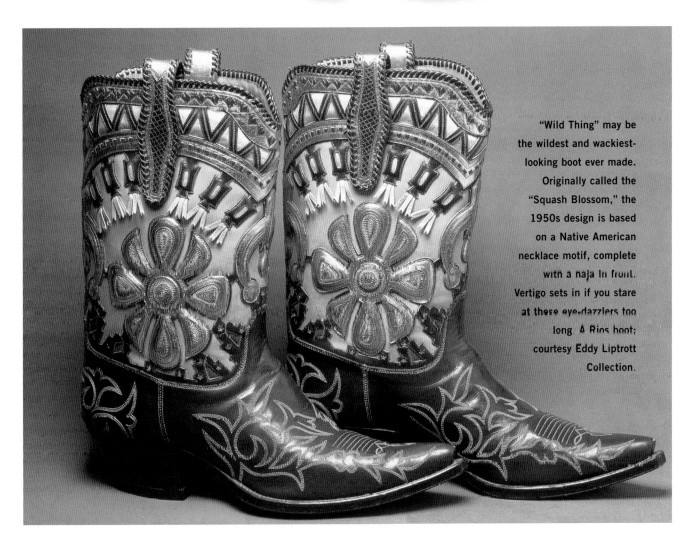

"Wild Thing" may be the wildest and wackiest-looking boot ever made. Originally called the "Squash Blossom," the 1950s design is based on a Native American necklace motif, complete with a naja in front. Vertigo sets in if you stare at these eye-dazzlers too long. A Rios boot; courtesy Eddy Liptrott Collection.

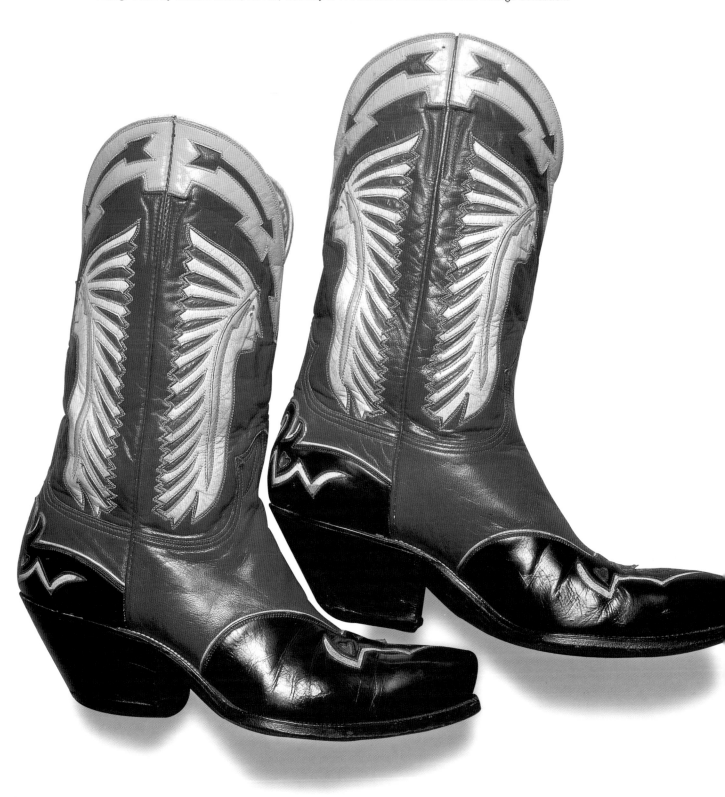

"Indians and Arrows" in shades of fire-engine, canary, and a dash of kelly green with Romero's famous toe and heel foxing. Boots by Romero Boots, 1940s; courtesy J. P.'s Custom Handmade Boots Vintage Collection.

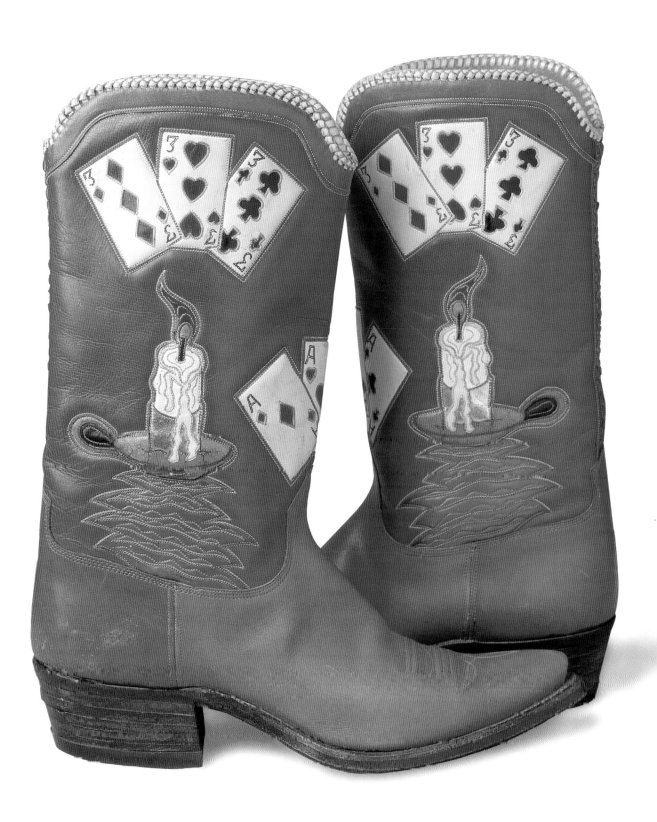

An intriguing cryptic message in leather—a winning hand? time is running out?
And what is the candleholder sitting on—piles of money? Another cowboy boot mystery.
A 1940s Rios boot from an anonymous collection.

Opposite: Layers of dust and polish have given this
1940s horse, shoe, and flower boot the perfect patina.
Maker unknown; courtesy Corky Dieringer Collection.

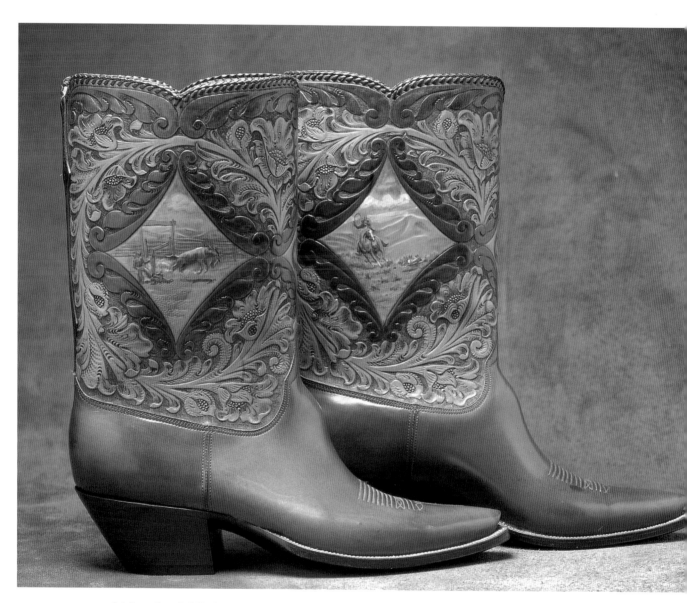

Art for art's sake? Yep! This pair eclipse all other boots from the 1960s. Hand-tooled and painted by master leather artist Al Shelton and built by Lucchese, these are beautifully inscribed to a Mr. Wesley West, 1965. They have never been worn. Perhaps they should be hung on the wall. Courtesy Lucchese Boot Company.

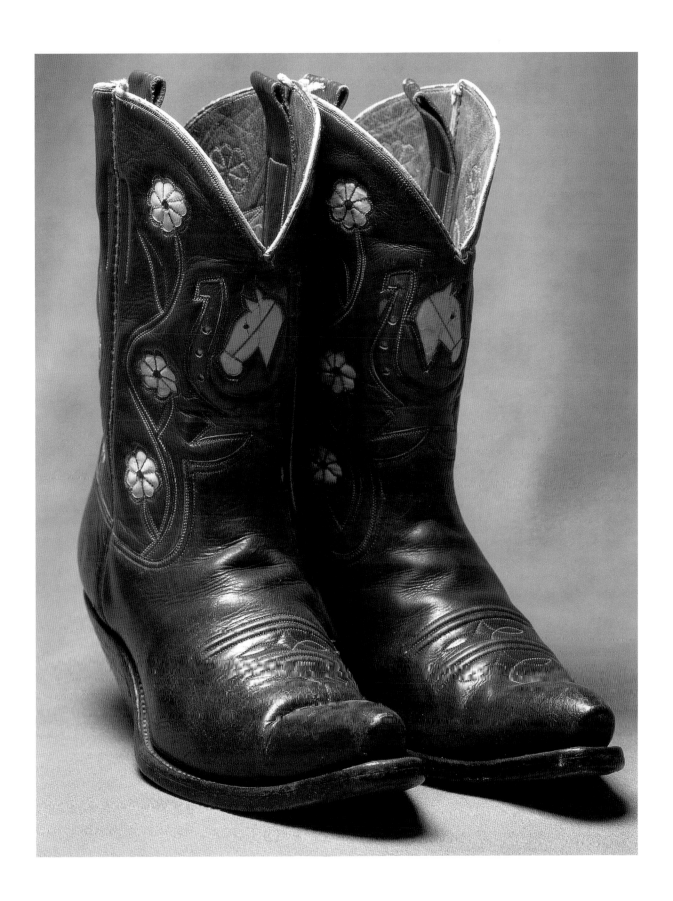

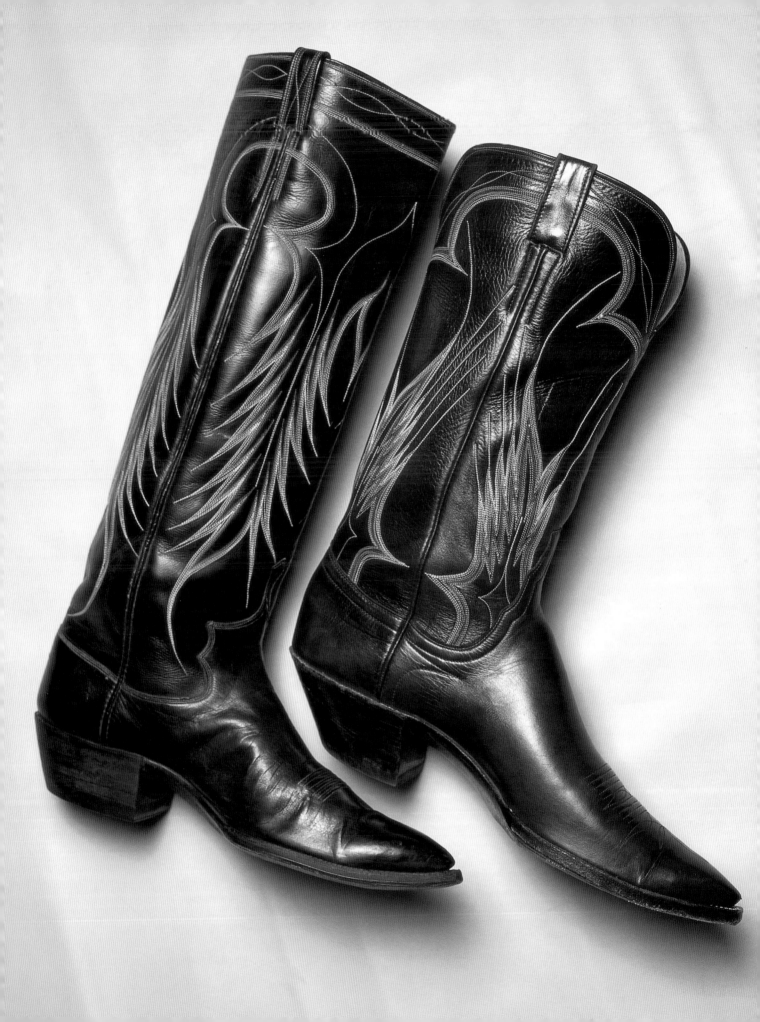

Opposite: Two versions of the famous and much-copied "Roman Candle" or "Flame Stitch" originated by Willie Lusk. Lusk and Walter George (of Amarillo, Texas) are the only two black bootmakers known to have their own boot shops. In 1945, Las Vegas casino owner Benny Binion walked into Brown's Boot shop in Lubbock, Texas, where Willie was working. When Binion asked why he wasn't working for himself, Lusk pointed out that he would need $5,000 to open his own business. Binion pulled out a wad that would choke two horses, peeled off the cash, and added, "Now you're in business. Make me some boots." Mrs. Evelyn Green worked with Willie and stitched all his boot tops once the new shop was open. Boot on the left by Willie Lusk, courtesy Caroline Shapiro Collection. Boot on the right by James Leddy Boots, courtesy John Tongate.

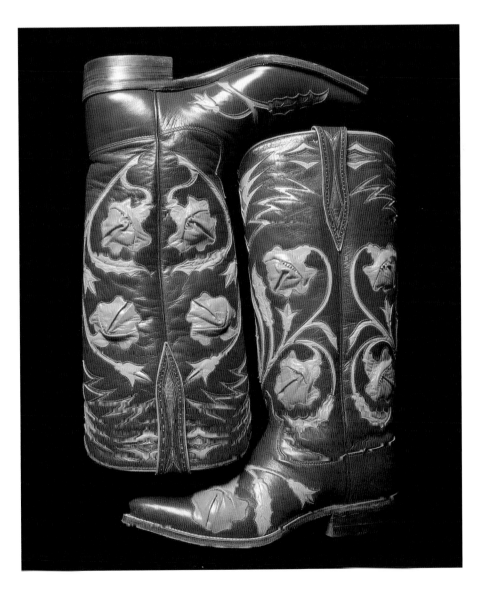

These boots were a gift from Buck Rutherford to June Ivory, both famous rodeo celebrities in the 1950s. Fashioned from purple calfskin, the vamps and uppers are inlaid with plump pink roses and gold-leaf metallicized leather designs. Boots by Justin Boot Company; courtesy The National Cowboy Hall of Fame.

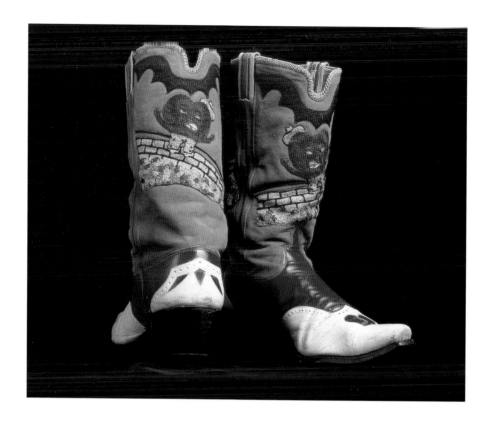

In the 1960s, John Wayne was competing with the Beatles for the admiration of American youth. Western heroes and western style took a backseat for awhile, it seems. Boots took on a more conservative appearance; the sharp narrow box toe and the needle nose were all the rage. Heels were lower, walking style and flat. The bright colors and inlaid designs were no longer popular; nor were short-top peewees. The cowboy boot industry prevailed as a fashion classic throughout the sixties and into the era of the hippie and the moccasin craze.

The 1970s rolled along with few changes in the cowboy boot. Toes were still basically pointed. The leisure suit and polyester influence had the tanneries in a fluster trying to match those weird bright and powdery colors. Toes began to round out a little bit more. The "h"- and "j"-shaped toes (see Glossary) were the most popular by the mid-seventies.

In 1980 the movie *Urban Cowboy* was released, starring John Travolta. The redneck hippie look of the late 1970s was suddenly replaced with redneck chic. In the same year, Sandra Kauffman's *Cowboy Catalog Book* was released, giving full instructions in the buying and wearing of cowboy boots and all things western to city dwellers and wanna-be urban cowboys. During this craze, the boot factories and all custom bootmakers

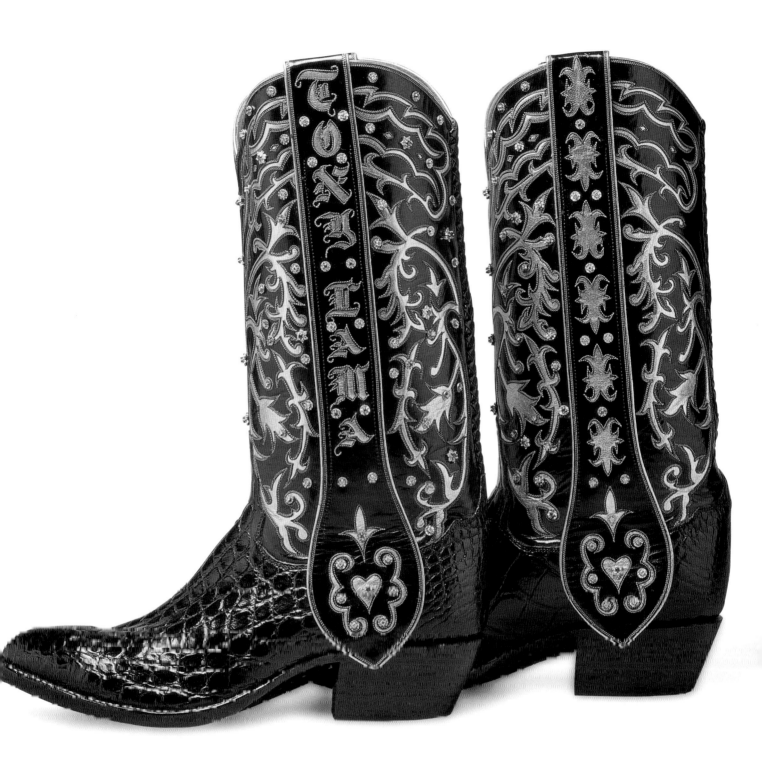

The incomparable Tony Lama "El Rey III" (translation, "the king"). These prismatic black alligator boots have English calf tops and are fully inlaid with 24-carat gold and encrusted with 384 diamonds and rubies in 218 bezeled settings. The "El Rey" were designed in 1951 by Tony Lama Sr., then stolen while on tour in Florida. The "El Rey II" were also stolen while in tour in 1970. The "El Rey III" are the most valuable pair of cowboy boots ever made, valued at more than $50,000; they now travel with 24-hour security.

were inundated with orders, backing them up years. This was the equivalent to a major gold strike if you were in the boot business in the early 1980s. In 1981 *Texas Boots* was released, the first book of its kind dedicated solely to the cowboy boot. The emphasis was to expose the new mass market of boot wearers to the custom bootmakers in Texas, a clear message that a shelf model designed by a total stranger, available in standard stock sizes at the western-wear store, was not the only way to go.

By 1985, however, like all trends, the urbane cowboy had ridden off into the sunset. The paddle-footed, two-tone pale and pastel boots of the early 1980s were now passé. Two 1985 movies—*Top Gun*, starring Tom Cruise wearing a pair of vintage inlaid boots, and *Silverado*, which was the stepping-off point for fashion boots in the entertainment industry—seemed to reignite a genuine interest in classic cowboy boot styles of the 1890s to the 1950s. It was during this time—the mid-1980s—that anything western, especially cowboy boots, was being sold at a frenetic pace worldwide. The vintage boot stores in New York and up and down Melrose Avenue in Los Angeles were going great guns selling nothing but vintage boots and copies of boots from the golden age of boot making. The retro cowboy boot stampede had begun, and a renaissance of boot making was well underway by 1991, finally challenging the creativity and artisanship of the golden age.

In 1992 *The Cowboy Boot Book* was released. Boot aficionados now had a new boot bible to study by. Its positive influence on the boot industry shocked not only its originators but the entire boot industry, sending customers scurrying to their favorite bootmakers to order boots directly designed from, or inspired by, designs featured in the book.

Who knows their toes?

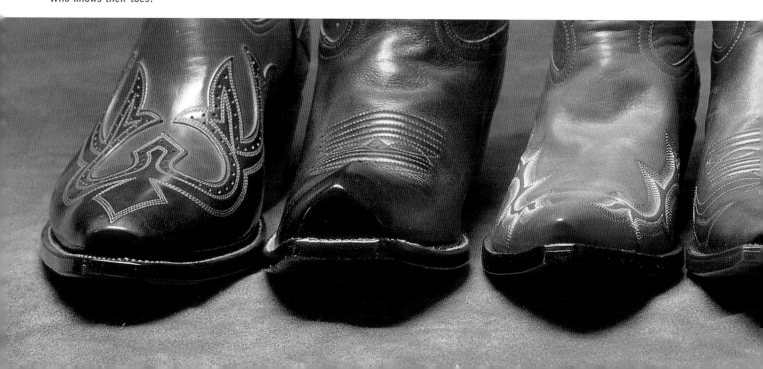

My hat's off to every man or woman who ever made a pair of cowboy boots. I have nothing but complete respect for anyone who chooses, or is driven, to create custom cowboy footwear from raw sheets of leather and hide. The ultimate tribute to these great American bootmakers is the sheer fact that they have been able to earn a living, whether on Main Street, in a basement, a shed, or a converted garage. The grateful, patient stream of customers over any length of a bootmaker's career is the absolute testament that they are doing something right.

People often ask if boot making is a dying art. My reply is always a resounding, "No!" Just in the past few years, the population of bootmakers across the country has nearly doubled. It is always heartening to learn through numerous letters and phone calls that *The Cowboy Boot Book* was the "sole" inspiration for launching many a new bootmaker's career. A poignant example dated July 8, 1995:

Dear Mr. Beard,

My name is Deaon Hockley from Fowler, Indiana. I am thirteen years old and quite interested in learning boot making, and thanks to you and the book you wrote I've been in contact with some of the bootmakers getting tips and pointers on boot making. We will be traveling to Texas in the next couple of weeks so I can meet and talk with some of them personally. We plan to be at the Boot and Saddle Makers Roundup in Brownwood, Texas. I hope to meet you and some of the bootmakers in the book, so I can get them to autograph it. Thanking you in advance.

Deaon Hockley

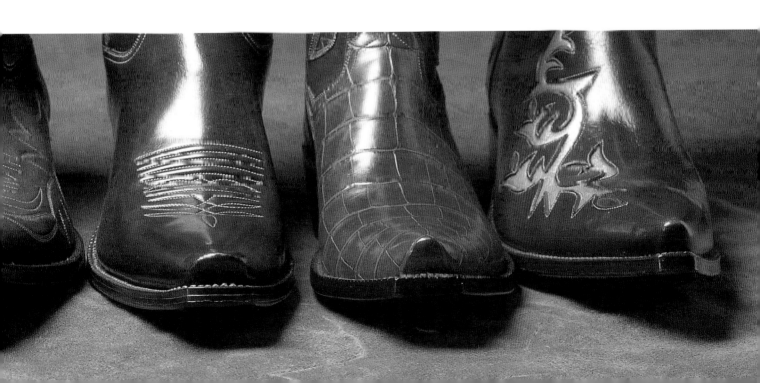

Bear in mind that while it may have been the book that exposed these budding bootmakers to this leather craft of cowboy boot making, without more than 150 years of bootmakers and boot companies, there would have been no stories to tell and nothing to inspire awe. In reality, there is a book in each and every bootmaker's life: the whys, whens, and what fors; the woes, long hours, and yippie-ei-os; the lean and flush years, the wasted leathers; the steady stream of apprentices who can't hack it and pack it in. I hope their stories are being recorded to preserve these verbal fragments of American history and folklore. Visiting an older bootmaker's shop can be an experience in itself. When the memories dim and the legends transcend into myth, a warning sign over the shop door should read, "Keep your boots on, tuck in your britches. It gets deep in here."

The most frequent question I am asked is "Who is the best bootmaker?" That's like asking "Who is the best artist who ever lived?" Any answer would be subjective. After all, beauty is in the eye of the beholder, and certainly this applies to cowboy boots. It all depends on how one sees art. *Artistry* is a word that applies to the quality of workmanship in every handmade pair of boots. There has never been, nor will there ever be, a "best" boot artist.

For example, Ray Jones from Lampasas, Texas, (now deceased) has been referred to innumerable times as "the bootmakers' bootmaker." I love Ray Jones boots. They were tough as hell, plain-to-average in description, with only two choices of stitch pattern. Most folks never saw the second choice because Ray didn't like it. You had to be on your second pair to ensure perfect fit before Ray could even be begged to inlay a few initials. I never heard a bootmaker say that Ray Jones was the best, but plenty of ranchers and cowmen thought he was; his boots were utilitarian for the most part. A bootmaker's pride is in the customers: if they consistently order from one maker, they must think that bootmaker is the best.

But if you ask three hundred bootmakers the best way to make a pair of cowboy boots, you will get three hundred different sets of instructions. And most of them preface with "My way is the right way."

With the exception of a handful of boot factory owners, there probably are not any wealthy custom bootmakers. It doesn't take a math whiz to do the calculations. At the end of the century, the average base price of a pair of custom-made cowboy boots is $450 and up—sometimes way up, depending on the maker. Forget about exotics; for a basic calfskin boot, materials alone can run $50 to $100, depending on the quality of the skin; you get what you pay for. It takes the bootmaker thirty to forty hours to complete this pair of boots. Figure the hourly wage: it's probably less than average.

Unquestionably, plain brown and black boots with a twelve-inch shaft, three-to-six rows of stitching, low walking heels, and rounded toes far outsell what you'll see in this book. Quality is measured slowly when the product is entirely handmade. I suppose I have seen and handled, collected, bought, and sold a greater variety of cowboy boots than anyone else in the world. Each and every time I think I've seen it all, some son of a bootmaker boot will come along and pitch me right off center, throw me for a boot loop with some new idea, design, toe, or technique. Starry-eyed and boot bleary, words sometimes fail me, but I never fail to admire the artistry—and always end up wanting another pair of new boots.

Featured in this book are some of the more artistic and imaginative cowboy boots to come down the trail. In the mix are an assortment of vintage cowboy boots ranging from the late 1800s through the 1960s. These will surely whet the appetites of boot wearers, makers, aficionados, connoisseurs, and collectors, as well as win a whole new clientele of first-time custom-boot buyers. This confetti of color, design, and skill, I feel, have finally pushed the boot boundary far beyond the golden age of boot making (1940–65) to a new level of platinum—1988 and forward.

At the turn of this century, the cowboy boot will be more than 150 years old. Has it changed much? Yes and no. Recently, there has been a wave of interest in period boots of the late-nineteenth century. Some makers are even fully pegging their soles (no stitching). Requests for high-tops, higher heels, angled Cuban heels, no stitching up top or a simple single row or two, and a wide variety of squared-off early toe styles have become something of a trend, and it's not the old-timers making these requests—It's the young cowboys. As in the late 1980s and early nineties, anything still goes.

"What's new in cowboy boots?" you ask. Plenty!

First off, women are slowly moving to the forefront of custom cowboy-boot making. The number of women enrolled in boot-making schools and fulfilling apprenticeships has quadrupled since 1992. While women have always been a driving force behind many a bootmaker, and a large percentage of boot tops have been stitched by women, the new thing is the advent of women owning their own shops and making their boots from beginning to end. In this male-dominated profession, it seems that the survival of a woman bootmaker is a rare and precious thing.

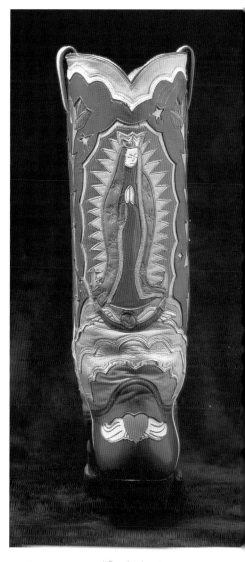

"Our Lady of Guadalupe" is a superlative example of overlay and inlay work from the platinum age. Boots by Rocketbuster Boot Company.

The "first lady" of cowboy boot making, Enid Justin (sister of the Justin brothers; started Nocona Boot Company in 1925) never made a complete pair of boots herself, but she knew as well as any bootmaker how a boot *should* be made—an important factor when you are the owner and president of one of the top five boot manufacturing companies in the world. From 1925 to 1980, no women had their own boot shops. Enid died in 1990 at age ninety-six, and if she were still around she would be so proud of how far women have come.

Melody Dawkins has the distinction of being the first woman to own her own boot shop. She represents the fifth generation in a long line of shoe and boot-repair shop owners from North Carolina. She grew up in the repair business in Porterville, California, and already owned her own repair shop when she got an itch to learn the full process of making a cowboy boot. After six months in Oklahoma in 1980 learning the craft, Melody had the ability to make a complete pair of boots from beginning to end. She now resides in Palm Springs, California, where she maintains her own business as well as teaching shoe and boot making at the local Calypatra Prison.

Then came second-generation bootmaker Deanna McGuffin. She began to learn boot making from her father, New Mexico boot legend L. W. McGuffin, in his shop in 1981. In addition to crafting fine boots, Deanna has been teaching boot making for several years.

At the moment, fewer than a half-dozen women are making a full-time living as bootmakers in the United States, but this number is bound to increase. Keep your eyes on the women!

Some of what's new in boots has never been seen before—100 per-

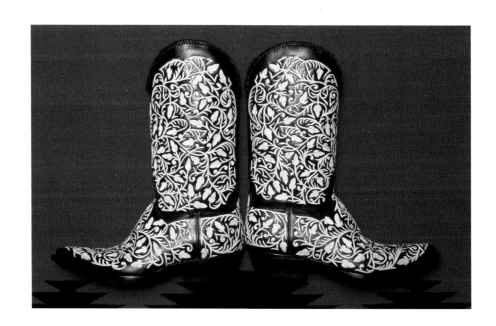

It took one man six weeks to complete this mesmeric maze of *pitiado*, which is on its way to becoming a lost art. You'd better get 'em while you can. Boots by Liberty Boot Company; courtesy Jim Arndt Collection.

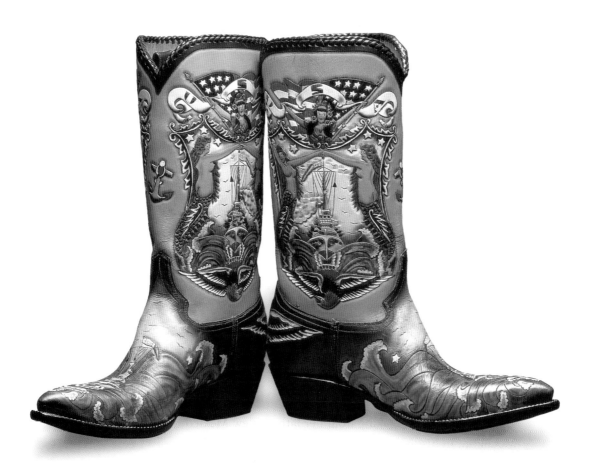

cent original. Other trends may have been inspired by a single detail or embellished, or perhaps just a few earlier examples of a particular idea or design are known to exist.

The first noticeably new trend after 1993 was an increased interest in hand-carved leather boot tops. In the past, floral designs and the occasional cowboy on a bronc were the limit. But now, saddle makers and leather-crafts people are being called upon to tool tops of every description—portraits of loved ones and pets, a favorite boat or classic automobile, pictorial story-telling from top to bottom and toe to heel. More and more, these designs, as well as the classic floral patterns, are being hand painted and stained in a rainbow of colors for visual impact and emphasis on minute details.

Suddenly, hand-beaded boots began to pop up; then varying tech-niques and styles of machine embroidery came on the scene; rhinestone boots are back; studded boots; long mule ears with sterling silver conchos; ornate stitching and inlays; then the ancient art of *pitiado* was revived (see page 103). We are seeing gold, diamonds, silver, prehistoric mammoth tusk, ancient coins, and precious stones set into boot leather to create wearable cowboy-boot jewelry.

This new zenith in cowboy boot artistry since 1993 has placed us in

These tantalizing tattooed boots are a true original. Hand-tooled and painted tops are inspired by 1940s-era tattoos. Boots by Rocketbuster Boot Company.

the eye of the platinum age of boot making. Bootmakers and wearers have accepted the challenge to go where no boots have gone before. The cowboy boots offered up now are not only footwear but sculptures in leather, a cornucopia to challenge your imagination, tug at your heartstrings, touch your senses, leave you speechless and gasping for breath, and finally, leave your toes twitchin' and your dogs barkin' in exquisite longing for a new pair, a lulu of a pair, a tattoo for your dreams, your hopes, your loves, your future, something that would knock your granny down and make your mama cry.

Long live the cowboy boot!

I would have bet my boots this was a vintage pair . . . nope! In the early 1990s at Jay Griffith's shop in Oklahoma, Lisa Sorrell made the tops under Jay's direction and using his patterns. A local artist painted the pull straps, and finally Cricket Garcia re-lasted them for Vicki Smith when she spotted these unclaimed boots in the Griffith shop. This style of very thin pie slices of petit-point inlay work seems to have originated with Jay. Courtesy Vicki Smith.

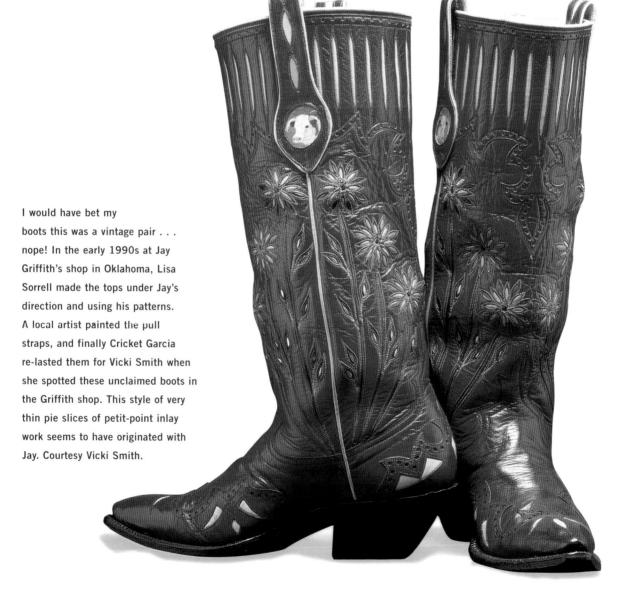

A veritable feast for the eyes in variegated colors with lapping scarlet inlaid flames, a diamond-shaped geegaw with a stone is a Lee Downey creation made from ice-age mammoth ivory unearthed during the brief arctic summers in Canada, Alaska and Siberia. This fossil is at least 10,000 years old. Boots by Paul Bond Boot Company, courtesy Lee Downey.

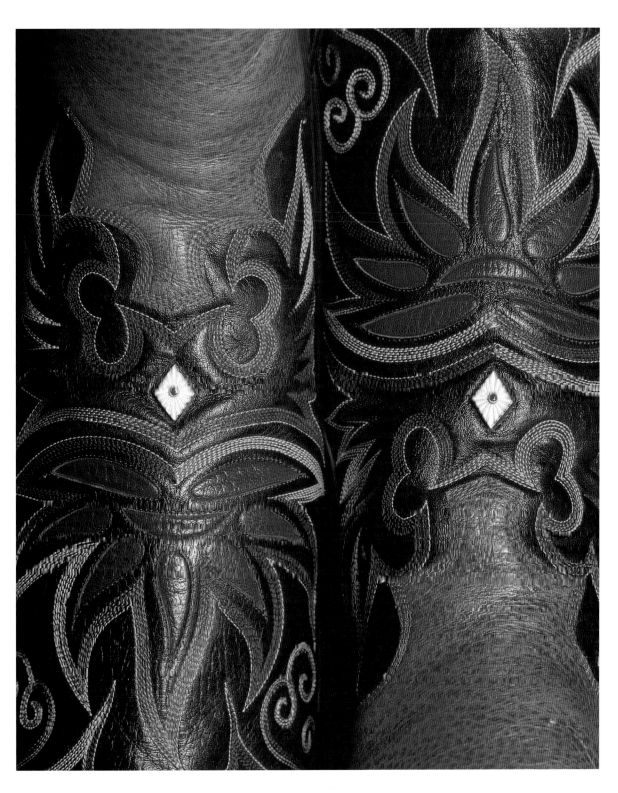

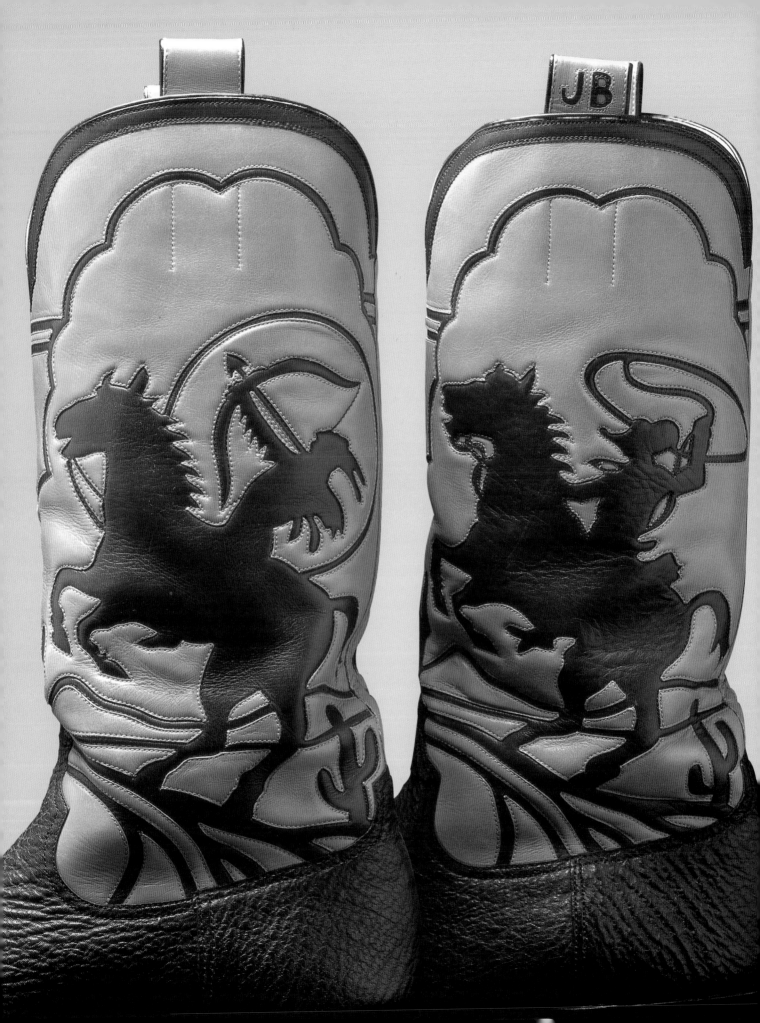

THE
BOOTMAKERS

Ammons Boot Company

Michael Anthony

Alan Bell/Bell's Custom Boots

Blucher Boot Company

Paul Bond/Paul Bond Boot Company

Carl Chappell/C.T. Boot Shop

Stephanie Ferguson Custom Boots

D. W. Frommer/Frommer Boots

J. B. Hill Boot Company

Pablo Jass/Jass Boot Shop

Blake Jones/Jones Custom Boots

Eddie Kimmel/Kimmel Boot Company

James Leddy/Leddy Boot Company

Liberty Boot Company

Dave Little/Little's Boots

Lee Miller/Texas Traditions

James Morado/Morado Boots

Bill Niemczyk/Wild Bill's Boots

Joe Patrickus/J. P.'s Custom Handmade Boots

Jack Reed/Jack Reed Boots

Bo Riddle/Bo Riddle Boots

Rios of Mercedes Boot Company

Tex Robin/Tex Robin Boots

Rocketbuster Boot Company

Lisa Sorrell/Sorrell Custom Boots

Stallion Boot Company

Tres Outlaws Boot Company

Dave Wheeler/Wheeler Boot Company

**Facing: Boots by Dave Wheeler,
courtesy Jeff Borins.**

Ammons Boot Company

Rodney Ammons has traveled more than a few miles in the cowboy boot business. Originally from Nashville, Tennessee, his first toe in the water was with the Johnson and Murphy Shoe and Boot Company. His next step up the boot ladder was a job with Bluebell/Wrangler Company as production manager in Tennessee.

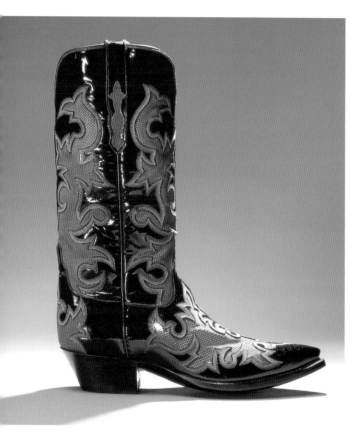

A shimmering sweet and sexy summer boot with a ventilated mesh inlay. Boots by Ammons Boot Company.

When Sam Lucchese sold his legendary boot company to Bluebell in the early 1970s, Rodney seized the opportunity to transfer to the Alamo city, San Antonio, to oversee production as plant manager. His goal was to up Lucchese's small cowboy boot production output of six-to-ten pairs a day to 120, and so he did. "Sam was my mentor—I was lucky to know him and work with him. You know, Sam was not a bootmaker, but he knew more about the human foot and how a cowboy boot should be made than anyone before or since," Rodney said.

Homesick, Rodney took a job in 1976 with the Wrangler Boot Company in Tennessee, but his experience working with Sam Lucchese had spoiled him for high-volume mass production of the cowboy boot, so after a few years, it was back to boot mecca El Paso. Ammons worked from 1980 to 1984 with T. O. Stanley Boots. This partnership put on the shelves of western-wear stores all over the Southwest, a Stanley stock-size boot whose reputation has survived as one of the highest-quality factory-production cowboy boots ever made. These two gents rode out the wave of the urban cowboy boot boom, after which Rodney founded Ammons Boot Company in 1985. With a small production line of craftsmen, Ammons turns out a first-class cowboy boot. The size of the company allows for both custom made-to-measure cowboy boots for one customer at a time, and a full run in stock last sizes in retail stores.

Cynde Pieri heads up the marketing, research and development and also helps design boots. Celebrity clients Robert Redford, Burt Reynolds, George Strait, and Dolly Parton seem to go for Ammons' elegant and exotic gators, ostrich, lizard, and slick kangaroo. You can pick an Ammons boot out

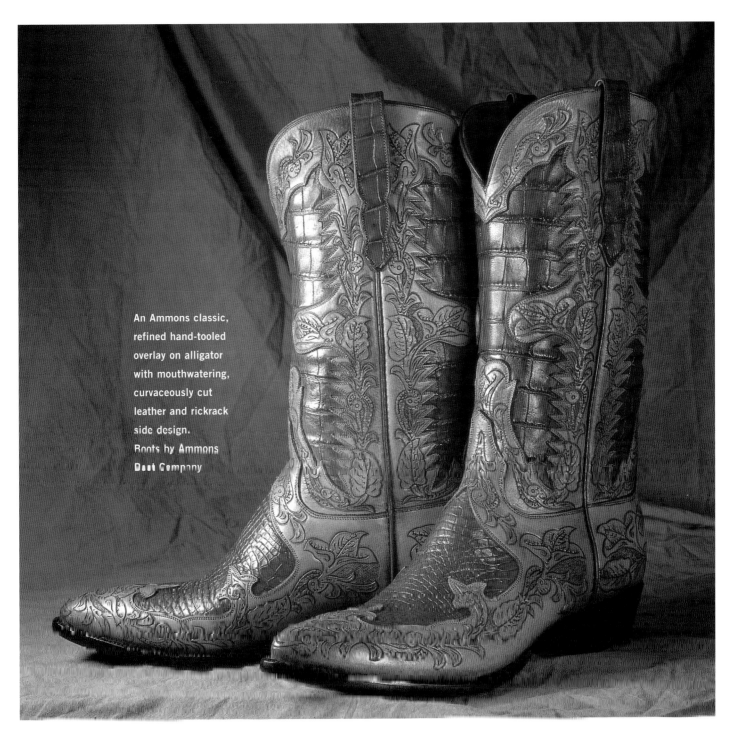

An Ammons classic, refined hand-tooled overlay on alligator with mouthwatering, curvaceously cut leather and rickrack side design. Boots by Ammons Boot Company

of the crowd by its deep, rich colors of exotic hides, usually paired with a contrasting leather overlay, sometimes hand tooled in a floral design trailing asymmetrically from the top to the toe.

P.S. Rodney, I'll bet Sam is looking down and smiling.

Michael Anthony

Detroit native Michael Anthony cut his leather teeth in shoe repair shops in his home state of Michigan. After reading *The Cowboy Boot Book* in 1993, with visions of cowboy boots dancing in his head, Michael called Jack Reed in search of some lemon-wood pegs he needed to properly resole a pair of cowboy boots. One call led to another and in 1994 Michael's boot-making odyssey began. He saddled up his Harley and took Horace Greeley's advice, "Go west, young man."

At Reed's, Michael's boot roots took hold, and there was no turning back. After a brief but intense boot-making crash course with Reed, Michael saddled up again and headed for California—a state not known for it's cowboy bootmakers. Michael was determined to put his permanent bootprint there. After short stints with various boot and shoe repair shops, Michael opened his own shop in July 1994 in northern California. Over the next few years, he continued to make his boot sojourns to Jack Reed's shop, where Jack passed on his craft as well as a little boot wisdom: "Michael, when you make your first pair of perfect boots, call me, because I haven't made one yet." Now, keep in mind, Reed has been making boots since the 1940s!

Michael's customer base is naturally in California, the wine country's "mink and manure set" in particular, for whom fine wine and fine cowboy boots seem to be interwoven. Anthony's attention to detail, sturdy construction, and his knowledge of fine leathers is impressive. His boots seem to emit a studied elegance. He does some terrific work in the crème de la crème of hides: salt-water crocodile, imported full-grain boot lining from England, and aged pit-tanned sole leather from Germany. Always on the prod for a new exotic hide, Michael generally prefers to work in gator, French calfskins ("French cows are better fed and there is no barbed wire to scratch their hides"), lizard, snake, shark, stingray, and numerous other non-endangered animal hides.

"If you're going to San Francisco," drive ninety miles north to visit Michael. He might be coaxed into showing you a great party trick: how to balance a boot on its heel atop a wine bottle. (If you didn't learn boot making from Jack Reed, this trick won't work; it's an engineering puzzle.) If Michael is stitching boot tops when you arrive, he'll be yodeling along with cowboy yodeler Jimmie Rodgers, a superstition Michael picked up from Reed.

P.S. Michael, your Egyptian inlay is awesome. I challenge you to do a Cleopatra theme boot. By the way, did you know the very first person to cross the Golden Gate Bridge at its opening on May 24, 1937, was on horseback, wearing a pair of cowboy boots? Now, if we could just find out who made 'em. . . .

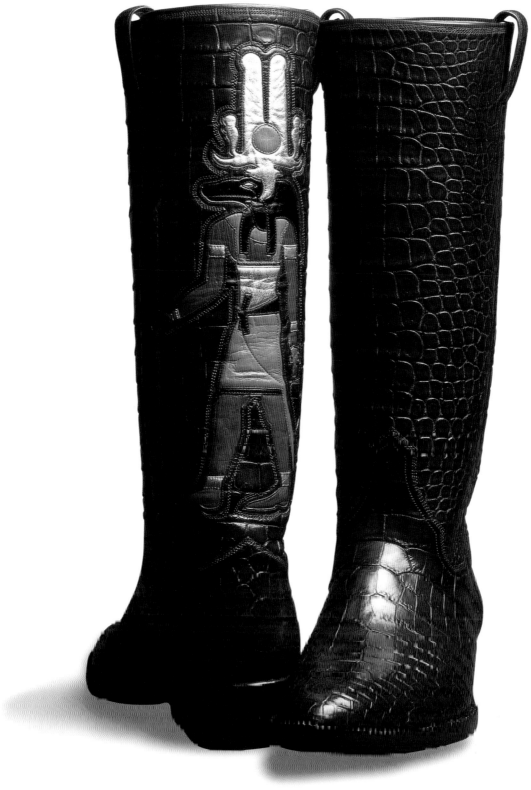

A salacious saltwater crocodile boot with impeccable inlay inspired by hieroglyphics of Sobek, the Egyptian crocodile god.

Boots by Michael Anthony.

Alan Bell / Bell's Custom Boots

In 1981 Alan was quoted in *Texas Boots* as saying, "I'm going to be around for a long time." He was right. After working with Tex Robin in Coleman, Texas, in the early 1970s, Alan strayed to Abilene, where he humbly remains one of the living boot legends. Barely middle-aged and with back-orders exceeding one year, my guess is Mr. Bell will be around a lot longer. I know his devoted customers hope so.

As one of the dozen bootmakers featured in *The Cowboy Boot Book*, Alan continues to hold that 75 percent of his customers are from Texas, the other 25 percent are loyal, macho ironworkers and hockey players from Michigan, a result of word-of-mouth advertising. His Texas customer base is largely from a two-hundred-mile radius around Abilene. Fifty percent are cow people and 50 percent are horse people.

Alan's favorite hide to work with is still ostrich, but, of course, "I do them all," he says. Bell remains one of the few bootmakers in Texas who still makes all his boots entirely by himself.

Alan has some great advice for the wanna-be cowboy bootmaker: "Go to work for a good bootmaker, and if you want to own your own shop some-day, work for him long enough to get good at it. Also, sweat the small stuff. Attention to detail, along with fit, in my opinion, is the most important part of boot making. Don't ever become satisfied with your work. I've personally never made a pair of cowboy boots that completely satisfied me. Understand, now, that your customers are very pleased with their boots, but to me, every pair could be made just a little bit better. If you become satisfied with your work, right there is as good a bootmaker as you will ever be. Better, better, better, is what you should strive for."

"Be patient and long-suffering," Bell adds. "Boot making takes a long time to learn. Use no shortcuts and no shoddy material. Stay humble. It is my experience that anyone who thinks he knows it all really knows little. Don't go into boot making for the money you think is there. It's not."

We all assume that Alan must make his boots in his sleep, because he spends a lot of his time talking—mainly telling stories about boots and their makers. He's got a slew of 'em. I guarantee if he ever tired of making cowboy boots, he could pursue another successful career as an orator.

P.S. Alan, take the time to make yourself a well-deserved pair of sumptuous ostrich boots; you need 'em bad!

Here is one of Bell's best stories:

"One bootmaker got such a kick out of practical jokes that before a customer would come to get his boots, he would cut a circular piece of leather that did not match the color of the boots. He would take it to his sewing machine and stitch all over it, add some rubber cement, and place it on the side of a pair of finished boots, making it look like an ugly patch job. When his customer would come in to pick up the boots, he would begin to explain that he had accidentally made a slice in the side of the boot and had to patch it. It wasn't a big deal, he would say—nobody would notice this patch on a fast-bucking horse or if the wearer walked fast.

Just about the time the customer began to stutter or become disagreeable, the bootmaker would simply peel the patch off and reveal a beautifully finished pair of boots."

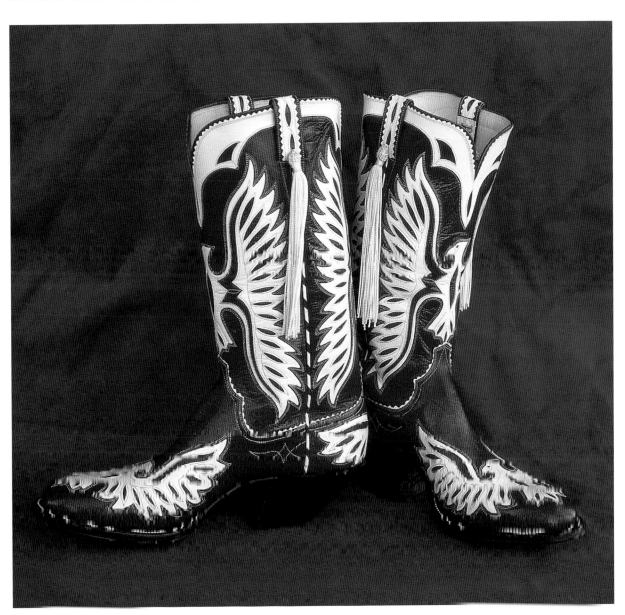

Red-and-white eagle essence with tassels, a unique feature on a pair of cowboy boots, trimmed with Alan Bell's original candy-striped piping.

Blucher Boot Company

In 1915 G. C. "Gus" Blucher and Archer LaForce decided to leave the employ of Justin Boot Company and hightailed it to Cheyenne, Wyoming, to open a boot shop. These boys thought there were just too many bootmakers in Texas, Oklahoma, and Kansas, but I'll bet it was the freezing winters and the distance between cowboys in wide-open Wyoming that drove these bootmakers back to Olathe, Kansas, just three years later. Gus opened a boot shop right across the street from esteemed cowboy boot competitor, Hyer Boots. Archer LaForce finally settled in Tucson, Arizona, where he founded the Western Boot Company. Gus continued making cowboy boots for nearly fifty years until his death in 1932.

With a string of moves, owners, and a floundering reputation in the 1980s and early 1990s due to mismanagement, the reputation of Blucher Boots had suffered. Finally, in 1997, Oklahoma oil man and entrepreneur Clyde Aldridge purchased the company. A clean slate required a move from Fairfax, Oklahoma, to Okmulgee. "The advantages of moving Blucher to Okmulgee," Aldridge said, "are that the company is now located in the heart of cowboy country, and Oklahoma State University at Okmulgee is home to the premier shoe, boot and saddle-making programs."

Part of the Blucher legacy is that they made "cowboy boots for cowboys." In addition to those working cowpokes, another part of their legacy was way out west in Hollywood: Tom Mix, Gene Autry, and John Wayne all owned more than one pair of Blucher boots.

Blucher vice president John Martens has rounded up eight skilled bootmakers, all trained under the guidance of Little's Boots, Jay Griffith and, now, Cricket Garcia. Aldridge reckons, "calf and kangaroo represent about 90 percent of our sales. They are both good boot material, soft and pliable yet tough. The other 10 percent are more exotic leathers—snake, eel, ostrich, and alligator."

Cricket Garcia has hung with Blucher through its ups and downs since 1974. Energetic Garcia remembers, "We had one man who wanted some fancy design work with rhinestones; another wanted a pair with twinkle lights; but the strangest boots I have ever made were a pair that came up to the crotch—they were a size 000 and made for a newborn baby! I like the whole process of making boots" he said. "It is a big challenge to create something that no one else has ever made before."

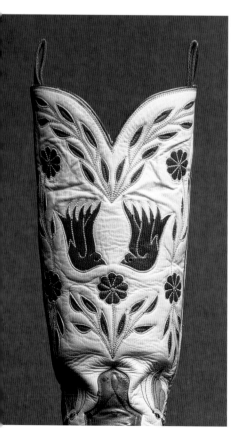

A peach of a petit-point-style inlay with exquisite composition and color choices by Blucher Boot Company. Courtesy Cricket Garcia.

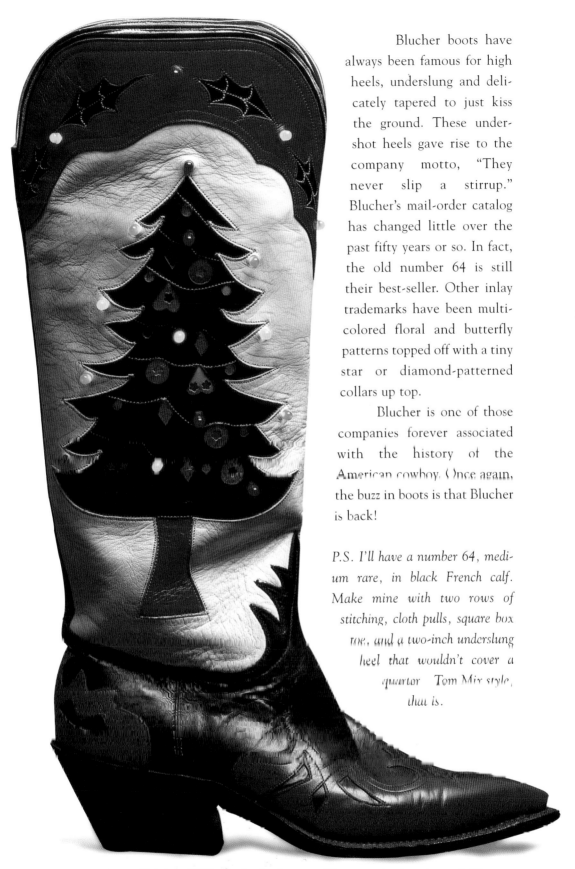

Blucher boots have always been famous for high heels, underslung and delicately tapered to just kiss the ground. These undershot heels gave rise to the company motto, "They never slip a stirrup." Blucher's mail-order catalog has changed little over the past fifty years or so. In fact, the old number 64 is still their best-seller. Other inlay trademarks have been multicolored floral and butterfly patterns topped off with a tiny star or diamond-patterned collars up top.

Blucher is one of those companies forever associated with the history of the American cowboy. Once again, the buzz in boots is that Blucher is back!

P.S. I'll have a number 64, medium rare, in black French calf. Make mine with two rows of stitching, cloth pulls, square box toe, and a two-inch underslung heel that wouldn't cover a quarter. Tom Mix style, that is.

"Merry Christmas." This Blucher boot comes with a guarantee to make you smile, but batteries are not included. Courtesy Cricket Garcia.

— Paul Bond / Paul Bond Boot Company —

At eighty-one, Paul Bond has the enthusiasm, attitude and stamina of a man thirty years younger. To get the big picture, Paul made his first pair of boots in 1939! The rodeo, bustin' broncs for the U.S. Cavalry, and a stint at horse racing kept Paul from full-time boot making for awhile. But in 1946, he partnered in a cowboy boot venture in El Paso, Texas. Restless and not entirely pleased, he soon moved to Carlsbad, New Mexico, and opened his own small custom boot-making shop. Then in 1957 his boot roots sunk deep in Nogales, and Paul has remained a mainstay business in that city ever since.

Bond is still mailing out his classic pocket-size made-to-measure mail-order boot catalogs. This book of Bond boots has changed little over the years. Paul comments, "At one time you could tell what part of the country a man was from by the boots he was wearing. Most buckaroo cowboys in the cold country of the Northwest wore eighteen- and twenty-inch tops. Some of their boots were all the way up to the knee. Now New Mexico and Texas cowboys are also wearing tall tops, so it's getting harder to tell them apart." What about boot tops, Paul? "Some want their boot tops stiff—others want 'em soft. Most north Texas cowboys want their boot tops so stiff you can hardly bend 'em. I guess that's because they're doing a lot of brush popping."

Paul's wife, Margaret, who is a fifth-generation Texas rancher herself, helps with the boot designs. Bond is quick to point out, "Our first love is making boots for ranchers and cowboys. Not much has really changed out here. Ranchers and cowboys love cattle and the country life—it's simple and satisfying and I make a lot of boots for these folks." But when things get too crazy

Brilliant beaded roses and butterflies, hand-appliquéd on dress black. Boots by Paul Bond Boot Company, courtesy Margaret Bond.

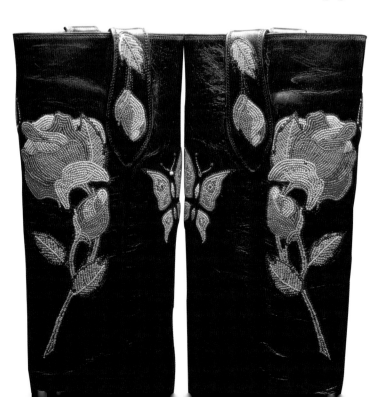

in Nogales, the Bonds head for Margaret's ranch in Wichita Falls, Texas.

Paul's favorite hides are calf and kangaroo, but he acknowledges that a lot of cowboys want something a lot tougher, like shark, bull hide, or buffalo. "Ostrich is still popular, especially for a dress boot. The price has gone down a bit due to higher production in Africa."

Like most bootmakers, Paul can reel off celebrity customers with great ease; this list reads like a Who's Who of rodeo, film, and country music: Randy Travis, Willie Nelson, Waylon Jennings, Clint Eastwood, Rex Allen, Johnny Cash, Barbara Mandrell, Paul Newman, Dwight Yoakam, the late John Wayne, and hundreds and hundreds of others.

If your pockets are bulging and owning a company steeped in cowboy history with twenty-plus bootmakers—and Paul Bond at the helm to tell you how he does it—is your idea of cowboy boot bliss, give him a call. Paul and Margaret want to ease off and slow it down for awhile.

P.S. No finer, kinder, more obliging man and woman ever walked on this earth. If cowboy boot making had its royalty, y'all would surely be king and queen.

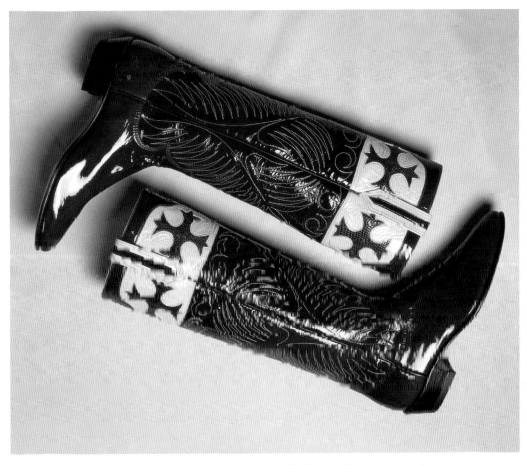

Patent leather "Maltese Cross Boots" with inlaid lizard and a delicate single-row stitch pattern by Paul Bond Boot Company, courtesy Margaret Bond.

Carl Chappell / C. J. Boot Shop

Carl Chappell has an affable manner that at once puts a stranger at ease. I am not sure Carl has "never met a man he didn't like," but he seems like that kind of guy. He is a second-generation boot man. His dad, Glen Chappell, started making boots in Seymour, Texas, clear back in 1945 (for the youngsters, that was right after The Big One—World War II, a way long time ago) and is still making a few pairs for his most dedicated customers.

C. T. made boots from his home for thirteen years, slicing himself a large piece of the Texas Panhandle custom boot-making pie. He now counts four years on the square in historic St. Jo, Texas, "where the Chisholm Trail crosses the California Road." Like all custom bootmakers, Carl can count customers spread out all over the country. His devotees are working cowboys, ranchers, oil men, and professional businessmen and women all over the wide-open Texas plains.

Carl offers a two-week crash course on the ins and outs of boot making, plus how to select hides, tools, and equipment, and sundry tricks of the trade. His boot-making seminars are limited to a half-dozen students, so if you are just itchin' to become a bootmaker and have always wanted to fly into scenic Amarillo, give C. T. a jingle.

Carl told me he likes all kinds of boots—tall tops, peewees—the lot! The Texas boot talk I've heard indicates that he is fast becoming known for his tall-top, colorful, collared, rootin'-tootin'-style buckaroo cowboy boots—for work, play, or whoopin' it up on a Saturday night.

P.S. C. T., you do some wonderfully radical angles on your boot soles, heels, and toes. I also love your three-story scalloped boot tongue.

These boots are for some brave cowboy who might be named Sue.
A brilliant art piece with elegant extremes in toe, heel and foot shapes.
Boots by C. T. Boot Shop.

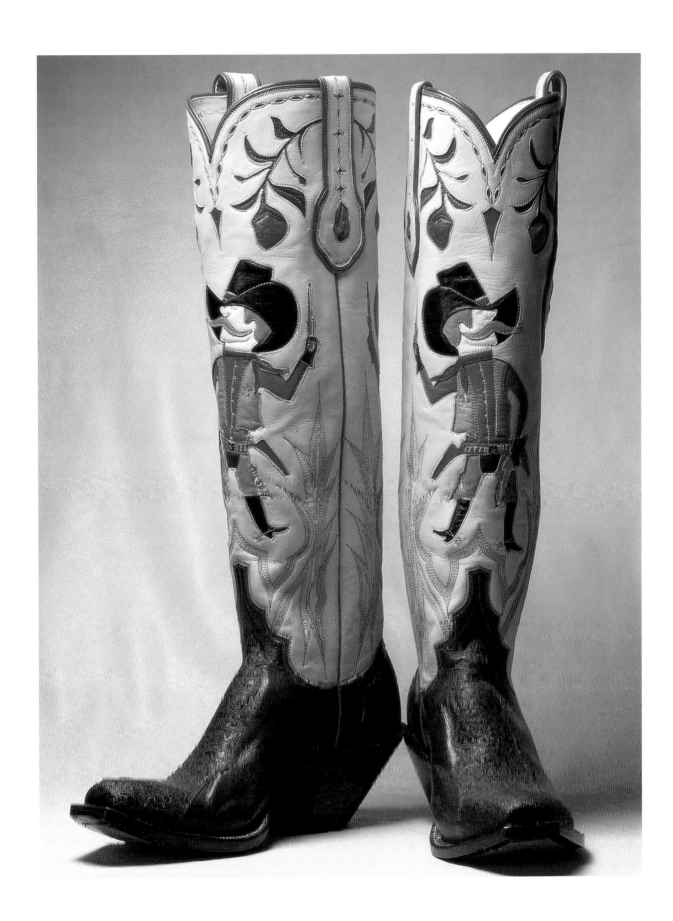

— Stephanie Ferguson Custom Boots —

Don't be fooled by Stephanie Ferguson's delicate stature. She can pack a wallop into a pair of cowboy boots. This gal hails from Ohio, where she began her career in leather crafts designing women's sportswear, leatherwear, and evening wear under the label "Stephanique."

After receiving many design awards, Stephanie diversified, working with an Amish man, Eli D. Miller of Mesopotamia, Ohio, to learn the skills required in the restoration of antique side saddles. One thing led to another and she decided to tackle the task of boot making. The beaten boot path led her straight to Jack Reed's door, and further honing of her intricate inlay skills can be credited to Bo Riddle, bootmaker and musician. In 1995 Stephanie's boot tops were chosen "Best Uppers" at the Custom Boot and Saddle Makers' Convention in Silverthorne, Colorado. In 1996 she was again awarded "Best of Show" at the Mesa, Arizona, Custom Boot and Saddle Makers' Convention.

In Stephanie's family, there have always been hunter/jumpers, cross-country eventing and dressage, prompting the addition of English riding boots to her repertoire of fashionable footwear. Elaborately laid-out multicolored leather tapestries depicting birds and floral themes are one of Stephanie's trademarks. It's unusual that any bootmaker has the ability to make a boot that is masculine enough to please any man, and at the same time create boots for women thoroughly western yet definitively feminine and fashionable. And for the hard-to-fit folks out there, Stephanie has professional training in podiatrics, enabling her to make boots and shoes for even the most touchy of feet.

P.S. Stephanie, good luck, and welcome to Texas. We need some women bootmakers to shake things up down here.

A triad of colorful singles by Stephanie Ferguson reinterpret
classic themes of bluebirds, hummingbirds, and flowers.
The center boot is an original Zuni Indian design inspired by a necklace.

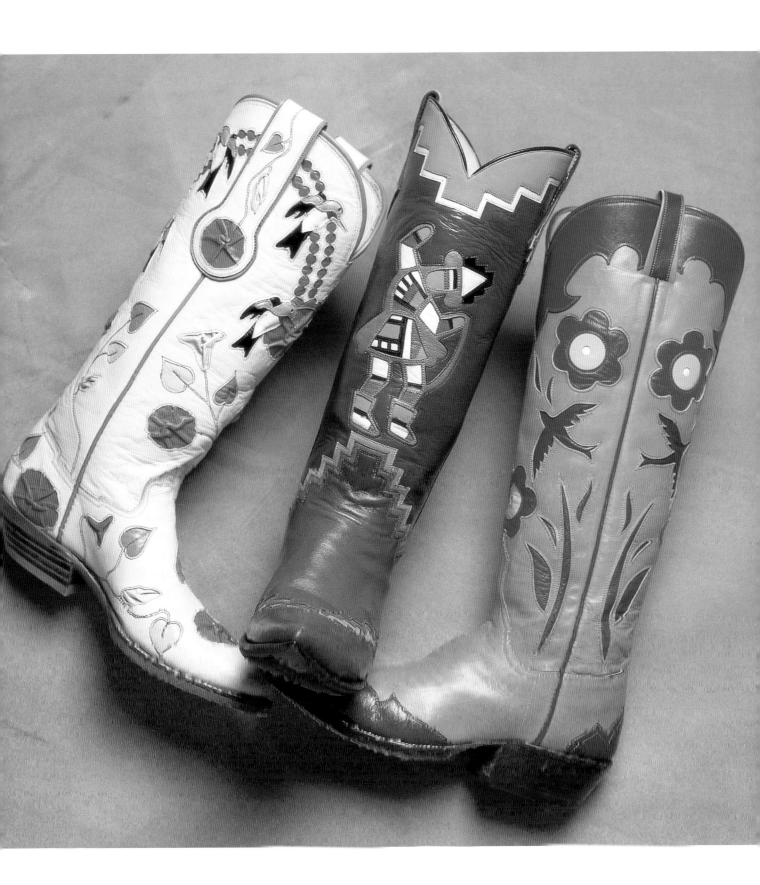

Give me nine words to describe D. W. Frommer: obsessed with the history of boot and shoe making. This man is a walking, talking wealth of boot and shoeana. After Vietnam and some trials and tribulations with shoe repairs, D. W. finally stepped up to the running of a boot and shoe repair shop in the back of a western-wear store in Harrisburg, Oregon.

D. W.'s first bite from the old boot bug was in Harrisburg one day when old-time cowboy and saddle maker Frank Finch wandered in with tales of the Old West and lured D. W. away for nearly three years to teach him the craft of saddle making and repair. It was during this time that a back-and-forth education with Billings, Montana, bootmaker Mike Ives began. "Ives promised me a knock on the head every time I made a mistake." Reminiscing, D. W. added, "I had lumps on the back of my head for a long, long time." Ives held the same philosophy as legendary Texas Tech boot-making professor Ted Truelove, passing on to D. W. the tried-and-true tradition of "detail is everything."

The remote hamlet of Bend, Oregon, is way out there! And so was Frommer for a few years, finally moving his shop to the historic and livelier Redmond, Oregon, in 1986.

A disciple of perfection, D. W. has won first place in every single "finished work" contest of boot and shoe making he has ever entered. Frommer has also gained national recognition for his twenty-seven-hour instructional video course, Western Boot Making: An American Tradition. Three-week hands-on boot-making seminars are also offered in basic and advanced techniques. D. W.'s wife and soul mate, Randee, helps with stitching boot tops and other assembly processes. This dynamic duo has crafted some of the slickest cowboy boots and lace-up packers (another D. W. specialty) the human foot has ever encountered. The D. W. Frommer boot creed has always been "No paper, no plastic, no nails." This is one serious bootmaker!

P.S. If people have nine lives, D. W., all of yours, I am sure, have been or will be as a bootmaker.

An exquisite three-piece, super-slick inlaid star boot with a Cuban heel and inside cloth pull straps by Frommer Boots.

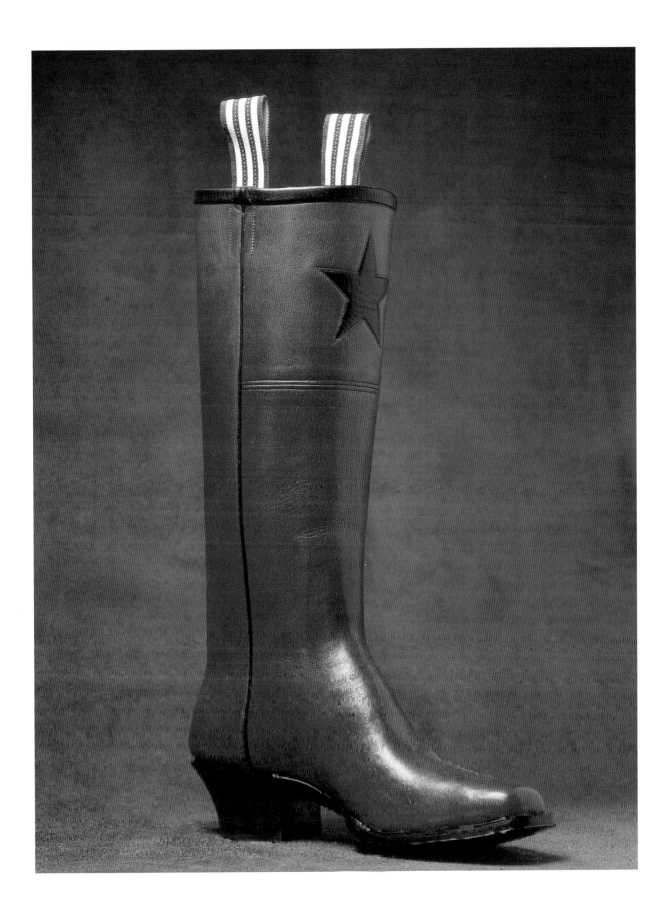

J.B. Hill Boot Company

The J. B. Hill Boot Company was formed in December 1996, with Dr. James M. Hill, IV, as the president of the company. This cowboy boot-savvy doctor named the company in honor of his children: son, James, and daughter, Brandon. Ben Richardson is vice president of sales and marketing. Ivan Holquin is vice president, master designer, and production whiz.

"I make these boots as much with my heart as with my hands," Holquin says, "and I kind of like the idea that someone who wears my boots might feel just a little different while they're in them. Maybe it's because they sense the quality that goes into making them, or maybe it's a throwback to the days when your boots partly defined your character. Whatever it is, nobody's ever the same after they've put our boots on their feet."

Before I ever heard of J. B. Hill Boots, by chance, I was in Prairie Rose, a western housewares emporium in Fort Worth, Texas. I was asked to hang around and give my opinion on a new boot company whose line they were considering carrying. I was sharpening up my critical teeth and anticipating a lot of boot baloney. But my sometimes boot-bleary eyes were soon refocused. In walked an immaculate, articulate salesman from J. B. Hill. With great aplomb, and wearing a beautiful pair of boots, this guy had my full attention. I sat transfixed in a stunned state of boot bondage. These boots were slick as glass, beauteous to behold, and I was very impressed. One by one he pulled luscious samples from tasteful black bags whose only ornamentation was a single silver Texas star and the company name.

Beautifully tanned calfskin, water buffalo, and exotics that include alligator, ostrich, lizard, stingray, and shark are the hide backbone of J. B. Hill. These folks are a class act all the way. They have a vision of their customer and a line of boots that match. The attention to detail inside and out of a J. B. Hill boot are reminiscent of early Lucchese quality from the 1940s, '50s and '60s.

J. B. Hill boots are available only through high-end retailers of traditional western wear and some specialty stores. The 1998 production line included fifty-eight styles for men and women, with five flashier numbers specifically designed for women. These are not boots I would tromp through manure in to feed the cows. For daily wear, work, or any other occasion when being dressed to impress is required, these boots fill the bill. My guess is that most of J. B. Hill's customers see a lot more concrete than cactus.

Call them for a catalog—it's a tasty tidbit of boot marketing and pretty enough to crown a stack of art books on the coffee table.

P.S. Ivan, you will surely go down as one of the great gentlemen in the cowboy boot industry.

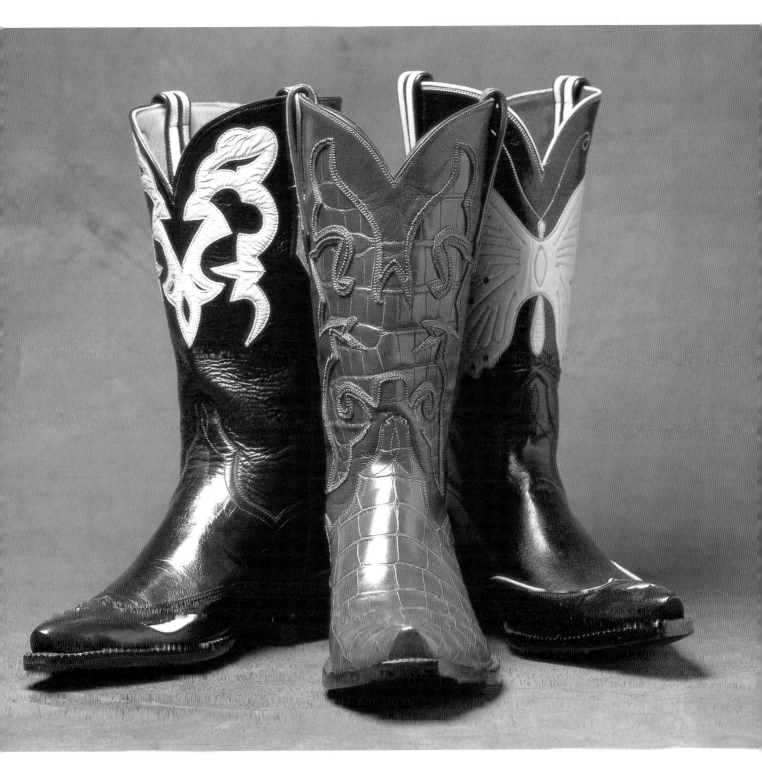

These easy-on-the-eye singles by J. B. Hill Boot company can be described in two words: understated elegance.

Pablo Jass / Jass Boot Shop

If you travel through Lampasas, Texas, you're bound to run smack dab into the Jass brothers, all making fine, sturdy, tough-as-nails cowboy boots. The brothers are all disciples of the Ray Jones Boot Shop, which closed its doors in 1983 when Ray retired. John Jass is right on the main road through town and brother Mike is making cowboy boots in nearby Clifton.

But to locate Pablo you will need to ask for directions; he's off the beaten path. Pablo is the older brother and former shop foreman for Jones. Pablo is unquestionably the most stoic of all the bootmakers, taciturn even when discussing cowboy boots. Following in the same steps as Jones, Pablo basically has one stitch pattern, one toe bug (as Texans call the toe stitch), a half-dozen choices or fewer of leather, and a half-dozen or fewer choices of thread colors for topstitching. Pablo's wife, Juanita, helps with some stitching, and in a pinch, his son will assist a late-night boot-a-thon.

Pablo is boot wise: Why mess with a good thing! From central Texas to Hollywood, cowboy boot connoisseurs can recognize at fifty paces the classic toe stitching: "Is that a Jones or a Jass?" If you are a student of bootology, you will know that Pablo changed the style of Ray's pull straps; they now angle in a little more at the top.

There is a definite utilitarian beauty in Pablo's boots. You don't go to Pablo to order something with intricate multicolored layers of inlay and overlay. Pablo Jass makes a classic twelve-inch-top (sometimes taller) work or dress cowboy boot, with a plain-stitch top (usually three to six rows) The only choices, really, are the heel style and toe.

Recently John Tongate, the premier collector of custom-made cowboy boots to wear, convinced Pablo to do an old, beautifully stitched matching top and foot pattern—a continuous flow from the boot shaft down to the tip of the toe—in red, green, and white on black calf: the Christmas boot. It's a beauty isn't it?

P.S. Pablo, you and your hundreds of customers know you don't need to change a thing. Keep the tradition alive.

The "Christmas Boot," with a festive stitch pattern and a quilted foot,
is a central Texas classic modeled on an early Ray Jones stitch pattern.
Boots by Jass Boot Shop; courtesy John Tongate Collection.

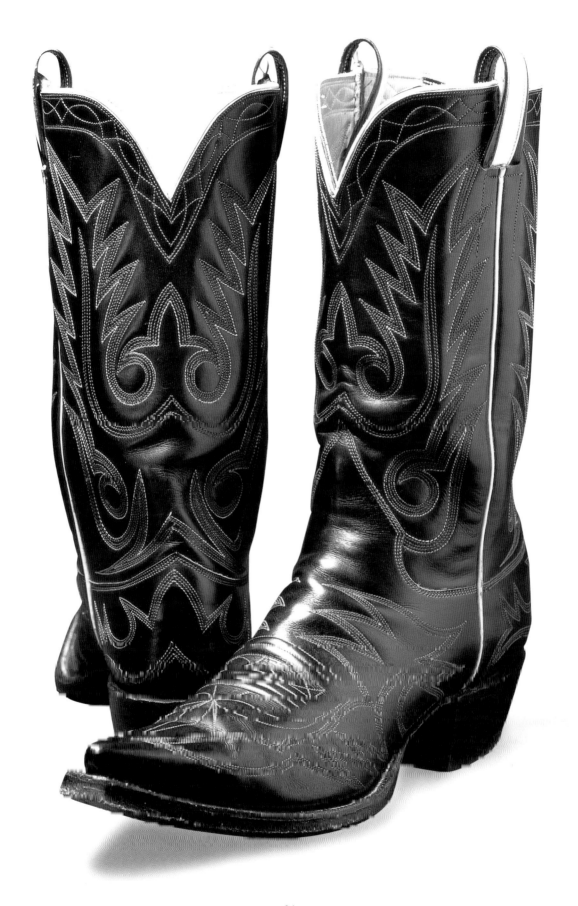

— Blake Jones / Jones Custom Boots —

One day last year I got a call from an my old friend and renaissance cowboy Rusty Cox. "Tyler, there's this feller next door to me down here in Harper, he's makin' cowboy boots, and he's gooooood! You need to see his work." Rusty was right—he *is* good. And what doubled my amazement was that these hybrid cowboy/pirate boots in all their knee-high glory, black-and-white splendor with full-length mule ears, dripping in sterling silver conchos and lace were only the eighth pair of boots this humble artist ever made!

At about age fourteen, like so many other western youngsters, Blake bought his first Tandy leather-craft kit. For the next fifteen years, deep in the heart of Texas, he devoted himself to a career building handmade leather luggage and hunting accessories. Jones always had a hankering to make cowboy boots. Four years after he first planted eyes on *The Cowboy Boot Book*, Blake could abide his boot longings no longer. As another Jack Reed recruit, Blake took the boot-making crash course; fifty hours later, he had made one pair— his first pair—of cowboy boots, the first baby step in boot making. Blake excelled with the help of Reed, his leathered past, and given talent.

Blake has noted a trend with his custom boot orders: "My customers are wanting to personalize their boots with ranch brands and initials, and a lot are getting higher tops now, fourteen to seventeen inches."

At age thirty-six, Blake has a near lifetime of boot making ahead of him. Yeeehaaaaaa!

P.S. Blake, you're one of the best new bootmakers on the scene, and being from Divine, Texas, good things just have to come your way.

"Treasure Island Meets Tombstone," a very frisky original design indeed, with full-length mule ears dripping in sterling silver conchos, tips and tidbits. Boots by Jones Custom Boots: courtesy Theresa Abernathey.

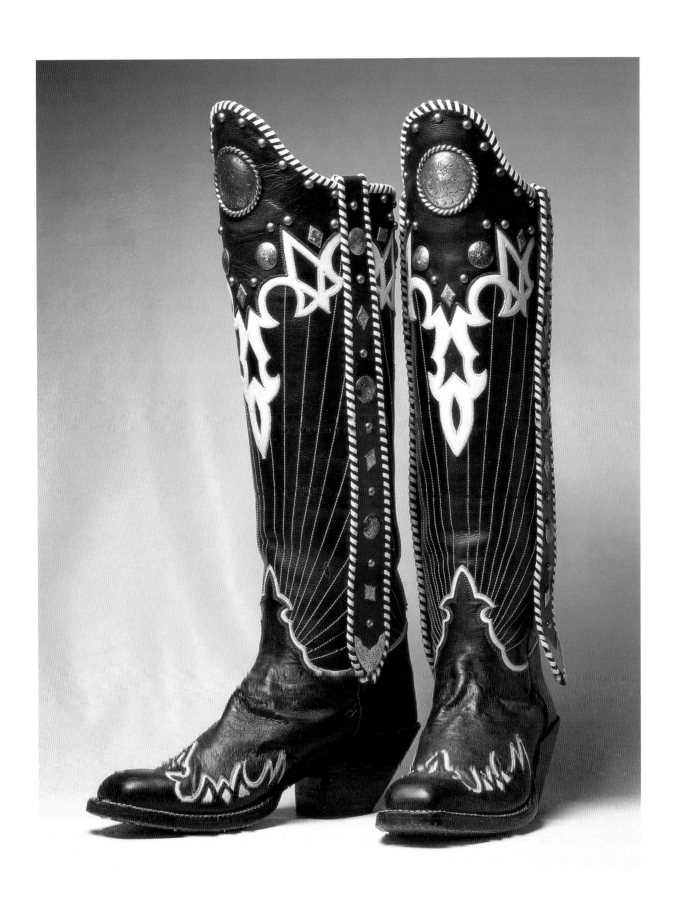

— Eddie Kimmel / Kimmel Boot Company —

After more than seventeen years, Kimmel Boots in Comanche, Texas, continues to turn out kick-ass working cowboy boots for cowboys and ranchers. A steady stream of boot fans take the journey from Dallas–Fort Worth and as far away as Michigan, New York, and even Japan, to be personally measured by Eddie. "Some of my customers just order over the telephone," says Eddie. "They will call and say, 'Make me the same pair as before,' or they might just change the color of the thread or the exotic hide. One of my good customers ordered twelve pairs of ostrich boots, all different colors—I guess one for each month of the year! Many of our customers we have never even met before. With our new mail-order measurement instructions and with people too busy to get away, more and more orders are all done through the mail." Kathy Kimmel adds, "Eighty to 90 percent of our customers still are Texans. The rest usually call or write and just pick something right out of *The Cowboy Boot Book*."

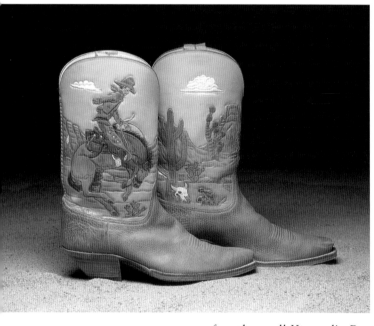

"Desert Dreams" by Kimmel Boot Company sports a shrunken shoulder calfskin foot. The tops are painstakinly hand-carved and painted by leather artist Shirley Robinson.

Chava Guevara, shop foreman, has been with Kimmel's Boots for nearly fifteen years. When Billy Martin's, New York's world-famous purveyors of western wear and cowboy boots in particular, needs a one-of-a-kind, something totally bootrageous requiring skills possessed by very few, they call Kimmel's. Bootmakers everywhere are still trying to figure out how Chava executed the now-famous "gill work" (layers of leather finely sliced, resembling fish gills) on top of the "Indian Head Boots" (facing).

"Some of the fancy boots we make have taken one man a full month of work to complete," says Eddie, "but our backbone has always been in exotics: ostrich, gator, and stingrays. Horned-back gator has become very popular these last few years." Eddie and Chava are men of few words. Boots do their talking.

For the past five years the Kimmels have graciously taken over the responsibility of managing and expanding the size and concept of the Boot and Saddle Makers Reunion held annually in Brownwood, Texas. It's Kathy's baby, so if you require some information to enter or visit this event, give her a buzz.

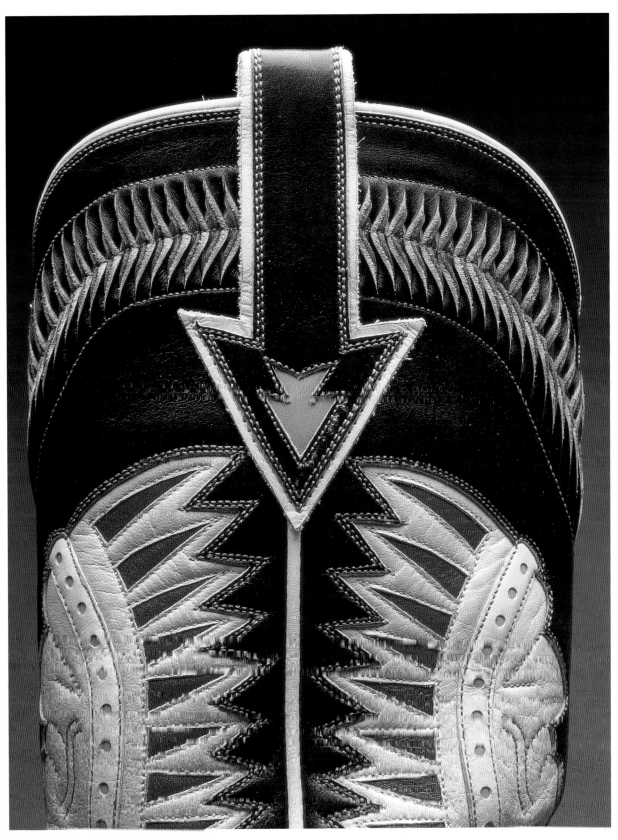

Minute detailing of the famous Indian head profile pattern with the much-imitated but never equaled collar of "gillwork" by Chava Guevara. Boots by Kimmel Boot Company, courtesy Tyler & Teresa Beard Collection.

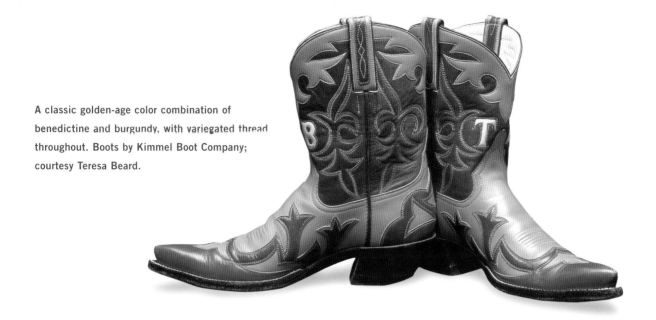

A classic golden-age color combination of benedictine and burgundy, with variegated thread throughout. Boots by Kimmel Boot Company; courtesy Teresa Beard.

One of the great things about Kimmel's Boots is the lack of artistic temperament and ego. You occasionally run into bootmakers who only want to do it their way or not at all. The Kimmels' aim is to please; they are artistically flexible while still able to humbly offer up suggestions and opinions based on their vast boot making experience. With the Kimmels, what you see is what you get. They were country before country was cool, and I love them to death!

One artist who works hand in hand with Eddie and crew is Shirley Robinson, local leather carver and painter. Roses, bluebonnets, Indian heads in full headdress, cowboys on broncs, desert scenes, and anything your little ole heart desires can be hand-tooled on natural leather, or hand painted, for dazzling leather boot tops and bottoms.

Below: A stovepipe hand-carved stunner by one of the best!— master leather artist Bob Dellis. Boots by Kimmel Boot Company, courtesy Tyler Beard.

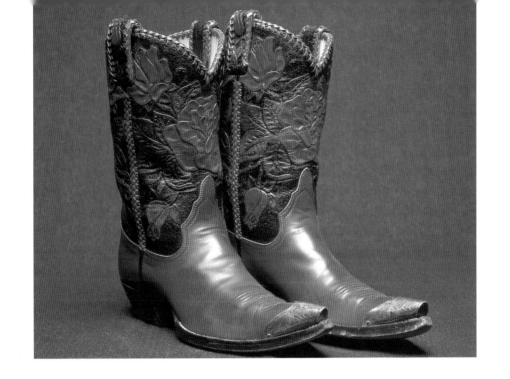

"Ramblin' Rose" was hand tooled and painted by leather artist Shirley Robinson, who specializes in floral designs. Boots by Kimmel Boot Company; courtesy Teresa Beard.

If you go to visit Eddie and Kathy, don't get stalled by some of the more blasé boots sometimes out front. Always ask to see the outrageous boot bill of fare being dished up out back. Every time I go to order boots or visit, I make a beeline for the back bench to drool over the works in progress. Fine boot making is fine art.

P.S. Kathy, Eddie, and Chava, words fail me I love y'all, love your boots, and cherish the memories.

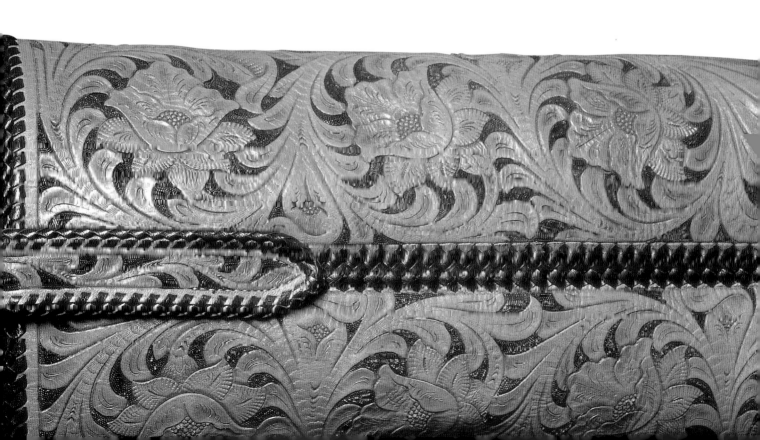

— James Leddy / Leddy Boot Company —

James Leddy is the owner of Leddy Boot Company in Abilene, Texas. His uncle was M. L. Leddy, who began this boot-making clan more than sixty years ago in Brady, deep in the Texas hill country. The Leddy name is synonymous with cowboy boots in Texas.

James, raised in Oklahoma, made his first pair of boots at age twelve. He moved to Abilene in 1953 to partner with another uncle, Clifford Leddy, in a shoe- and boot-repair venture. This union lasted eleven years. After about six months in Brownwood, Texas, with old-time boot maker A. J. Malouff, James moved once again to San Angelo, Texas, to work with his dad's brother and legend M. L. Leddy. But it didn't take long for James to decide he needed to run his own boot shop; after less than a year with his uncle, he was on his own again.

James's shop had been humming along from 1965 to 1970, when Cowtown Boots in El Paso offered him a job designing their boots and running the show to boot! "I guess I really like to work for myself," he remembers. "I was down on the border less than a year."

Since 1971 the James gang has been consistently producing a superlative example of the cowboy boot in all of its personalities. His ex-daughter-in-law, Janie Benson, is the resident boot-top artist, while James's wife, Paula, holds it all together with expertly stitched tops and whatever else is required at the moment. Debbie Jones, Glenn and Debbie Meek, and Gabe Hernandez complete all the bottoms and finish work.

James has kept the likes of George Jones, Buck Owens, and Hank Snow in their needle-nose country western cowboy classics for decades now. "Things have leveled out since the *Urban Cowboy* days—whew! Back then we had twenty-four pairs a week flying out that door; now we average ten or twelve."

"Looking back over the years, I would have to say our best customer has been country star Mel Tillis," says James. "He has more than sixty pairs from me, and we always make the boots for his twelve-piece band."

Leddy reckons that more than 70 percent of their boots end up less than a hundred miles or so from the shop; another 10 percent exceed that distance but remain in Texas, with the balance going out of state and sometimes out of country.

One special thing about Leddy's—besides being the only shop that will hand-file a boot toe down to a point so razor-sharp that it looks lethal—is their trained use of an old technique from Mexico that isn't seen too often:

string work. Created by sewing varying thicknesses of cotton cording between the two layers of boot leather, a raised and unusual 3-D effect makes a subtle play on the eyes.

There is nothing these folks have not done or cannot do when it comes to cowboy boots. A boot-making tradition is alive and well in Abilene.

P.S. James, I am always so impressed by the family-like friendly atmosphere in your shop. You're too modest to admit to the "legend" status in boot making, so I will hang it on for you.

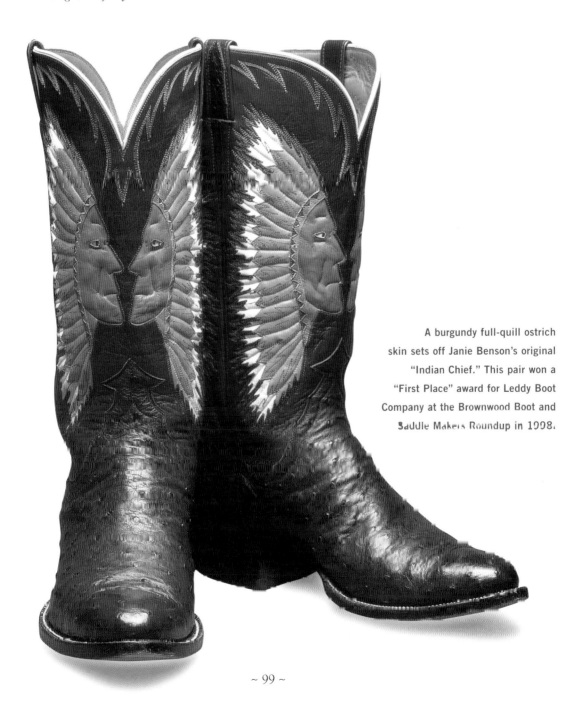

A burgundy full-quill ostrich skin sets off Janie Benson's original "Indian Chief." This pair won a "First Place" award for Leddy Boot Company at the Brownwood Boot and Saddle Makers Roundup in 1998.

A bolt of boot lightning had hit Tony smack dab in the head while roaming the fashion districts of his native Toronto, Canada. Those retail stores needed an alternative boot, something a little more rock 'n' roll than the boot blight inflicted on the masses in the 1980s.

In 1986 Tony Benattar and his sweet wife, Robin, were vacationing in Mexico. On the beach, a friend introduced Tony to Yan Ferry, an expatriate Frenchman who had also taken a vacation to Mexico in the early 1980s but who, drawn in by the cowboy boot mystique, had never left. Yan settled in León, the boot-making capital of Mexico. Soon after, he became a middleman—the agent between retail stores in Europe requiring cowboy boots and an overseer of production quality and design.

"Yan and I hit it off right away. He was young, hip, and happening. He had a very young attitude and an open mind toward the boot business: anything goes," Tony remembers. But it would be another seven years—1993—before Yan and Tony would become full partners and form the Liberty Boot Company. At that time, boot-making sources in León, with the help of Yan, began to manufacture Tony Benattar boots, a boot line custom tailored for Canadian retailers. This line of boots is still available in Canada only.

"Back in the 1980s when I started my company, the number-one selling boot in Canada was a shiny black on black boot with flame overlay design, a very pointy toe, and a radical staggered heel." After the seven years of friendship and communications, Tony and Yan took a long leap off boot hill and launched the Liberty line at the Denver Western Wear Market, where all things cowboy and western are annually showcased for store buyers from around the world.

I remember stumbling onto Liberty Boots at the Denver show in 1993. The new kids in bootdom had been Rocketbuster for the past few years. Now we had even newer kids on the block—Liberty Boots had arrived. I also noticed extreme quality in all aspects of these boots, fine combinations of threads, colors, and luscious leathers; the drop-dead inlays and overlays and the sparkling clean finish work. They looked good enough to eat, let alone wear. Basically I was blown away, boot-wise—peewee designs and patterns borrowed from the 1940s and '50s have always been Liberty's strength.

Like all bootmakers, Liberty has borrowed freely from the tried and true classics of the golden age. Some styles have been modified and others embellished.

"We use only the highest-quality calf for our boots and linings, no

splits or pigskin. There are two reasons for this: comfort and durability. Also, the leathers we use to make Liberty boots come from the finest tanneries in the world. We select only the best skins and match them up to a consistent color and finish. Nothing leaves with the Liberty name on it that I wouldn't wear myself," says Yan Ferry.

On page 47 in *The Cowboy Boot Book*, there was a one-of-a-kind hand-tooled Justin boot. At the time, we assumed that the unusual stitching had been done with silk thread. Tony and Yan recognized this ancient Mexican hand skill of *pitiado*; translated, that means "working with pita." Pita are the strands of white fiber pulled from the cactus plant. This ancient art of poking and pulling one strand of cactus fiber at a time has been seen over the last two centuries on belts and small leather goods. But in all the museums, private collections, and more than a hundred years of custom boot making, to anyone's knowledge, the Justin boot is the only example of pitiado found on a vintage cowboy boot. Liberty Boots are the only bootmakers in the world that offer pitiado.

A classic pitiado with lone stars and Greek key collars. These are one classy pair of boots by Liberty Boot Company, courtesy Jim Arndt Collection.

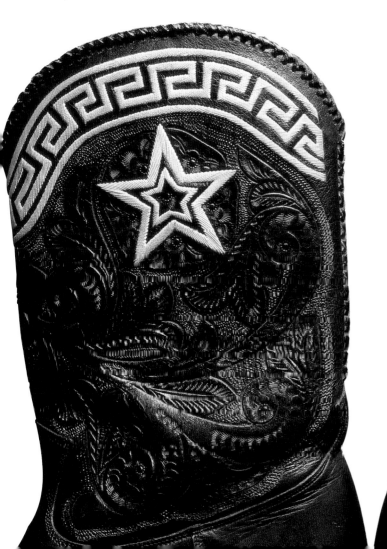
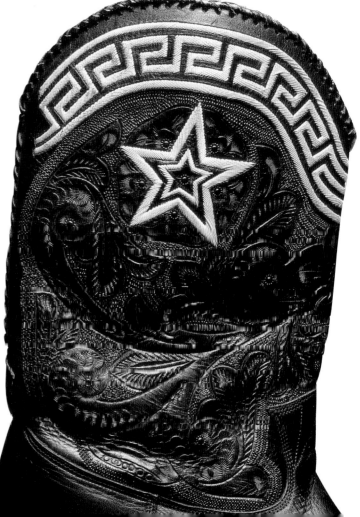

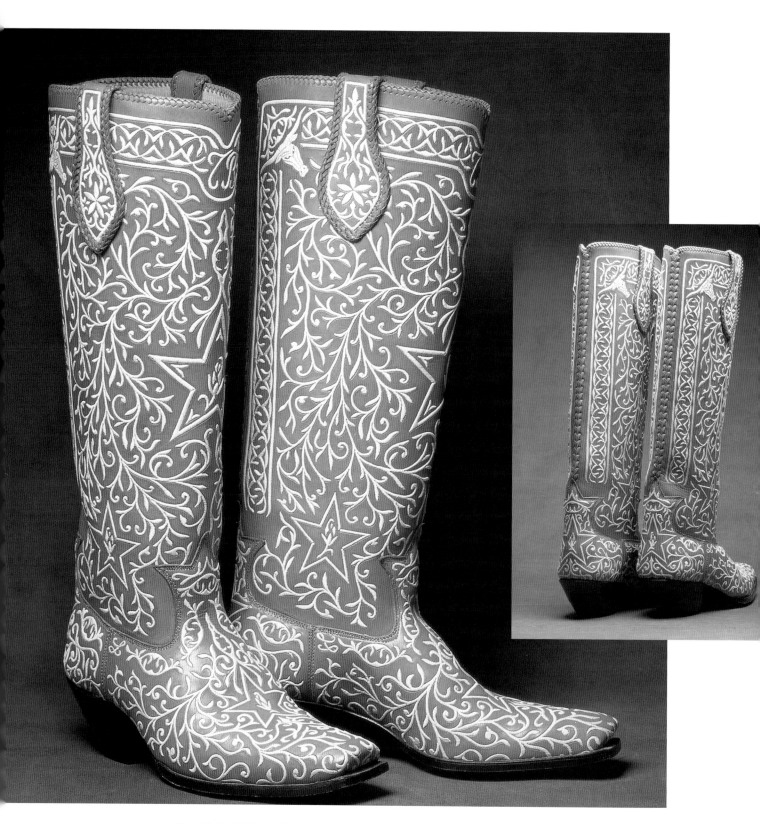

One stitch artist took three months, one poke at a time, to complete this paramount pitiado work of folk art designed by Patty and Tadeo Duran. Boots by Liberty Boot Company, courtesy Tyler and Teresa Beard Collection.

Tony Benattar describes the making of pitiado boots this way:

Fibers are pulled from the cactus plant one at a time. They are combed and left to dry and bleach in the sun. Thin strands are then separated and hand-rolled into thread. In very fine work, only six or eight strands are used in a single thread. Next the thread is rubbed with a cow tail, which gives it a natural waxed finish.

Then begins the painstaking work of embroidering the pita onto the leather. This work is done by families who have passed the art from one generation to the next. Pitiado artists are highly respected and sought after because there are so few of them. One pair of pitiado boots in our collection takes up to three months for one man to complete. The cactus fiber thread is very strong and durable. If it gets dirty from wear, it can be cleaned with water and lemon juice.

This is definitely a dying art, and I can see that someday it might be impossible to find craftsmen doing quality pitiado work. It's like folk art: the people who do it are so far removed in small villages that we have to drive hundreds of miles sometimes just to deliver the boot orders because they don't even get mail!

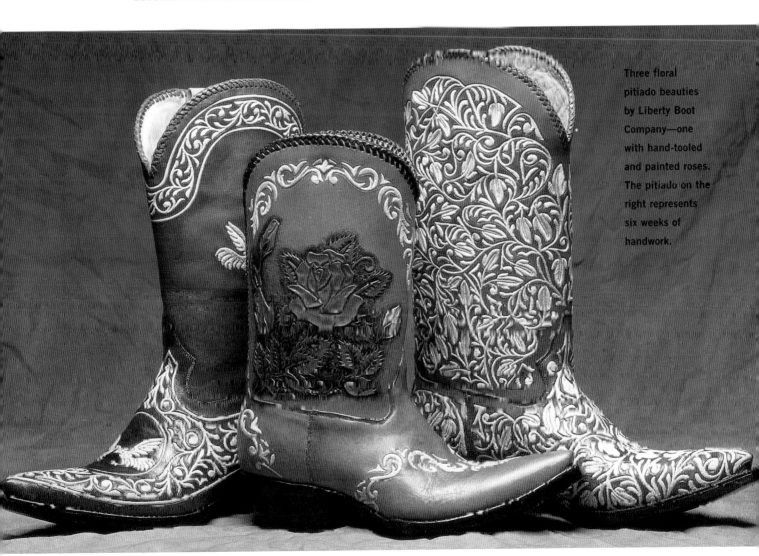

Three floral pitiado beauties by Liberty Boot Company—one with hand-tooled and painted roses. The pitiado on the right represents six weeks of handwork.

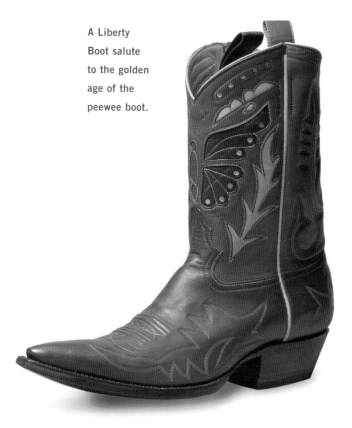

A Liberty Boot salute to the golden age of the peewee boot.

In 1998 Luis Torres joined ranks with Liberty. Luis's family in León, Mexico, has been manufacturing traditional cowboy boots and shoes for decades. With Luis's input and knowledge of the foreign and Japanese shoe and fashion footwear market, some unique cowboy (and not-quite-cowboy) boots have been created. Outrageous platform cowboy boots in crazy '60s and '70s colors, and metallic snake skins with iridescent trim have become just part of the blinding booty offered up from Liberty Boots. They have also added clunky fashion heels, women's mules hand-tooled and inlaid, and mini and micro-mini peewees. An overview of the Liberty line reveals some conservative boots for the faint of heart. I would lay odds that any fashion maven worth his or her weight in boots and flashy footwear would agree: If you're looking for retro cowboy boots in the new mil-

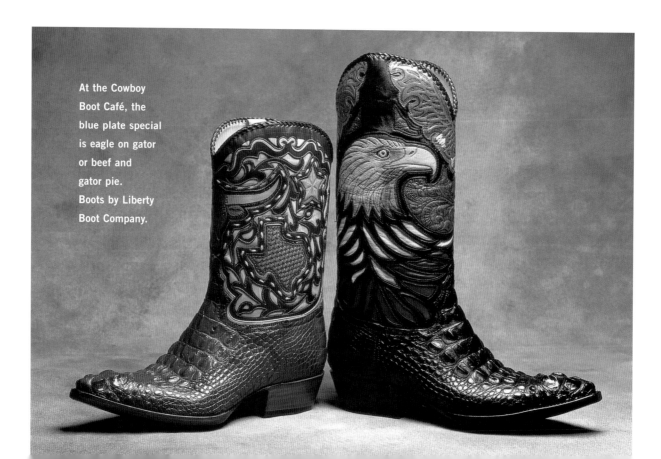

At the Cowboy Boot Café, the blue plate special is eagle on gator or beef and gator pie. Boots by Liberty Boot Company.

lennium, Liberty can oblige you. If you're a fifties, sixties, seventies, or nineties kind of dude or dudette, try one on for size. If you feel cool, calm and collected, your boot thirst has probably been quenched.

P.S. Tony and Yan, gold stars and pats on the back are in order. Your stellar company has raised the bar on the artistic threshold of cowboy boot making.

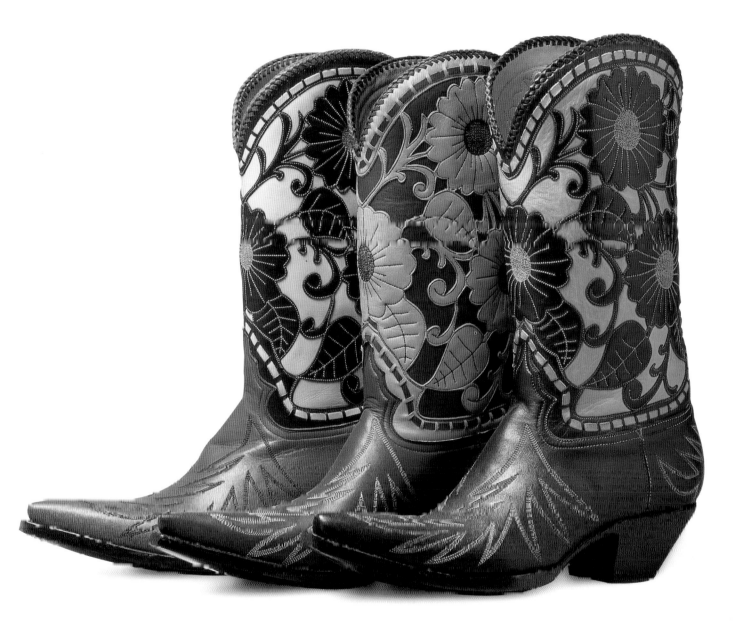

A triad of hybrid sunflowers arranged in a veneer of overlay, topped off in three variations on a laced collar theme. Boots by Liberty Boot Company.

Dave Little / Little's Boots

Little's Boot Company, founded in 1915, is a class act all the way. Dave Little is third-generation owner. With his daughter, Sharon, they claim over eighty years and four generations in custom boot making in San Antonio, Texas. The venerable, friendly, and always energetic Dave is infectious with his enthusiasm on the discussion of quality boot making. Little's is the only boot shop that is deliciously shelf-lined in what seems an inexhaustible boot buffet of try-ons in standard sizes. These are all for sale, or you can get your very own custom made-to-measure boots. But be prepared to cool your boot heels for awhile; with quality, you get what you wait for.

The supreme attention to detail at Little's is a throwback to the golden age of boot making, when San Antonio laid claim to more boot-making talent than any city in Texas. Dave nostalgically reminisces with stories of Lucchese, Carlos Hernandez Sr. and Jr., and the Galvans. "Quality was there when all of these people were still making one pair of boots at a time. Back when the Garcia brothers—Jesse and Gilbert—worked with Lucchese, they set the standard for other bootmakers to strive for." The other San Antonio legendary bootmakers are either deceased or retired; only Little's Boot Shop is there holding down the fort.

With the wizardlike talents of master bootmakers, shop foreman Ruben Diaz holds the reins on brother and bottom artist Alfonso Diaz; inlay man extraordinaire Juan Ortiz; Carmen Rosales, who stitches with a golden needle; and Gerry Morales, who puts the finishing touches on all of Little's boots. When the customer roughs them up a little, J. Luis Martinez handles the daunting task of making old boots look new again.

At Little's, the time-honored tradition of creating only the finest in western footwear, cowboy boots, belts, and wallets continues into the new millennium. Very little

A circusy leather sculpture with a crazy-quilt pattern of flowers, buds, and butterflies from Little's. What a beaut!

This optical illusion in leather is a fiery collaboration between Little's and boot connoisseur Fausto Yturria.

Opposite: A lesson in boot aesthetics, a potpourri painted in leather and lace to artistic consummation. Boots by Little's Boots

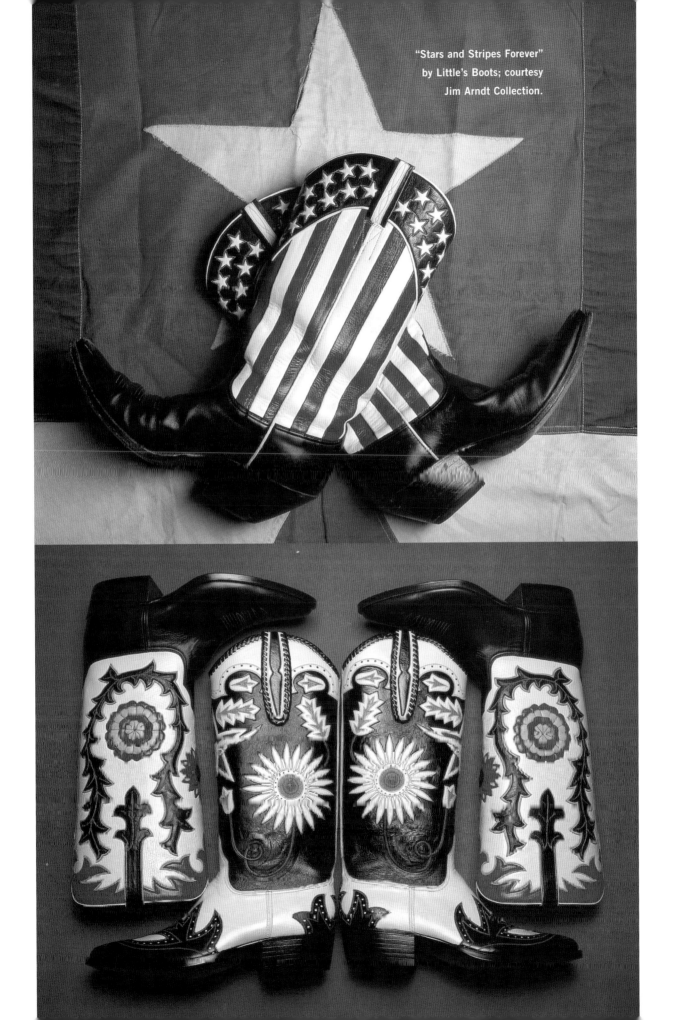

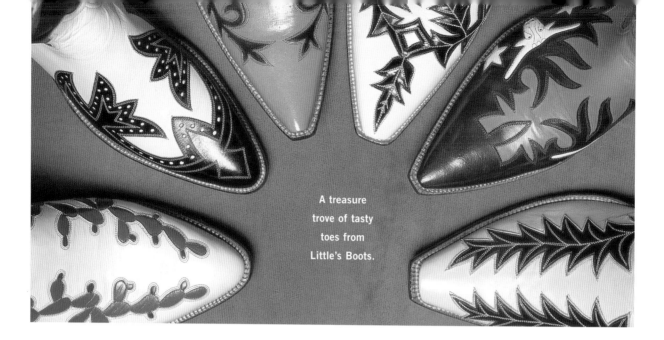

A treasure trove of tasty toes from Little's Boots.

plain vanilla is served at Little's Boot Shop. They specialize in over-the-top, outrageous inlay designs, personalized statements artfully carved out in leather, one cut and one stitch at a time.

Dave's other specialty is exotic skins—alligator, crocodile, anteater, ostrich, lizard, snake—the list goes on and on. "Most of my business with the fancy inlays comes from outside Texas, men and women who see something in *The Cowboy Boot Book*, call up and just say, 'I want the boots on such and such

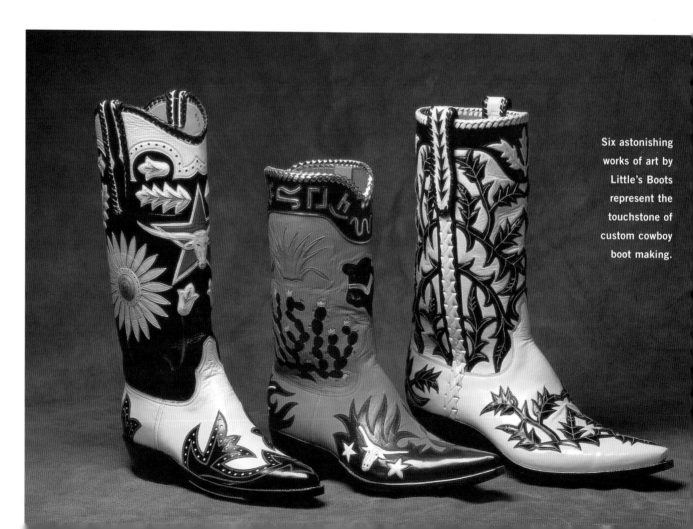

Six astonishing works of art by Little's Boots represent the touchstone of custom cowboy boot making.

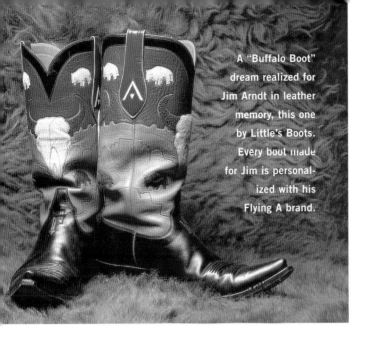

A "Buffalo Boot" dream realized for Jim Arndt in leather memory, this one by Little's Boots. Every boot made for Jim is personalized with his Flying A brand.

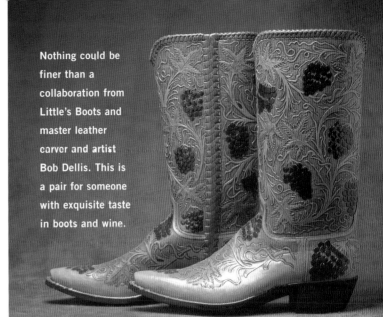

Nothing could be finer than a collaboration from Little's Boots and master leather carver and artist Bob Dellis. This is a pair for someone with exquisite taste in boots and wine.

page.' Sometimes we get an absolute new design, a business logo, or a combination created from several boot ideas."

Dave and Sharon may soon be dubbed in Japanese, in a film documentary shot over a three-day period at their boot shop in San Antonio on the ins and outs of boot making, ordering, and customer satisfaction. The Littles happily mail out their forty page color catalog, which features eighty-two pairs that would cure even the most jaded bootist from a case of the boot

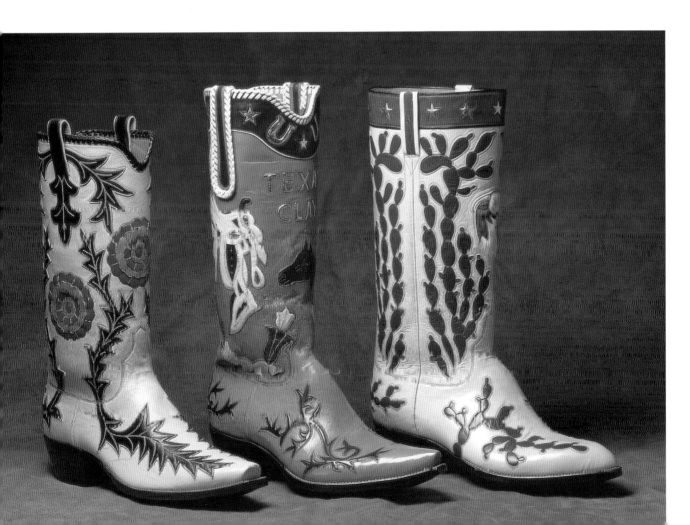

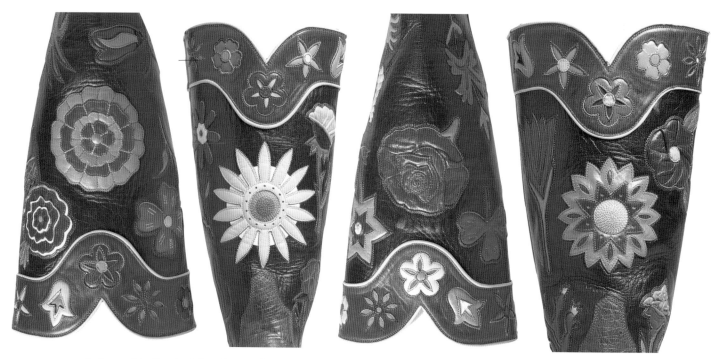

Juxtaposed leather boot tops form a chromatic lesson in a psychedelic Garden of Eden. Boot tops by Little's Boots.

blahs: thirty-four exotics, twenty-seven classic Little inlay designs, twenty-one pairs of kangaroo and calfskin, replete with matching belts and wallets. Little's is one of the few custom boot shops to offer their catalog boots in stock sizes. If you want to be measured by hand, it's time to plan a trip to Texas, go see the Alamo, have some great Mexican food, and visit Dave and Sharon to bask and browse in the beguiling booty offered only at Little's Boots.

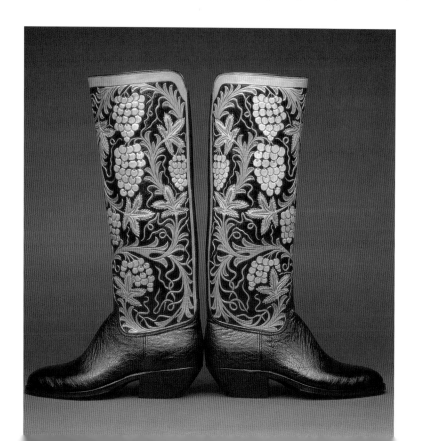

P.S. Dave, Mary Jane, and Sharon, it's obvious that the patron saints of boot and shoe making, Crispin and Crispiano, have blessed your boot-making establishment and your dancing skills. I've heard y'all can really cut a rug!

A gracious tri-tone grape cluster and vine theme by the leather maestro Bob Dellis. Boots by Little's Boots.

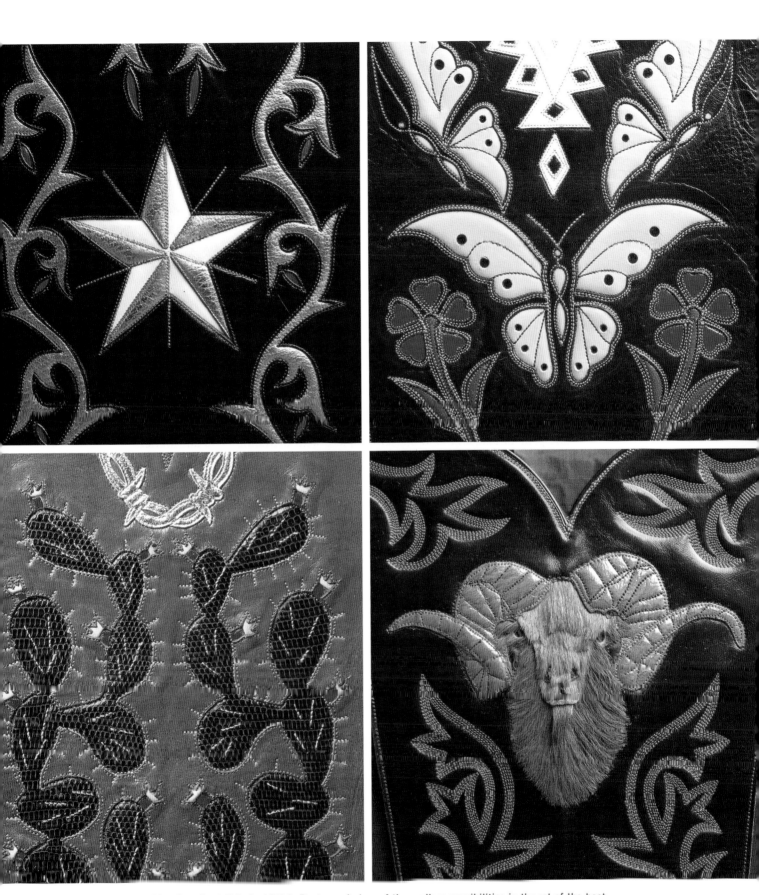

Four flirtatious boot flats by Little's Boots remind us of the endless possibilities in the art of the boot.

As a child in Vermont, Lee Miller's first boot work was on a pair of his Acmes: he attempted to alter the toe with a hand saw!

His fascination with feet and footwear, combined with his desire to work with his hands, led Lee to enroll in the bootmaking course at Okmulgee, Oklahoma, in 1975. After graduating, he engaged himself in a boot-making stint with Utah bootmaker Randal Merrell. In 1977, through the grapevine, he caught wind of an opportunity to move to Texas; the legendary Charlie Dunn needed a bootmaker. "The moment I saw the boots Charlie was making, I knew I had to stay in Texas and work with him. His boots were beautiful."

In 1986, Lee and his wife, Carrlyn, bought Charlie's boot shop. Carrlyn wrangles the correspondence, phone and books, while Lee heads up the shop with his two bootmakers. Maximiano Fernandez, whose specialty is top and inlay work, came on board with Charlie in 1979. With the trained eye-and-hand coordination of an accomplished artist, Max's tops are a graceful testimony, flawless and exacting in their execution and pretty enough to frame. The foundation of each boot is built by José Coyoy with the sound skill of an architect turned artist.

Lee's reverence for his art is sublime and seductive. He fancies slightly rounded or boxed toes, sleek French calf and kangaroo hides. The sky is the limit with Lee, but with some classic inlay designs he blends combinations of petaled roses, bluebonnets, prickly pear cactus, or scripted initials or names in gold and silver—all topped off with a cherry of inlaid twisted barbed wire.

A perfect fit is a near obsession with Lee, but everybody knows the "last" comes first: let the ritual begin. Following in the bootsteps of Lucchese and Dunn, Lee spends thirty to forty-five minutes with your feet. He measures and re-measures. He surveys every bump and blood vessel. He then makes ink impressions of the bottoms of your feet with a giant ink pad, followed by a contour gauge that measures the top of the feet. Drawn out, it looks like a lie-detector graph. Lee then compiles all of these measurements into a master plan. This man has forgotten more about feet than your average podiatrist knows.

Lee and Carrlyn don't crow much about their vast customer base of politicians and celebrities, but a little birdie told me that musician Lyle Lovett won't leave home without 'em.

You only have to look at one Lee Miller boot to recognize the refinement and quality that go into every pair. Explained by Lee himself, "I think every part of the cowboy boot should be beautiful, not just the tops."

P.S. Lee, Max, and Jose, every part of every pair of boots y'all make is
spectacular art.

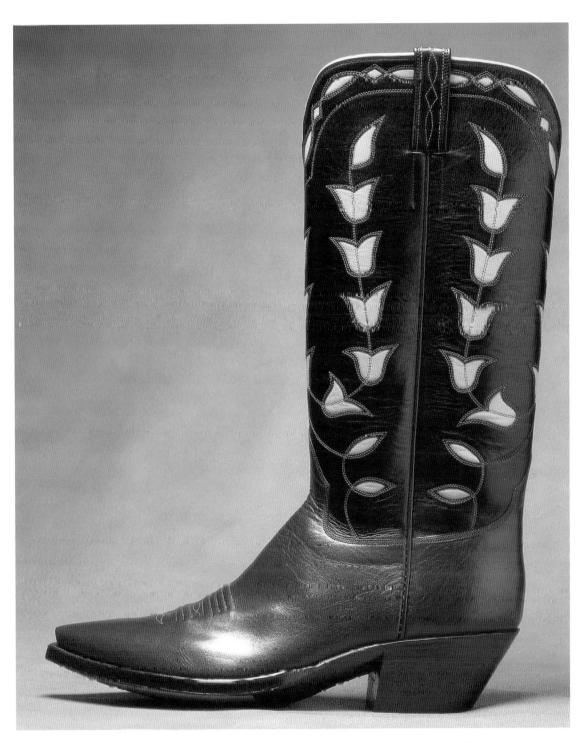

Sometimes it only takes a single boot to express the absolute quality of a bootmaker's art.
Boot by Texas Traditions.

— James Morado / Morado Boots —

James Morado and his brother, David, go back a ways in the history of Houston, Texas. They are seventh-generation bootmakers. Though they were both born in Los Angeles, their parents moved them to Mexico City when they were young. Between 1947 and 1948, James and David pulled up their boot straps and hightailed it to Houston where an uncle offered them jobs at Frank's Boot Shop. In the early 1950s, they worked for less than one year for Steve Panos, owner of the Palace Boot Shop in Houston. Then Joe Cecala, owner of the Model Boot Shop, offered the boys a three-month job stay. During those three months, they thought a lot about opening their own shop but decided to stay on for another thirty years! In the 1980s the Morados opened their own shop, and with a customer base that keeps boot orders backlogged a good year or more, my bet is this boot brotherhood has made its last and final move.

With the help of Ramon Torres and Francisco Majano, the Morado Brothers and James Jr. easily qualify for the top on the heap of any boot hill. I continue to be boggled by the intricately cut and stitched inlay and overlay swirled and curlicued patterns so expertly executed by the Morado shop. "We love to do it all."

The Morados have booted the bulk of corporate Houston in a wide selection of exotics and fine calfskins. "We have shipped boot orders to every state in the country, Japan, and many other foreign countries," adds James.

How in the heck have James and David been able to work together all these years? James's dry reply, "My brother David is very quiet; we are complete opposites." Plain and simple.

P.S. James and David, let me know when James Jr's Jr. starts making boots. You guys are some of the best!

These finely stitched abstract curls, twirls, and swirls laid out in a jigsaw puzzle of glorious chalk, black, and blue inlay and overlay truly set a viewer agog. Boots by Morado Boots; courtesy John Tongate.

Bill Niemczyk, also known as Wild Bill: I keep forgetting to ask why he's so wild. Anyway, back in the late 1960s and early 1970s, Bill Niemczyk played Hammond organ in rock 'n' roll bands up and down the East Coast. A fringed leather vest was prerequisite attire for all budding hippie rockers at the time, so this clever fellow decided he would make his own. Fast forward thirty years, two thousand sumptuous handbags, wallets, and pieces of luggage later. The self-taught leather artisan was born, raised, and resides in cowboy-boot-barren Connecticut. Let's drop some names. Bill has created prototypes and patterns and product in luggage, leather goods, and fashion accessories for the likes of Calvin Klein, Ralph Lauren, Donna Karan, Coach, Armani, Lucchese, J. Crew, North Beach Leather, Swiss Army, and Yves St. Laurent (should I stop? All right, y'all get the picture). This Yankee is good!

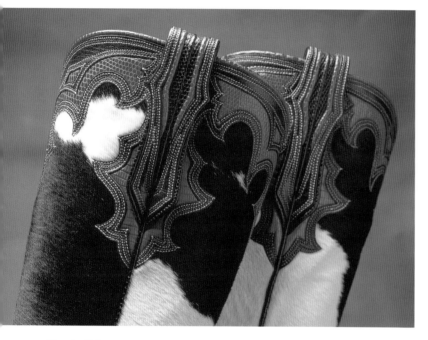

His interest in cowboy boots was born the day he purchased *The Cowboy Boot Book* in 1993. With his leather skills, determination, and D. W. Frommer's books, he taught himself how to make cowboy boots.

Simply divine pull-strap detailing by a unique leather artist. Boots by Wild Bill's Boots.

"I have always loved a challenge," says Bill. His birds-eye view of boot making also sparked his interest in the collecting and selling of antique boot, shoe, and leather-craft tools and memorabilia.

Wild Bill's cowboy boots are brimming with highly unusual details, virtual leather architecture, a mesh of fashion flair meeting the rugged cowboy boot. Inside and out, this man's attention to detail and finish work is equal to that of any veteran bootmaker on the scene.

P.S. Wild Bill, hop on the boot band wagon, and welcome to the wild and woolly world of cowboy boot making. You are now a charter member.

A knock-out tribute to Jack Reed in a whirligig of colors and stand-out canary yellow piping. Boots by Wild Bill's Boots.

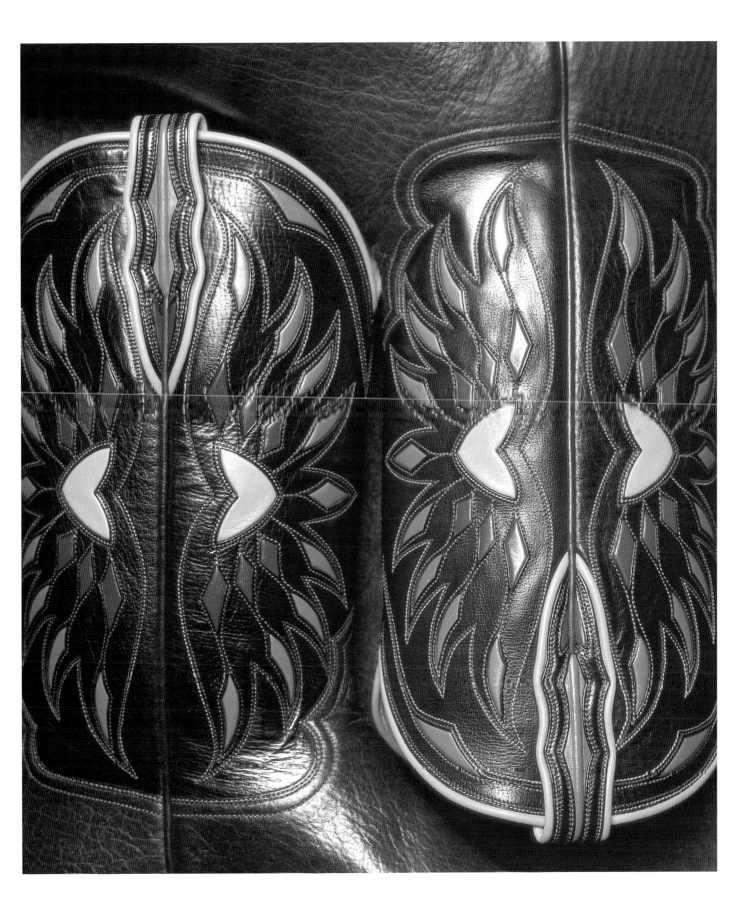

— Joe Patrickus / J.P.'s Custom Handmade Boots —

Joe Patrickus, also known as J. P., is fifth generation when it comes to footwear. Reared in the Chicago area, Joe strayed from his family and their involvement in the shoe and footwear business. Then after years as an electrical engineer and a move to Missouri, the knowledge he grew up with came back and bit hard; the old boot bug struck again. J. P.'s Custom Handmade Boots opened its doors in 1978.

Of Joe's close attention to inlay work and fine detail, he says, "My education and training as an engineer has given me the ability to picture circuit boards and micro processors. This helps in visualizing a finished pair of cowboy boots before I even make the first cut of leather."

With recognition from the National Endowment for the Arts and the Missouri Arts Council as a master craftsman, Joe maintains a faithful following of boot fans all over the world. His willingness to push the limits of traditional cowboy boots includes a pair covered in snake symbolism for author Jonis Agee. Crafted in layers of leather on the left boot, a padded and coiled *real* snake works its way up to the top of the right boot, fully padded and inlaid from head to tail.

The legendary leather carver Bob Brown, of Hollywood, has been coaxed out of semiretirement to collaborate with Joe and several other bootmakers on highly personalized commissioned boots. My personal favorite is the carved wolf boot, fully hand-crafted—one hair at a time—and painted. You expect this pair of boots to growl at you.

In 1986 a series of Roy Rogers boots, the official Roy Rogers double-eagle collectors edition, were licensed by Roy himself and endorsed with a woven signature label, serial number, and certificate of authenticity. These boots, created for Roy and Dale's fiftieth anniversary, were in black and gold leather, bedecked with a ten-point diamond bezeled within solid gold shields, topped off with Roy's Double R brand emblazoned in gold. Each pair is crowned with a collared row of twenty 18-carat gold stars. Only ten of the series were signed by Roy due to his failing health. I called Joe at the time of this writing and a few pairs were, surprisingly, still available.

P.S. Joe, your pictorial theme boots are amazing works of art.

The Roy Rogers and Dale Evans fiftieth-wedding-anniversary boots by J.P.'s Custom Handmade Boots, a limited edition replete with diamonds, gold, and metallic leather.

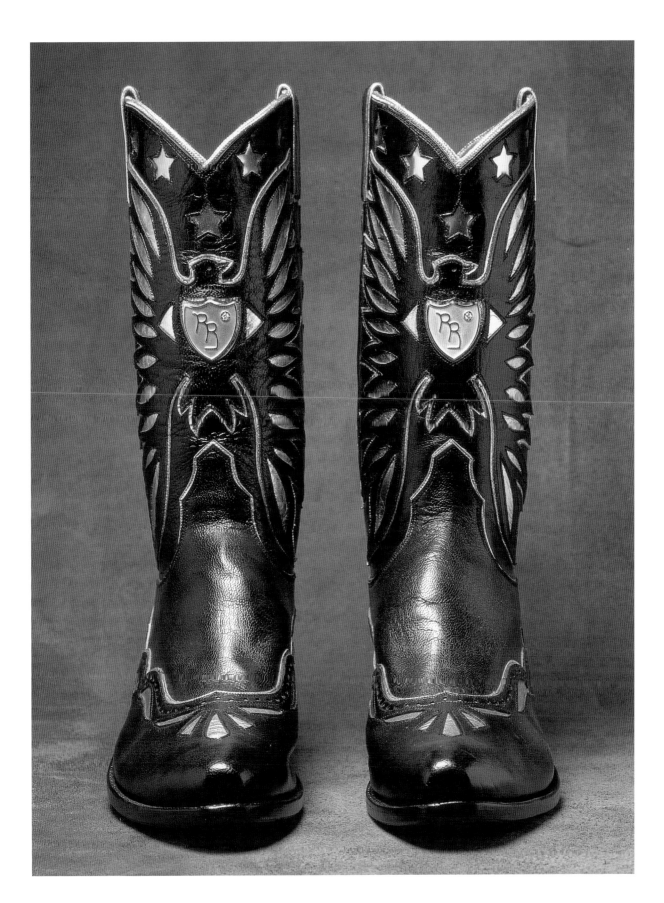

Jack Reed is the consummate cowboy bootmaker. The first time I walked into his shop in Burnet, Texas, he was stitching the inseam of a cowboy boot with a waxed string threaded with a hog's hair on the end. "The old way: it's tighter and tougher," said Jack.

As a younger man, Jack rodeoed a lot and bumped around, but shortly after a bareback rodeo accident left him unable to perform heavy labor, Jack began to eyeball boot making. He returned to his birthplace, Hamilton, Texas, and began his boot-making journey at Trujilio's Boot Shop. Over the years that followed, he worked with cowboy boot legends Ray Jones, Lucchese, and Abraham Rios. About 1949 Jack landed in Waco, Texas, at Baylor University studying civil engineering, "I starved out after awhile and had to start making boots full time," he said. Still young and not yet ready to settle with the slow, laborious processes of becoming a master custom cowboy bootmaker, Reed took a seventeen-year boot hiatus in Africa and South America with an engineering firm. His first boot shop in Henderson, Texas, opened in 1974.

"Eventually that old east Texas pine pollen drove me to dry Lampasas." Now in Burnet, this one-man dynamo, age seventy-five, is still one of a few good men who builds a pair of cowboy boots, all 372 steps, by himself. Back in 1992 Jack turned out one pair of boots a week. "I'm down to about one pair a month now," he recently said. His health has slowed him down some, but this quintessential Texas cowboy bootmaker has orders years in advance. "I'm in no hurry anymore."

Jack's brother, Pete, is also a bootmaker in the Reed tradition. He sometimes helps Jack in a pinch; other times a quiet respect for the concentration required in boot making pervades the shop's atmosphere.

In 1987 Jack and his saddle-making buddy, Sam Harris, organized the Annual Boot and Saddle Makers Round Up. Originally held in Burnet, the goal was for "folks to get to know each other, swap tall tales, and exchange information." The boot and saddle makers, wanna-bes, and enthusiasts swelled the building in Burnet, forcing new headquarters. For the past five years this event has been held at the Coliseum in Brownwood, Texas, attracting several thousand visitors from coast to coast and as far away as Japan.

The cowboy boot gift Jack has bestowed on all of us has been teaching men and women to make cowboy boots. Over the past fifteen years, Jack has passed this time-honored profession down to more than forty budding bootmakers. These folks spend one week at Jack's and turn out their one, and sometimes only, pair of cowboy boots. By now, Jack thinks he can suss out who will and who won't stick with it.

P.S. Jack and Norma Reed, it is a privilege to know y'all. You should be declared a national treasure. I mean it!

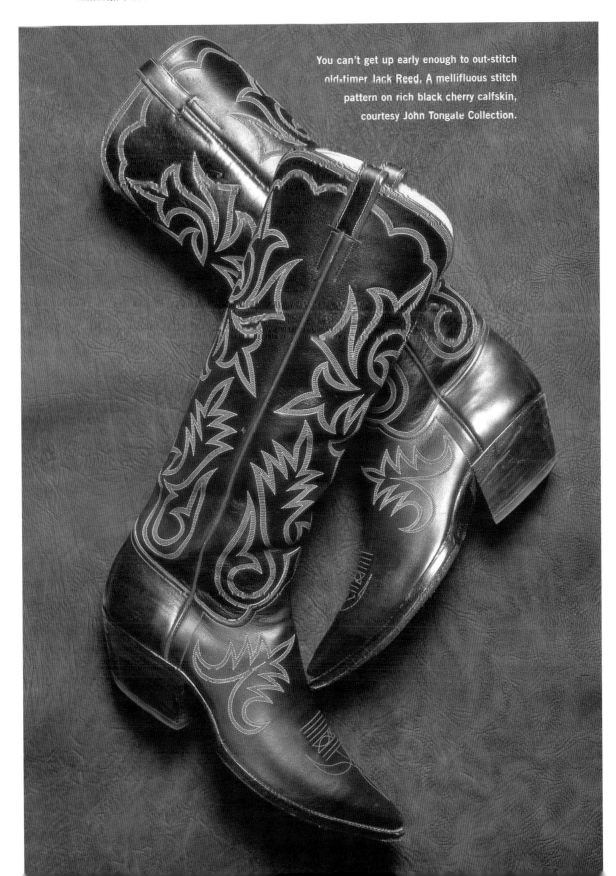

You can't get up early enough to out-stitch old-timer Jack Reed. A mellifluous stitch pattern on rich black cherry calfskin, courtesy John Tongale Collection.

Bo Riddle / Bo Riddle Boots

Bo Riddle, bootmaker and musician deluxe, was the new kid on the boot block back in 1992. Grandpa Riddle was a Confederate bootmaker in the Civil War. More than one hundred years later, in 1976, grandson Bo learned boot making at Oklahoma Technical College in Okmulgee, Oklahoma. The *fine art* of boot making he learned on his own.

Setting up his boot bench first in Birmingham, Alabama, Bo moved to Brentwood, Tennessee, in 1982 to be near the Nashville music scene. While he pursued his musical career of fiddling, he was also making the most bodacious cowboy boots to bedeck and bedazzle country music's finest feet.

Bo's special talent is best represented in over-the-top, confetti-colored, multi-leathered overlays and inlays with such balance in depth and design that they take on a beautiful and bizarre 3-D effect. Riddle has also achieved a reputation for extremely high underslung heels and needle-nose toes. My favorite thing about Bo is his unrelenting drive to do something original on a pair of cowboy boots. He is forever ambitious, with his filigree leather patterns and a myriad maze of jigsaw-puzzled tiny leather tidbits artfully arranged to set a scene, tell a story, or just plain "oogle" the eyes.

Like all true artists, Bo remains humble in his pursuit of total self-satisfaction through the elusive goal of perfection. Recently Mr. Riddle returned to his home state of Missouri and opened a boot shop in order to be closer to his family. An exemplary cowboy bootmaker and artist to boot, Bo has found his natural niche making cowboy boots and playing the fiddle.

P.S. Bo, your boots are boss; keep the faith!

Three beautiful Bo's in a row.

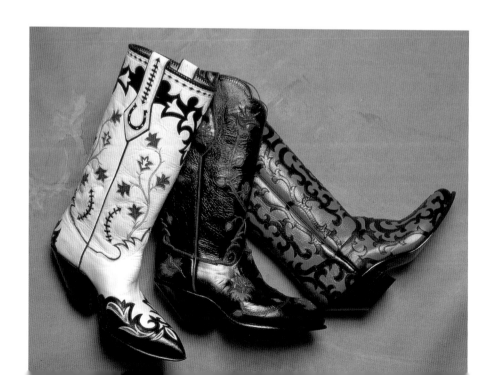

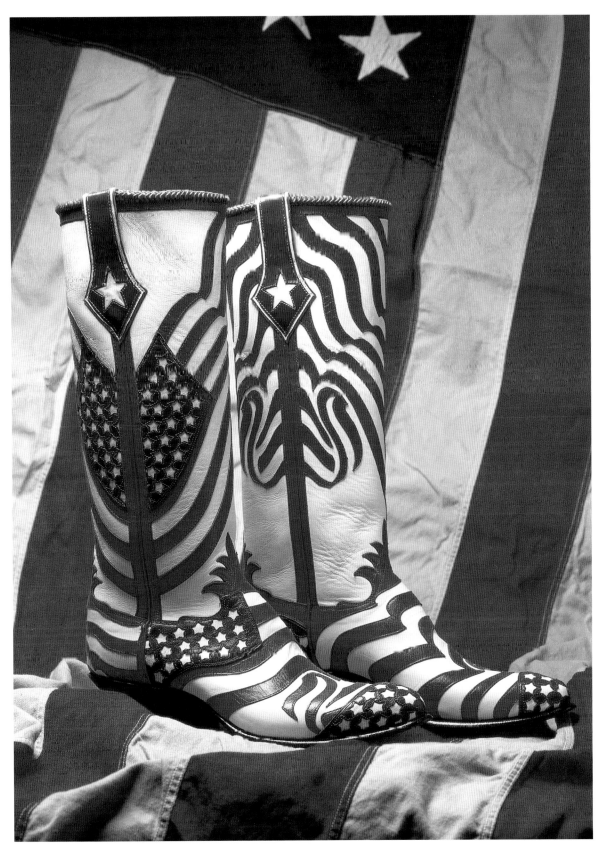

A fantastic asymmetric "American Flags" boot.

Bodacious Bo Riddle is fearless with his arresting one-of-a-kind arty designs.

Rios of Mercedes Boot Company

The Rios name can be traced back to the mid-1800s when the Rios family of General Terán, Mexico, gained a reputation as premier artisans in the art of boot making. Around the turn of the century, some of the Rios family began making boots in the Texas Rio Grande valley. This close proximity to San Antonio's boot elite—Lucchese and, later, Little's Boot Company—spawned a battle of the bootmakers. This blast of boot competition spurred the creativity and skills of the Rios brothers. Some of their borderline-bizarre-boots have only recently been challenged artistically.

Any bootist or collector will agree that a pair of vintage Rios boots is a gold mine. At the time (1940s–60s) these two brothers were boundless in their irrepressible variations in the use of colored thread and leather combinations that no other bootmaker would have even considered. Their pictorials, padding, filigreed inlays, and western icons and overlays resplendent with horse heads, sunflowers, and floral vines—all enhanced with swirling stitch circles in a multitude of crazy color combos—can leave even the most jaded boot collector howling with respect and awe.

Thousands of amazing boots later, Abraham and Zeferino Rios parted company. Abraham set up shop in Raymondville, Texas, while Zeferino remained in Mercedes, Texas.

Fast forward a little to 1969. Zeferino retired and sold the family business in Mercedes to Trainor Evans and J. P. Moody. For the past thirty years, these partners have maintained the handmade quality and reputation of the Rios family name. With roughly sixty bootmakers, the word *factory* naturally comes to mind. But no way! The amount of handwork and the tradition of doing everything the right way, not the fast way, separates Rios from the large cowboy boot factories.

The most popular boot skins at Rios are calf, Italian horse hide, kangaroo, and ostrich. Their three biggest boot-buying states are Texas, Oklahoma, and Louisiana—comprising some 50 percent of sales. The quarter-horse crowd from the Midwest and exports to Italy and Japan make up the balance.

P.S. There are no words to describe the truly amazing "Liberty Bell" boots. I challenge Rios to bring back retired master stitcher and top man Antonio Sanchez to create another one-of-a-kind 3-D leather sculpture like these.

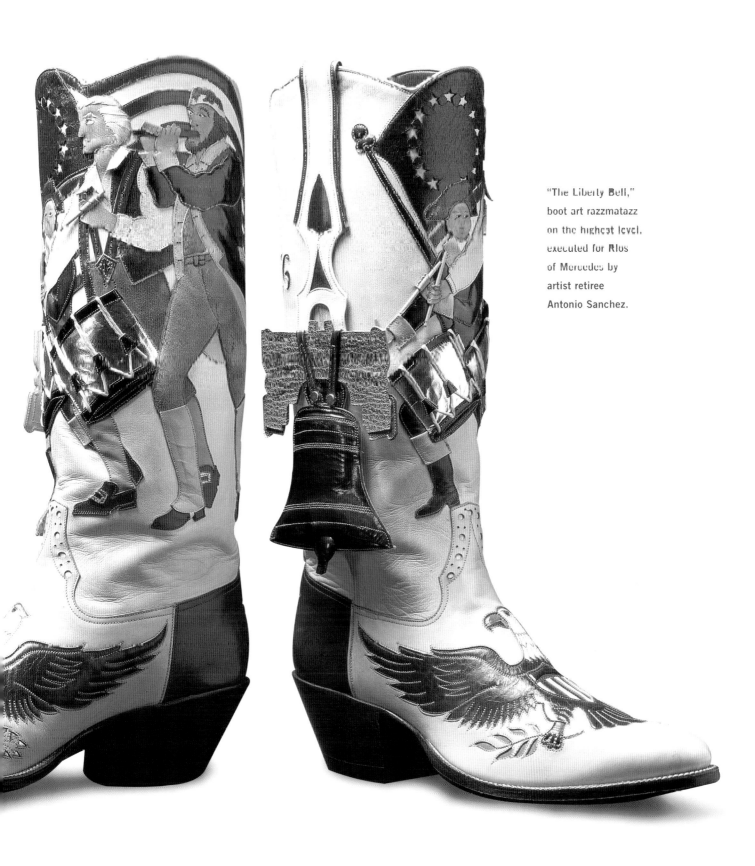

"The Liberty Bell,"
boot art razzmatazz
on the highest level,
executed for Rios
of Mercedes by
artist retiree
Antonio Sanchez.

Tex Robin is a second-generation bootmaker. His father, Waymon Robin, was nicknamed "Tex" because of his interest and participation in rodeos and Wild West shows. Self-taught, the first Tex began by repairing the boots of his rodeo buddies. He set up shop in the old Bennett Nance Saddle Shop in Coleman, Texas, in 1944. Like most beginning bootmakers, Tex wandered a little, working in other shops, setting up here and there, slowly developing his own style and technique. In 1972 his son, Tex Robin, took over the boot shop when his dad passed away.

Since then, Tex has put cowboy boots made the old way on the feet of thousands of satisfied customers. Tex's boots are mostly for businessmen, ranchers, and cutters. His boots are sturdy and tough, yet elegant and beautifully crafted, one slow step at a time. "The only machines that I use are for stitching tops, the side seams, and the soles. I still sew the welts by hand, use wood pegs for the shanks, and last each and every pair of boots by hand."

Tex has taken on a little boot instruction in order to pass on his trade to bootmakers-come-lately making a beeline to his door to see a Texas boot-making legend making them the old way.

P.S. Tex, whatever happened to those incredible, ahead-of-their-time boots made in 1959 for Elmer Patton with skulls, crossbones, and aces and eights—dead man's hand—all inlaid on black stovepipe tops?

The one and only "Bicentennial Boot" is a folk-art masterpiece in red patent leather extending to a gilded brocade cloth foot. Boots by Tex Robin Boots.

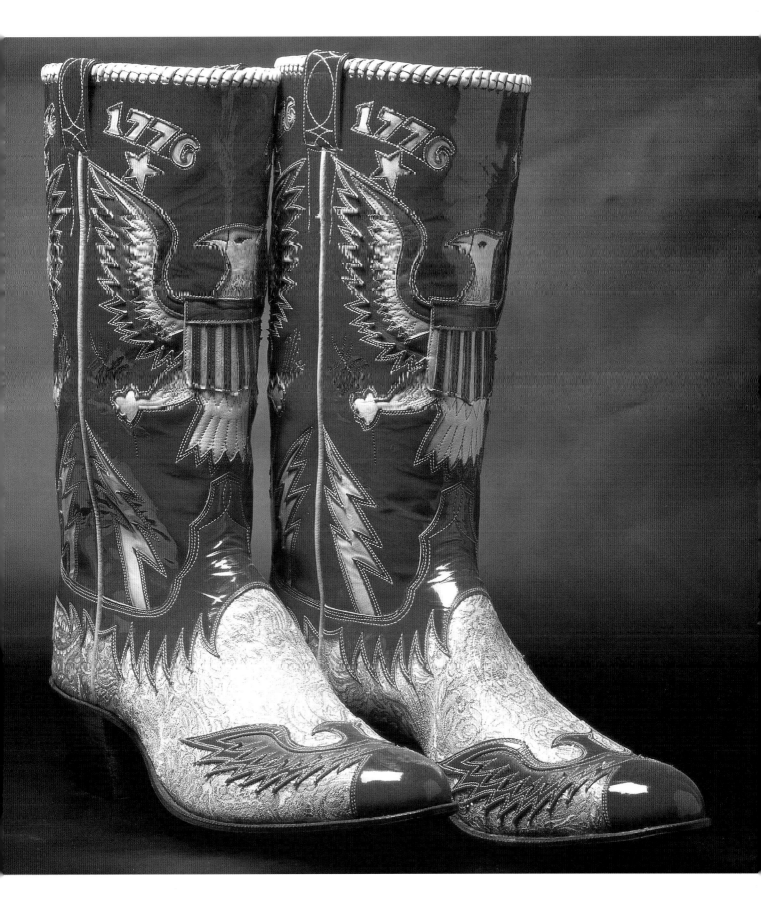

Rocketbuster Boot Company

In 1989 Marty Snortum rocketed into the cowboy boot business when he traded his 1953 Cadillac hearse for this fledgling boot company in El Paso, Texas. The deal was a lock, stock, and boot barrel bargain that soon had all of cowboy bootdom sittin' up and takin' notice.

Pre-Marty, the company had focused on reproducing vintage peewees and boot styles from the 1940s and '50s. With panache and an artist's eye backed up by a trainload of cowboy boot ballyhoo, Marty and company set the boot world on fire at the 1991 annual Denver Western Wear Market. I was there and remember it well. The Rocketbuster showroom was so packed with prospective buyers I had to wait to get in the door! Rocketbuster customers thought these flamboyant cowboy boots were the greatest thing since sliced bread. And the sight and wildfire reputation of their cowboy-boots-gone-berserk ingenuity sent the entire cowboy boot industry back to the drawing boards scratching their heads. Rocketbuster must be credited with supplying this first major go-round of retro cowboy boots and inspiring wearers and bootmakers to shed their old boot skins.

Rocketbuster's attention to detail can vary from good to incredible. I was blown away when Marty had dyes and paints custom mixed and special tools manufactured just to reproduce in stunning accuracy a hand-tooled, dyed, and painted vintage "Acorn and Leaf Boot."

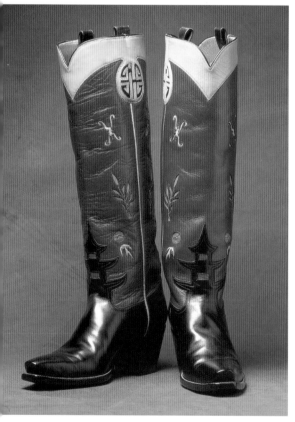

"Pretty Pagoda" by Rocketbuster Boot Company.

Marty now shares the running of Rocketbuster with Nevena Christi, a former clothing designer with Nicole Miller in New York City. Nevena is as sweet as she is savvy. "Our customers are not your traditional boot buyers," says Nevena. They are lifestyle customers. Our specialty has become personalized boots and corporate logo boots. We have also added leather vests to match our boots and a line of inlaid leather pillows with the same designs."

A delicious cowboy boot delicacy, Beluga caviar served on a stingray foot. Bon appetit!
Boots by Rocketbuster Boot Company.

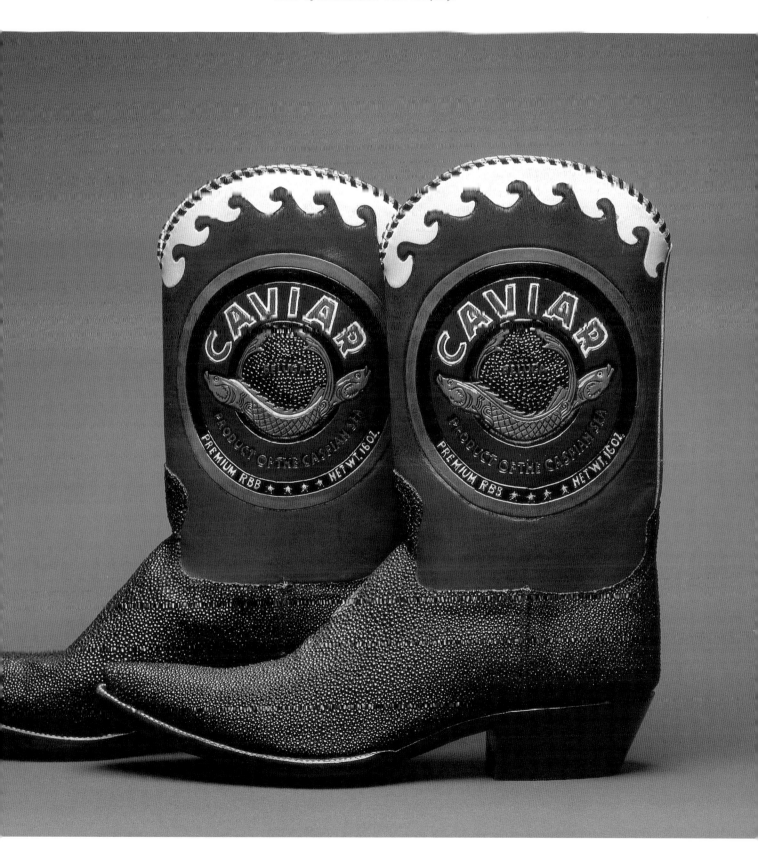

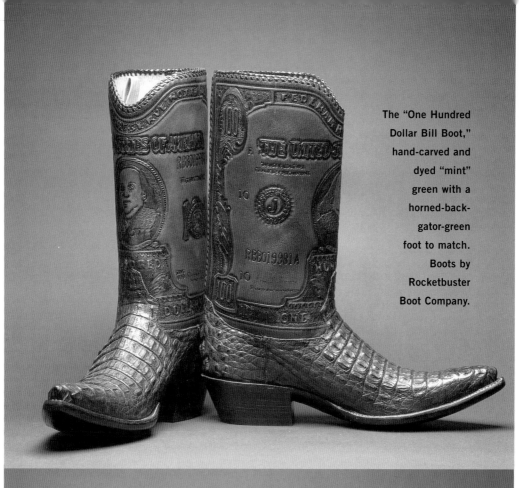

The "One Hundred Dollar Bill Boot," hand-carved and dyed "mint" green with a horned-back-gator-green foot to match. Boots by Rocketbuster Boot Company.

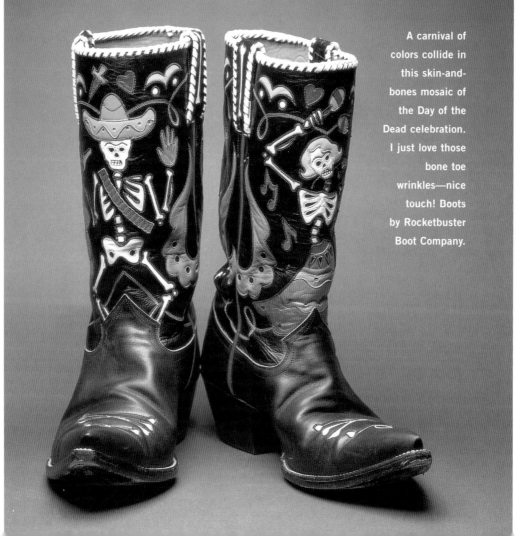

A carnival of colors collide in this skin-and-bones mosaic of the Day of the Dead celebration. I just love those bone toe wrinkles—nice touch! Boots by Rocketbuster Boot Company.

Rocketbuster boasts a star-studded following: Mel Gibson, Arnold Schwarzenegger, Sylvester Stallone, Oprah Winfry, Meg Ryan, Brooks & Dunn, Jay Bulmer, and even royalty. One of their best boot customers is Magnus Von Kühlmann Baron Von Stumm-Ramholz from Germany.

The annual release of a new Rocketbuster mail-order catalog is something to look forward to each year. It's a feast for the eyes. Call and get one, because the colors, styles, and innovative boot "firsts" and the whole kit 'n' kaboodle at Rocketbuster Boots defy description.

P.S. Marty and Nevena, keep on rockin', shakin', and stirrin' the boot pot! Nobody does that better.

This "Gothic Sci-Fi" boot was inspired by an antique water fountain in Havana, Cuba. The hand-tooled and painted vinelike maze evokes mystery. Cigar enthusiasts Mel Gibson, Arnold Schwarzenegger, and Jeremy Irons are all proud owners of this unique design. Boots by Rocketbuster Boot Company.

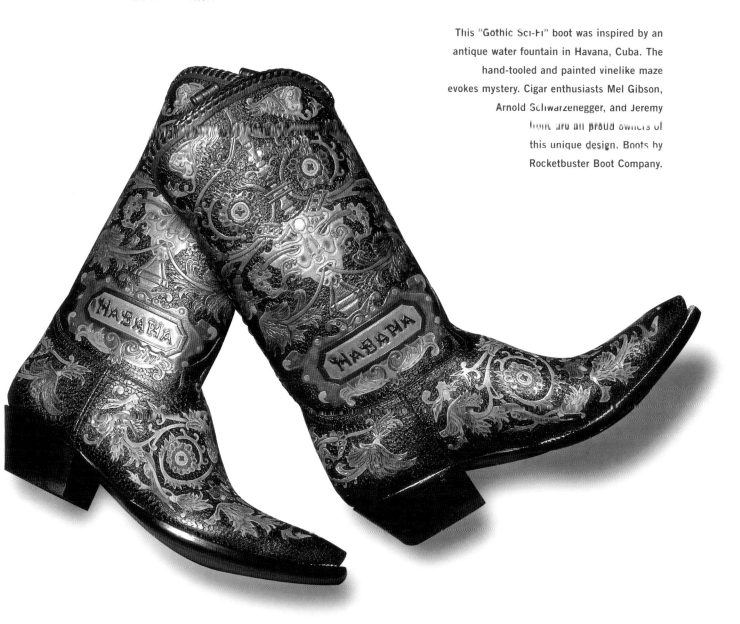

— Lisa Sorrell / Sorrell Custom Boots —

Self-described artist-in-boot-design, Lisa Sorrell is only thirty years old. Heck, she looks eighteen! With encouragement from her husband, Dale, Lisa has been pursuing her boot dream for the past ten years.

"I became a bootmaker by accident. Looking through the want ads, I found one seeking someone to 'stitch boot tops.'" I had never heard of a custom bootmaker and had never even worn a pair of cowboy boots, but I started out sewing clothing professionally when I was fifteen, so I figured if it was done on a sewing machine, I could do it. The ad I answered was placed by veteran bootmaker Jay Griffith. He was in his seventies when I met him. He built his first pair of boots when he was thirteen with only a hammer and an awl. Jay had invested a lifetime in building cowboy boots and was incredibly knowledgeable. I got to spend a year and a half with him. He was an excellent bootmaker and an extremely talented designer.

"As soon as I realized what a bootmaker was, I had found my calling. One boot in particular inspired me. Jay had an old pair of boots in his shop that he had made for his wife in the late 1940s, but they were too tight. He tore them down to re-last them but never finished. They were the fanciest boots I had ever seen, with six colors of leather, lacing, perforations, and an incredible amount of inlay. I loved to look at those boots and said to myself, 'Someday I'm going to be good enough to make boots like that.'"

Some dreams come true. Not even the most frivolous footwear fop could resist Lisa's boot collages. She designs with the skills of a master. Her fabulous formula for artistic success is the result of a no-holds-barred attitude with original ideas and practical skills befitting the "belle of the bootmakers."

After more than three years of stitching tops for Jay Griffith and other makers, Lisa struck a bargain with Ray Dorwart, former student of Jay Griffith. Lisa would stitch tops for Ray and help out in his shop in exchange for education on how to bottom a pair of cowboy boots.

Lisa is spunky, with the basic brass tacks of boot making behind her and enough boot backbone to bewilder even the hardiest veteran maker. "Occasionally I will still design or stitch a pair of boot tops for another bootmaker. I've worked on boots for Marty Stuart, Wynonna Judd, Leroy Parnell and Tricia Yearwood." Lisa is far from starstruck. She just wants to make "all different kinds of boots for all different kinds of people."

P.S. Sweet boot dreams, Lisa—you deserve them.

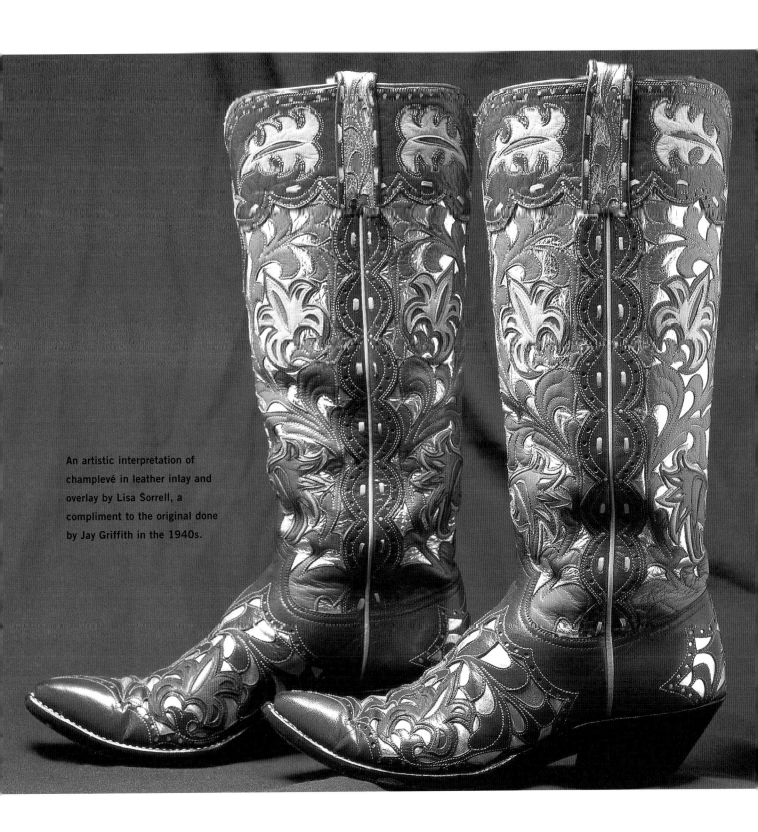

An artistic interpretation of champlevé in leather inlay and overlay by Lisa Sorrell, a compliment to the original done by Jay Griffith in the 1940s.

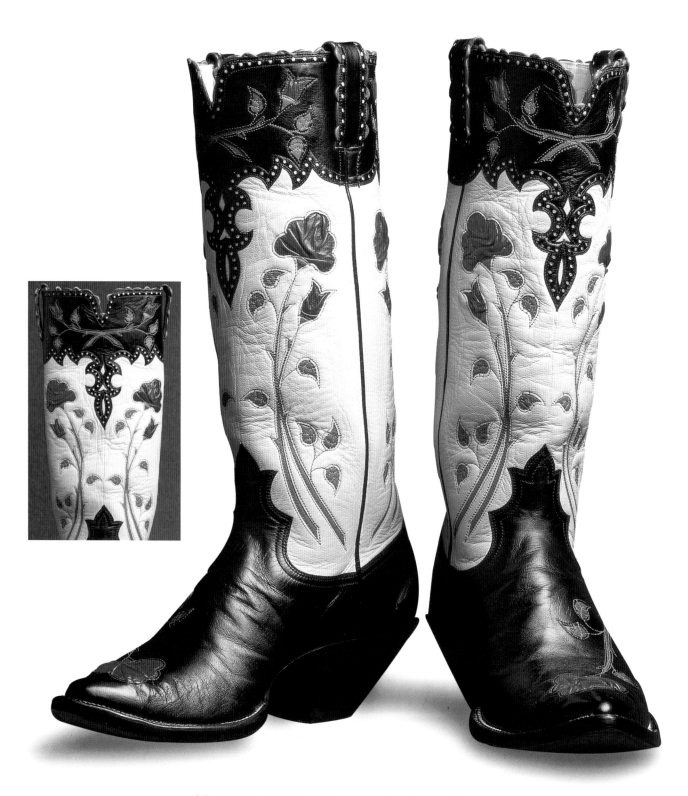

A bonny boot with two-tone interwoven red and green piping—
a nifty, never-before-seen technique from Sorrell Custom Boots.

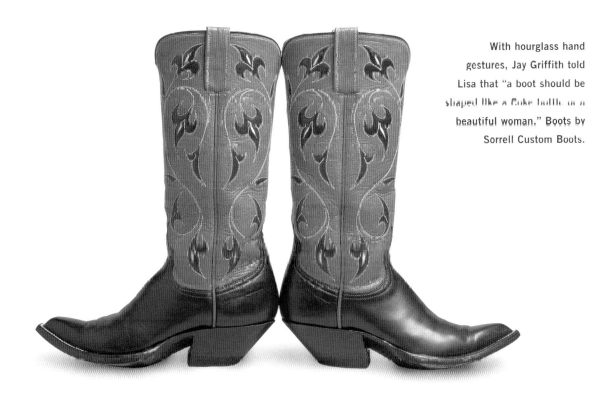

With hourglass hand gestures, Jay Griffith told Lisa that "a boot should be shaped like a Coke bottle or a beautiful woman." Boots by Sorrell Custom Boots.

A cowboy out of boots is like a fish out of water. Boots by Sorrell Custom Boots.

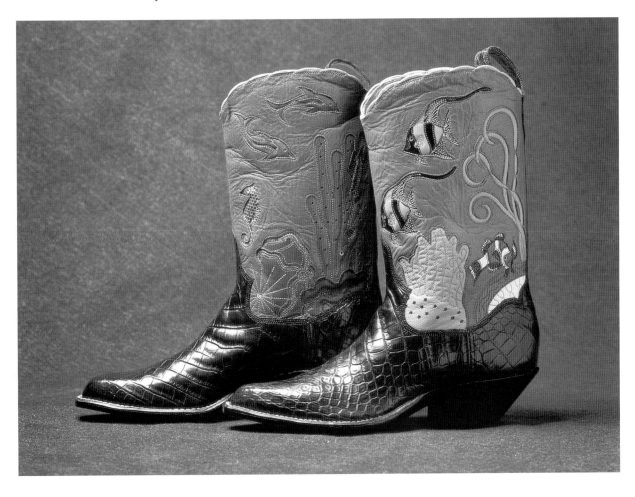

Stallion Boot Company

Sterling silver stars twinkle harmoniously with a classic horse and good-luck motif; co-designed by Pedro Munoz of Stallion Boot Company and Nathalie Kent. Courtesy Nathalie Kent.

Pedro Munoz cannot remember a time when cowboy boots were not a part of his adult life. In the late 1970s and early '80s, he was swept along by the *Urban Cowboy* craze and soon gained a reputation among friends for his flair in flashy custom footwear. One boot led to another and Pedro soon found himself measuring up feet and carrying orders over the border to oversee their construction. While still at college, he began selling leather and hides to these bootmakers he had befriended. As it so often does, a personal interest turned into a profession. With one boot over the line, Munoz had hopelessly been bitten by that old cowboy boot bug.

With a combined sixty plus years in the boot business, Jose Gallegos and Plutarco Rodrigues, owners of Gallegos Boots, welcomed this new boot blood, with his enthusiasm and inspiration. Pedro became their protegé and third partner.

Like Sam Lucchese and so many other company owners, Pedro learned all the processes and ins and outs of boot making, but more importantly for his position, he learned *how* a cowboy boot *should* be made.

When Gallegos retired, Jerry Black (now with Tres Outlaw) bought his boot share and they agreed to change the name to Stallion Boots. In 1990 Mr. Rodrigues decided to sell his portion of this boot pie yet chose to remain as Stallion's master bootmaker. Then a split with Black left Munoz as the sole owner of Stallion in 1994. With a stable of eighteen craftsmen, a steady stream of boots, belts, and leather accessories flow from their artful hands. Pedro estimates that more than 40 percent of

Fabulous full-gator boot with a truly original inlay concept. Jewelry maker and sculptor Lee Downey hand tooled this prehistoric walrus ivory, excavated by Eskimos on the Bering Sea coast. This fossilized material can be 500 to 8,000 years old. Boots by Stallion Boot Company; courtesy Lee Downey.

their production is made from alligator—their specialty. And they have retailers throughout the U.S., Canada, France, and Japan.

"Over the last few years, the trend has shifted," says Pedro, "from inlays and peewees to a more classic, traditional style of boot with a standard twelve-inch top. Exotic skins are hotter than ever, and I have noticed a sizable movement from a focus on women's boots back to men's." Pedro continues, "My sole inspiration and mentor was Sam Lucchese; his dedication to his craft was limitless. Our goal at Stallion is to emulate the style and quality of those earlier Lucchese boots. I believe boots are functional art. I appreciate who I make them with and who we make them for."

P.S. Pedro, you have a great talent for taking on a single vintage boot detail, superimposing a contemporary idea on that design, and making a new and improved classic.

This heavenly sterling-silver-studded heart boot, called "Harpo," was co-designed by Pedro Munoz with Nathalie Kent for sale at her friend's store in Paris. Boots by Stallion Boot Company; courtesy Nathalie Kent.

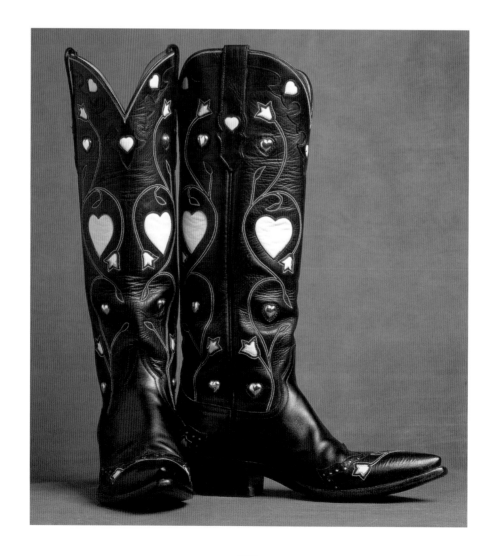

A lace-topped lizard foot with engaging symmetrical
inlay and overlay work by Stallion Boot Company.

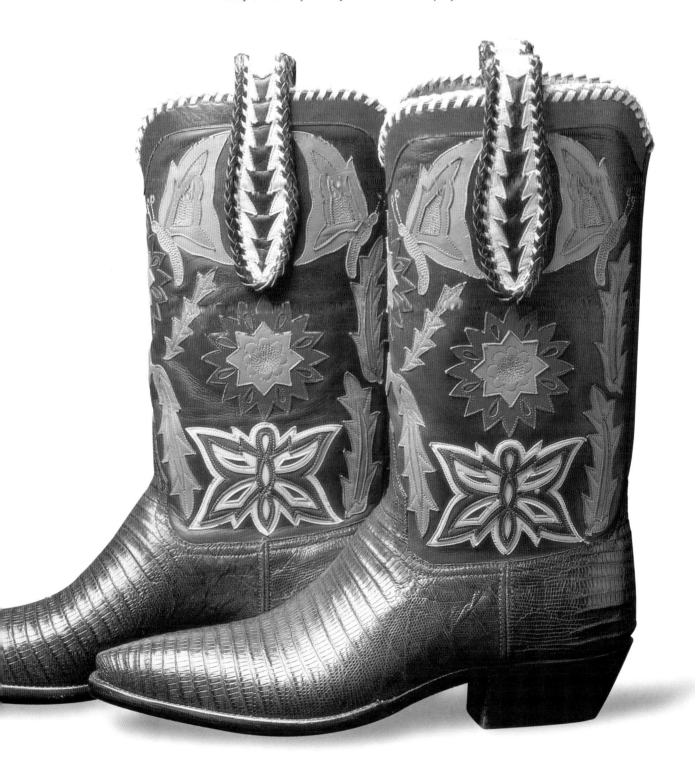

Pennsylvania native Scott Emmerich's first pair of cowboy boots were factory-made Fryes. Scott remembered, "They were basic and clunky, but I loved them anyway." From these humble boot beginnings, something tugged at Scott's heart and a cowboy boot bond was formed.

In 1980, like so many before him, Scott ventured westward, drawn to the cowboy boot capital of El Paso, Texas. There he began designing and contracting various companies to build his visions in leather. For two years Scott sold to retailers up and down the California coastline. He also put on trunk shows to market his line across the Southwest.

Scott's conviction to quality catapulted him into a retail venture all his own. Boom! In 1983 he opened a retail store, Falconhead, in Los Angeles. Location is everything, and where the movie moguls and stars reside, work, and play, money and a demand for the exotic and unusual will follow. And boy howdy, did it ever! Falconhead has evolved into the wonderland of western wear—duds that would confound any cowgirl or cowboy. Whatever your heart is pounding for, if it's in the western vein, they have it or will have it custom made.

In 1994 Scott joined forces with Jerry Black and Carlos Salazar (who has since left the company) to form Tres Outlaws Boot Company. Scott and Jerry are both sticklers for old-world technique and quality. Jerry explains, "All of our cowboy boots are made entirely by hand, with hand-cut leather toe boxes, hand-pegged soles, and full hand welting."

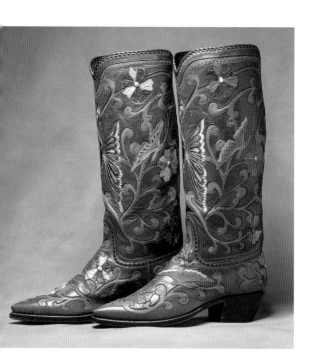

Two hundred hours were required to hand-cut more than twenty colors of leather in this whimsical butterfly and flower design. Yes, those are semiprecious stones mounted in recessed sterling-silver bezels. Boots by Tres Outlaws.

Through the store, Falconhead purveys their own exclusive Tres Outlaws line of boots that could only be described as sexy, evocative, and captivating. These boots are not for everyone. Still, the major cash cow of this partnership is the building of custom-designed wholesale cowboy boots, fashion mules, and assorted booties and bootettes for other retail and department stores.

For the master plan at the end of the decade, Tres Outlaws has created a one-of-a-kind lineup of wearable boot art. Like a stream of boot consciousness, some masterpieces have unfolded: multi-inlays with sterling silver accents; hand-tooled and painted western scenes caressing boot tops; twenty

and even thirty rows of topstitching; hand-beaded, crystal-studded, embroidered, and bejeweled footwear for men and women. Many of these designs are original, incorporating combinations of materials and techniques that have never been seen before.

Scott and Jerry originally supplied me with a bonafide list of more than 600 world class celebrities who don their cowboy boots. I can't list them all, but what the heck, let's drop a few: Bruce Willis, Madonna, Kurt Russell, Jane Fonda, Tom Hanks, Michael Douglas, Nicholas Cage, Tom Cruise, Nicole Kidman, Jamie Lee Curtis . . . whew! This list reads like an entertainment guide to the cowboy boots of the rich and famous.

The cachet that Tres Outlaws Boots carries with them is well deserved.

P.S. You two urbane city pokes have raised boot consciousness and the bar of boot making a few notches higher. Congratulations!

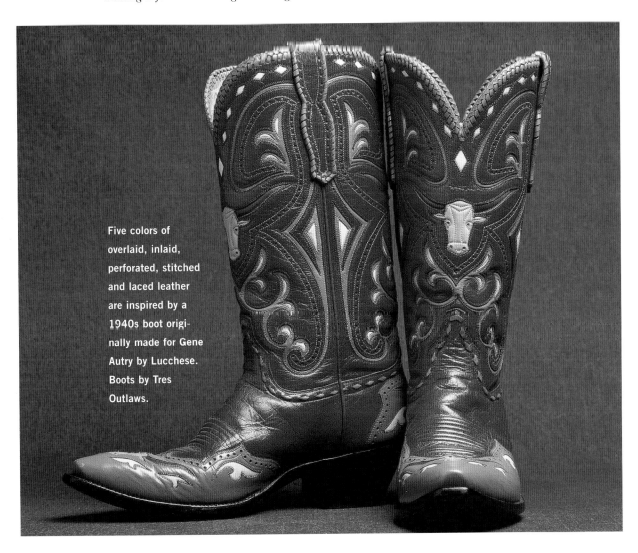

Five colors of overlaid, inlaid, perforated, stitched and laced leather are inspired by a 1940s boot originally made for Gene Autry by Lucchese. Boots by Tres Outlaws.

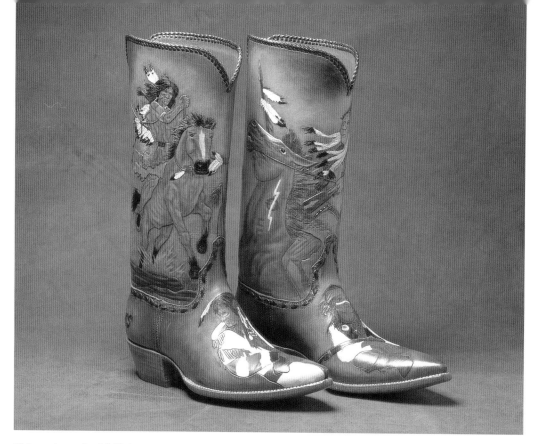

This work required 225 hours to wrap around hand-carved pictorials paying homage to Geronimo and other great Indian chiefs and warriors. All the artwork was executed by Karla Van Horn. Boots by Tres Outlaws/Falconhead.

A lifetime's worth of practiced artistry is required to complete the 300 hours of overlaid filigree-style hand tooling on this boot. The artist is legend Ray Pohja, now in his late seventies. Boots by Tres Outlaws/Falconhead.

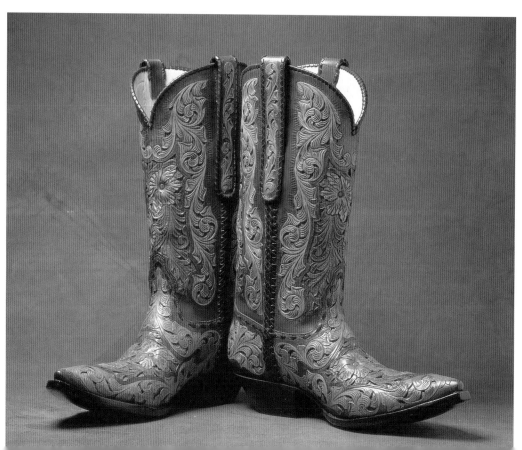

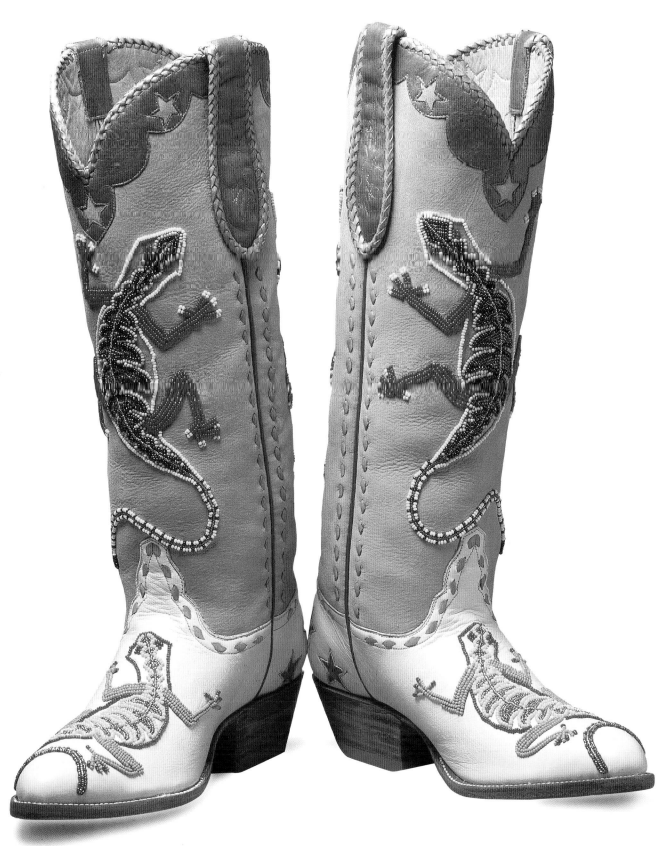

"Luscious Lizards" hand beading on glow-in-the dark shades of leather
was executed by Julia Phiffer. Design by Scott Emmerich. Boots by Tres Outlaws/Falconhead.

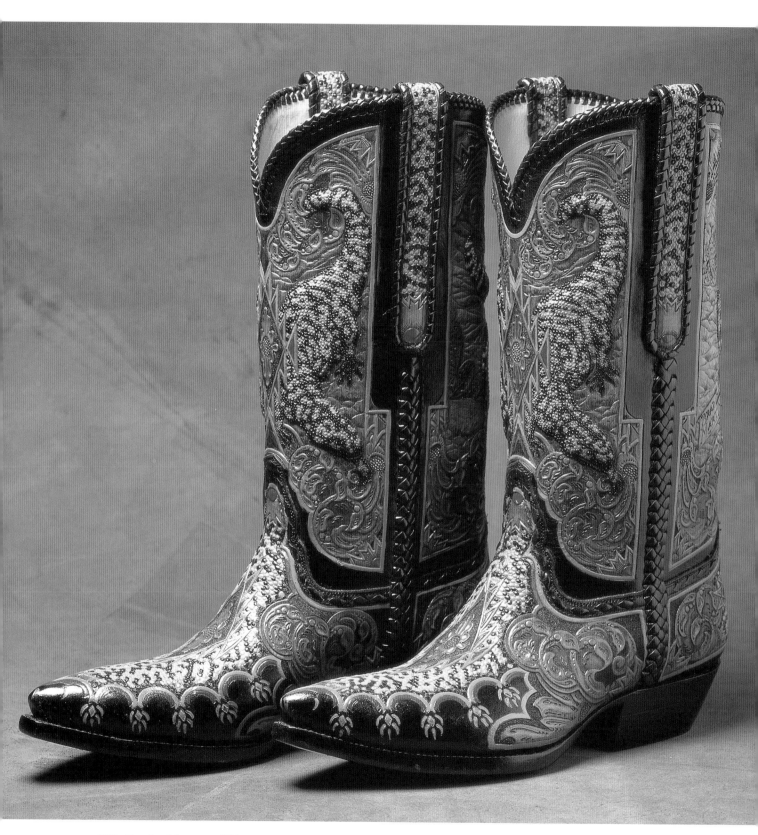

"Gila Monsters" is an amphibious masterwork in hand-carved and painted leather. It took 400 hours for cowboy boot muralist Brad Martin to complete this pair. Boots by Tres Outlaws/Falconhead.

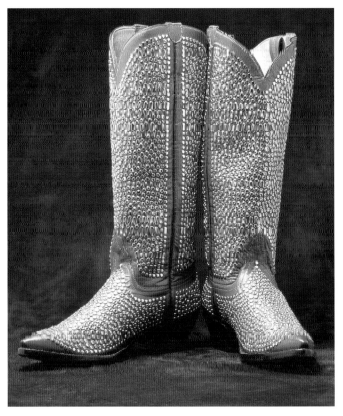

Left: Designers Brenda Biljanic and Michael Morrison collaborated on this black kangaroo boot with six thousand Austrian crystals and a flood of studs. Boots by Tres Outlaws/Falconhead.

Below, left: The spectacular sterling silver on "Chiefs" is by Dahlin, designed by Jerry Brown, using the finest American alligator that money can buy. Boots by Tres Outlaws.

Below, right: Inspired by the old Spanish bull fighters, the "El Presidente" completely embroidered in silver silk thread, racked up a stitch count of more than 2.4 million needle pokes. Think about it. Boots by Tres Outlaws.

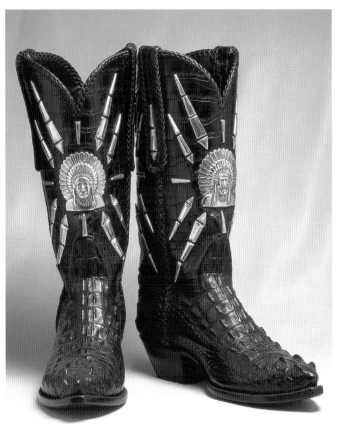

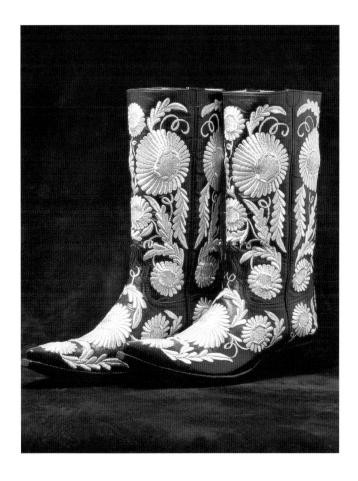

— Dave Wheeler / Wheeler Boot Company —

What can you say that hasn't already been said about the Wheelers in *Texas Boots, The Cowboy Boot Book,* and countless articles written on this legendary boot-making family in Houston? Dave's father, Paul, traveled down from Missouri in 1947 and opened his first shoemaking and repair business in Houston. By the early 1950s, many of Paul's customers were requesting custom-made cowboy boots, so he created Wheeler Boot Company.

Paul learned the old-world intricacies involved in the fine art of boot making from one of his workers from Mexico. Dave's mom, Dorothy, reminisces, "When we opened this part of our business in 1961, John Kennedy was president. The biggest thing out South Main Street was Bill Williams' Chicken House Restaurant, and a good pair of handmade boots cost $50." The social, economic, and political climate in Houston has changed dramatically over the past thirty years, and the restaurant is now closed, but the fine art of cowboy boot making does not change. There is no newer, faster, better way.

Dave is backed up by his proficient crew of bootmakers: Miguel Rico, now seventy years old, has been with the Wheelers twenty-five years; Oscar Gutierrez has been cutting and stitching tops for more than twenty years at Wheelers; bottom and last man Jorge Turrubiartes is the junior member of this boot-making clan.

One of my favorite bootmaker stories is when Dave made Robert Duvall's boots for the acclaimed western mini-series *Lonesome Dove.* I guess Duvall is so accustomed to having people put the mooch on him and take advantage of his star status and fat wallet, that when Dave told him the price of the boot, Duvall asked dryly, "Is that just for one boot?"

At Wheelers, plain vanilla is usually in the form of an exotic dress boot. However, some well-heeled customers such as Lewis Dickson, local Houston attorney, have collaborated on fantastic cowboy boot tapestries in leather. Dickson recently booted up in a $4,500 pair of boots depicting the popular Mexican Day of the Dead celebration. Dave also likes the challenge of duplicating corporate logos on the fronts and backs of boots. Many of his boot top designs have now been copyrighted.

A few years ago, Dave sent me a photograph of a pair of boots designed for a proposal of marriage. They had a floral boot bouquet in yellow, red, and green leathers. Around the top collars of the boots, in expertly cut inlaid writing, were the words "Tracey Marry Me?" As it turned out, she turned the poor guy down. How could she after such a creative beginning? Anyway, the wanna-be groom let the I-don't-wanna-be bride keep the boots

The next time I saw them, the tops had been replaced with the words "Deal Maker." It seems she was in real estate.

P.S. Dave, you are so good that I challenge your shop to do a new set of "State Boots" to complement your magnificent set of "Six Flags Over Texas."

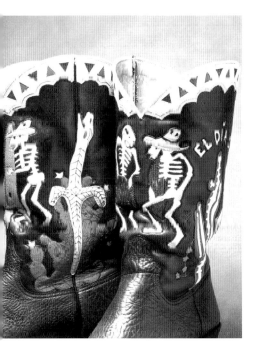

"Close-up, please," on Dave Wheeler's "Day of the Dead" celebration boots, commissioned by Houston attorney Lewis Dickson, who obviously doesn't mind struttin' his stuff.

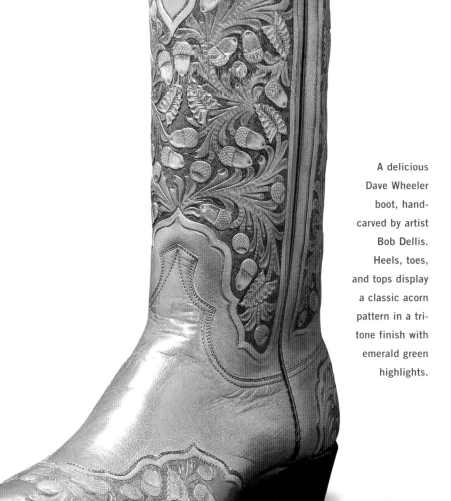

A delicious Dave Wheeler boot, hand-carved by artist Bob Dellis. Heels, toes, and tops display a classic acorn pattern in a tri-tone finish with emerald green highlights.

Overleaf: TTB brands by Little's Boots; Flying A brands by Little's Boots, James Leddy, Paul Bond, and Rocketbuster Boot Company.

SO, YOU WANT TO ORDER A PAIR OF BOOTS

I have worn cowboy boots all my life, beginning as a child with store-bought stock-size kiddie clodhoppers. (Growing children are usually encouraged to wear boots one size too large, to "grow into.") At age nineteen I had my very first pair of custom boots. They felt too tight, so the maker stretched them and then they were fine. In retrospect, they were probably a perfect fit to begin with, but being used to a sloppy-fitting boot I reacted too quickly. Now, after more than a hundred pairs of custom boots, I guarantee that once your bootmaker, or makers, have your last to perfection, you will be able to wear your boots eighteen hours a day and never even know they're on your feet unless you look down.

When the perfect fit is discussed, keep in mind this is very subjective. A bootmaker will gaze down at your feet, swimming or bulging in your existing boots, and give you an opinion on what is good and bad about your current state of foot affairs. But in the end, you are the one who wears the boot, not the maker, and you alone must decide what is comfortable for you.

The human foot is comprised of twenty-eight bones encased by numerous muscles, nerve endings, and blood vessels. Yet feet have an acute and peculiar ability to absorb pain and stress. A person's weight, the way one walks, one's profession, what one walks in, and good old genetics all have a profound impact on the physical condition of one's feet. Even with all their forgiveness and strength, how many times have we heard people discussing how much their feet hurt! Our poor feet hold us up all our lives; they work hard, and I think they deserve a lot of respect and attention.

The truth is, if you have never worn cowboy boots before, they do feel and fit differently than any shoe; therefore, some breaking-in time may be required. The old rule of thumb is still a good one: as you pull on the boot there should be a little whoosh and a pop as you enter the foot area. Once inside, there should be a little movement in the heel, but you shouldn't be sliding all over the place. The fit between your heel and the top of the foot where the lower calf and ankle connect is what determines how well you stay in your seat, not the length of the boot so much. The toe shape should have no impact on the way the boot fits.

However, even a sixteenth of an inch in measurement or in the thickness of the hide used can be felt by an experienced boot wearer. It's not a big deal, but you can feel it nevertheless. A simple procedure to remedy this is to wear a thicker or thinner sock and—presto!—all your boots feel exactly the same. Some folks like putting in a cushioned insert if they want to wear thin socks all the time and feel really snugged up.

If, after a week or so of daily wear, anything about your boots is bothering you, perhaps an adjustment is in order. Most custom makers will tell you that 10 to 15 percent of their boots are returned because the customer needs minor, or sometimes major, adjustments. These are almost always first-time buyers who are accustomed to wearing loafers or sneakers and do not understand how a boot should fit. All boots can be stretched and even shrunk to some degree, in any area. (Sprays and ointments are usually totally ineffective.) The best policy is to return the boots to the maker for these fine tunings; never take them to a local shoe or boot repairer who has no personal investment in those boots and who may not have the standard equipment for such procedures.

If you already know how boots are supposed to fit, they should be comfortable from the moment you slip them on, and you should expect additional enjoyment in the wearing as they break in more and more. There should never be any pain involved.

Contact your chosen bootmaker, preferably in person. If at all possible, tour the boot shop while on vacation or a business trip. This way you have the opportunity to meet the maker in person, see and handle the work. Getting measured in person, especially the first time, is always a little bit better.

If you don't have the luxury of a personal visit, choose a maker whose story and boot designs appeal to you. Call, write, or fax, inquiring if they do mail order, whether they have a measurement chart and instructions to send you. Some shops will only take orders in person; others will only do stock sizes by mail. With a custom fit, the maker will take about eight measurements.

Getting measured or self-measuring to order by mail. Custom-made cowboy boots are not a science; they are an art form. Taking a proper measurement requires anywhere from fifteen to forty-five minutes, depending on the maker. They all have a system.

If you're ordering by mail, you will be asked what size boot you normally wear, and possibly even to provide a tracing of your feet to double-check. Some makers will supply you with a packet of information and guide you through the entire process. I also have known a few first-timers who sent an old pair of boots that they liked (or possibly didn't like) so they could be analyzed. From a well-worn pair of boots, a maker can determine how you walk and the way you shift your weight—front to back or side to side. They can see if you are tough on your footwear or light on your feet.

Designing the finished boot. The boot's outside appearance can always be an ever-changing canvas for your imagination. Decide what you want by looking through books and catalogs. But be sensible: don't try to put *everything* into one pair. Order a plainer style on your first custom pair, and maybe the next—until the fit is just right—working up to the outrageous and highly personal stuff after a perfect fit is a shoe-in.

Once you have determined to order something, ask for leather samples to look at, colors of thread, perhaps a few copies of stitch patterns, toe bugs, toe shapes, heel shapes with their widths and angles. A good bootmaker will communicate with you for every detail to ensure complete satisfaction.

Don't be affronted if you are asked to sign the order; this will prevent later disputes over the details. Payment is almost always a deposit of half up front and the rest on delivery.

How to care for your boots and lengthen their life. A store-bought boot will last maybe a year under heavy wear, but a custom boot with superior materials inside and out will last four to five times longer. Here are some tips for care: Clean them after every wearing. Saddle soap and warm water are recommended, providing that you hand-dry the boots with a cloth afterwards. Never set a pair of wet boots by a heat source or open fire. After the boots are thoroughly dry, they can be wiped down with a neutral or compatible-color conditioning cream. Avoid sticky, gooey waterproofing products; they will do no service to the leather. If you nick the leather, you can touch it up with a cotton swab and matching color, then buff and polish.

Personal responsibility and your bootmaker's expertise will make it possible to get the maximum life out of your custom boots. I have had some of mine resoled six and seven times before the foot leather finally gave out. Another secret is that the maker can simply re-foot the boots: the tops will probably last a lifetime unless you work in manure or chemicals, or string barbed wire fence on a daily basis. It's a simple procedure to put a new foot on the old top. You can even change the color, hide, or details as long as the tongue pattern remains the same and the size is not altered much.

The toe can't be changed unless the boot is re-footed, but the heel can be altered at any time. There is a certain amount of built-in heel-height variance, and the angle of the back can be sheared off in any desired slope.

Once you've fallen head over heels for custom cowboy boots, you'll be wanting to order a second pair. . . . One of the best pieces of advice I've ever received came from my fellow bootist Evan Voyles when he suggested that if I loved a pair of boots, I should just have it copied instead of always trying to figure out how to change it. It makes sense, and I have stuck to this new creed, except for a few modified details, on the bulk of my custom boots ever since. Caution: if you try to play Picasso when designing your own boots, the result could be either a masterpiece or a mess! Either way, you own the boots.

In this day and age, anything custom-made is a precious luxury, and cowboy bootmakers are a throwback to a time in this country when everyone had a profession, a trade that set them apart as an expert at something handmade, one slow methodical step at a time. The experience of buying custom boots should be fun and personal, an event in self-expression. Have you ever met a person who didn't enjoy the sensual and primeval aroma of new leather? Nope!

So now you're ready to order a pair of boots. Get out your boot books and crayons, or be very twenty-first century and design it on your computer—maybe in CAD. There is no time like the present and no present like a pair of custom-made cowboy boots.

Long live the cowboy bootmaker!

GLOSSARY

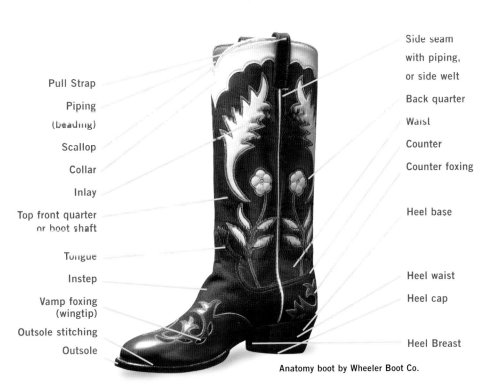

Pull Strap

Piping
(beading)

Scallop

Collar

Inlay

Top front quarter
or boot shaft

Tongue

Instep

Vamp foxing
(wingtip)

Outsole stitching

Outsole

Side seam
with piping,
or side welt

Back quarter

Waist

Counter

Counter foxing

Heel base

Heel waist

Heel cap

Heel Breast

Anatomy boot by Wheeler Boot Co.

Beading: a slender, rounded strip of leather that encircles the top of the boot. The beading is made from the same material as the piping that runs down the side of the boot.

Boot hooks: a pair of long, strong metal hooks attached to cross handles made out of hardwood or plastic. The lower section of the hook is flat so that the inside pull straps of the boot will not wrinkle when you pull the boots on. After the hooks are inserted into the loops of the pull straps, the foot is thrust into the boot, which is pulled on using slight force.

Boot jack: a tool that enables the boot wearer to remove boots while standing. The first boot jacks were made of wood and had a forked end to hold the heel of one boot while the wearer pulled his foot out of the other.

Many early boot jacks were hinged down the middle so they could be folded for traveling. After the 1870s, most boot jacks were made from molded iron. The jacks came in a variety of shapes and sizes. The most common design was a brightly painted beetle with its antennae outstretched to hold the heel of the boot. Popular with cowboys are the Naughty Nellies, which depict a woman lying on her back with legs spread to catch the heel of the boot. Designs featuring six-shooter barrels and longhorns were also widespread. Tobacco companies, boot companies, and clothing manufactures began to put their names on the jacks as giveaway advertisements. Boot jacks gave rise to the catchy expression "Once you use a jack, you will never go back."

Boot jockey: a curved metal plate, or today, more commonly, a plastic one. The jockey is used with tall boots, usually those over fifteen inches high. The device prevents a pair of boots from sagging and losing their shape while not being worn.

Boot tree: a form used to keep boots in shape when they are not being worn. Also known as "wooden feet," boot trees are designed to be inserted into the foot of the boot with relative ease, thanks to slide or spring action built into and underneath the wood. They are regaining popularity and can be readily purchased. Older ones were usually made of maple, but today cedar is more common because of its deodorizing quality.

Box toe: a boot toe that is squared off at the end. Square-toed boots have

been around for hundreds of years. Box toes were popular with the early cowboys and remained that way through the 1950s. Bootmakers often describe toes as one-eighth box, quarter box, half box, etc. This refers to the width of the tip on the toe. After the 1950s, the pointed, or sharp, toe became more popular than the box toe.

Buck stitching: a thin strip of leather, normally in a contrasting color, that is woven over and under the boot leather to create a laced effect. Although the purpose is usually purely decorative, this type of work can be used to hold layers of leather together. Buck stitching is often seen around wing-tip toes, up the sides of boots, or around their tops. Most buck stitching was done in Mexico and South Texas by the bootmakers and factories in the 1940s and '50s.

Clicker: a machine like a press that pushes down on the dies to cut out various pieces of leather for all parts of the boot. It works like a giant cookie cutter. The word *clicker* comes from the sound the machine makes upon impact with the die. Once largely found in boot factories, the click machine is now also used by custom bootmakers as well.

Cockroach killers: a street term that arose to describe the narrow, pointed, and sometimes hand-filed needle-nose boots worn in the 1960s and early '70s. This very popular toe style was just about all you saw on men and women for almost fifteen years. During the popularity of *Urban Cowboy*, the toes began to round out to satisfy the more conservative East Coast tastes. However this type of toe, along with the narrow box, has remained the most popular one in all other countries throughout the world, and since about 1990, sharp toes have come back into vogue in the U.S. again.

Collar: a layer of leather at the top of the boot, usually in a contrasting color or made from an exotic skin that is cut in a decorative design. This collar is usually overlaid but often has fancy inlay work on it, which dresses up the boot.

Counter: the leather piece above the heel of the boot, which is attached by stitching to the vamp.

Crimping board: a narrow piece of wood, usually less than 1-1/2 inches wide, that looks like a tall tube sock. The wet vamps of boots are stretched and nailed to this board before they are attached to the other parts of the boot. Then the leather is left to dry for a day or two. This is an extra step before lasting to ensure that all the stretch of memory has been removed from the leather. If this process is not performed, wrinkles will appear in the curves of the boot over the top of the foot.

Crow wheel: a wooden-handled tool with a wheel mounted in a forked carriage that uses sharp prongs to print narrow, decorative designs on the waist and heel of a boot. The crow wheel is sometimes confused with the peg wheel. The tool is heated and then applied to either damp or dry leather. In a catalog from 1900, there were over a dozen different wheels with various dots and fancy designs. One of these was a V shape, similar to a crow print, hence the popular name.

Cuban heel: a heel of any height, width, or length, where the circumference angles in toward the center, then curves out slightly toward the bottom, giving the heel an hourglass shape.

Custom makeup: a term used by boot factories to describe their version of custom-made boots. The major difference is that there is no custom last, nor are there any measurements involved. A stock factory last in a standard size that comes as close as possible to accurately fitting the customer's foot is used instead.

Die: a metal pattern with razor-sharp edges that works like a cookie cutter. It is used to cutout sections of the boot in various shapes; these are then glued and sewn together to form the vamp, counter, and top of the boot.

Ears: another name for inside or outside pull straps.

Forty-penny nail: a nail that old-time bootmakers would beat flat and then shape to the dimensions of the wearer's foot. The nail was then covered with a layer of leather, stitched, glued, and sometimes pegged between the insole and outsole to work as a shank that supported the wearer's arch. Jumping on and off a horse all day can be rough on a boot, so many West Texas cowboys still request forty- and sixty-penny nails put into their boot soles.

Foxing: a term describing a piece of leather that is sewn (overlaid) over another part of the boot simply for decoration. Bootmakers will say that the toe or heel is "foxed."

Fudge wheel: a wooden-handled tool with a cylindrical serrated wheel, also known as a boot rand wheel, wheel jigger, bunking wheel, stitched prick, or seat wheel. The fudge wheel is heated, then rolled around the finished welt of the boot in order to mash, tighten, and firm the leather and the stitching. It creates ridges and gives a uniform appearance to the stitching. Many old-time bootmakers think it gives the boot a nice finished look.

Graft: the front of the boot rising from the foot to the top.

Handmade: boots that are built entirely from scratch by hand the old way. There is little or no machinery involved, other than a foot-pedaled sewing machine for some of the fine stitching.

Heel: the part of the boot attached to the rear, or seat, of the sole. The heel comes in any shape and height imaginable and should be constructed to add support, comfort, and form to the overall boot design.

"h" toe: a toe tip rounded like the top curve in a lower-case letter "h." This style gained popularity in the 1980s.

Inlay: strictly decorative fancywork involving multiple layers and colors of leather. These may be overlaid or underlaid. Overlaid patterns are sewn over the principal boot leather, while underlaid ones are invisible, sewn in from underneath to produce a cutout window-type design.

Insole: the layer of leather between the foot and the outsole, or bottom, of the boot. The insole forms the inner foundation of the boot to which the outsole is attached.

"j" toe: a slim rounded toe tip that resembles the bottom of a lower-case letter "j." This style became popular after the pointed toes of the early 1960s and '70s went out of fashion.

Last: an Old English word for footstep. The last is the model used to make all custom and factory boots. Until recently it was always carved from wood, but now fiberglass poured into foot molds has almost entirely replaced wood. The toe, however, can be fastened to the end of the last in any style the customer desires. And small pieces of leather are shaped and glued and then sanded down smooth to compensate for any irregularities in a foot or changes that occur normally as a customer ages.

Mule ears: elongated pull straps that resemble long ears, sewn to the outside of the boot. Some of these extend to the top of the boot and literally touch the ground at the bottom. Many times you will see initials, names, etc., inlaid down the ears. Buck stitching, lacework, and sometimes fringe are added for effect.

Needle nose: the absolutely sharpest point possible on a cowboy boot. A needle-nose toe has to actually be hand-filed to create less than an eighth-of-an-inch point. This style is still popular with many Nashville per-

formers. The only custom bootmaker who makes these toes today is James Leddy in Abilene, Texas.

Peewee: a nickname given to the short boots popular in the 1940s and '50s. A standard cowboy boot is twelve inches high. Basically any boot less than twelve inches tall is considered a peewee.

Pegs: wooden pegs, little stakes of wood made from maple or lemonwood, usually from Germany. These pegs, in some cases, run from the breast of the heel down the waist of the sole of the boot. Along with stitching and glue, they hold the insole and outsole together. Pegs are usually a sign of a better-quality boot, and you should also be able to see the tops of the pegs when you look inside your boots. Bootmaker Ray Jones is the legendary "king of the pegs," known to use as many as 300 pegs per pair.

Peg wheel: a wooden-handled tool composed of a metal wheel with tiny metal spikes. It is used when the leather is damp, and is rolled along the sole of the boot to create a path as a guide for the bootmaker to space his pegs evenly.

Piping: rounded strips of leather that run up the side seams of the boots. Sewn dead center between the back and front of the boot, piping can be in the same color or a contrasting color of leather to make the boot or its stitching patterns stand out more. Early bootmakers had to hand-make all their piping. Now it comes in rolls in dozens of colors, already rounded and ready to sew.

Pull holes: finger holes at the tops of boots that replace pull straps and are very often used by working cowboys, who also call them "windows." Outside pull straps can catch on things and have been known to pull a rider off a horse. Inside pull straps sometimes rub against a leg and create a lot of discomfort.

Pull Straps: straps that are used to assist in pulling the boot on. They can be on the outside or the inside of the boot in any size or shape. In the 1940s and '50s, when men and women frequently tucked their trousers into their boots, bootmakers and factories began to stitch their names into the cotton cloth pulls, which then hung out over the top of the boot, for free advertising.

Roper: a style of boot with a wide, round toe, no decorative stitching, usually a nine-to-ten-inch top, and a low walking heel. From the 1920s through the 1960s, this work-style boot, rugged but plain, was called the Wellington. It comes with low or high tops. In the late 1970s the boot was renamed "roper" by the factories. The style caught on and became very popular with both men and women. The roper bears little resemblance to what we think of as a real cowboy boot from any era.

Saint Crispin: the patron saint of shoe- and bootmakers whose festival is celebrated October 25. Legends and stories about Saint Crispin, who supported himself as a cobbler while preaching the gospel, are popular with bootmakers.

Scallop: the V-shape in the front and back of the cowboy boot. This can be shallow or cut very deep.

Shank: the portion of the boot that is used as reinforcement for the wearer's arch. Most bootmakers today use a thin, precut strip of eighteen-gauge steel, which is glued, whipstitched, or tacked in place. On urban sidewalks this works fine, but most folks in the country, including cowboys, still prefer that forty- or sixty-penny nail for support.

Skive: from the Norse word *skifa*, "to make leather thinner." Skiving is also known as feathering the leather. This is usually done when overlapping is required, as in overlay and inlay. The backside of the leather is scraped thin along the edges, or wherever the leather is too thick, with a sharp

knife, lightly sanded for continuity, then quickly burned with a match or flame to remove any small, loose beads of skin that remain. The leather is then ready for glue and thread.

Sole: the only part of the cowboy boot, besides the bottom of the heel, that actually has contact with the ground, unless you happen to get thrown off a horse or a bull.

Spur rest: a ridge or shelf on the back of the boot that helps hold up a spur. Below the counter, extending from the base, the top of the actual heel is pronounced by a quarter inch or more. Looked down upon by some older cowboys as a wimpy crutch for those who don't know how their spurs should fit, this spur ledge has become very popular with young cowboys today.

Stay: the strip of leather that runs up and down the back of the inside of the boot lining to stiffen and support the boot and hold up the top, which gets the most movement. The width of the stay and how high it extends reflect an individual bootmaker's idea of how a boot should be made. Most working cowboys prefer a stay that extends all the way from the bottom of the boot to the top and is about four inches wide.

Stovepipe: refers to the top of the boot when there is no scallop. The boot resembles a sawed-off pipe. Most early cowboys, before 1900, wore boots with stovepipe tops because they were still clinging somewhat to military fashion.

Straights: a term describing boots that have no designated right or left foot. Because high-heel lasts were more difficult to make in mirror images, straights remained popular from the 1600s until 1819, when the irregular-shape copying lathe was invented. Straights continued to be worn extensively until 1900.

Toe box: a stiff piece of material that is placed in the top of the boot toe between the outer vamp leather and the lining to reinforce the shape. All toe boxes used to be made of leather until the advent of super man-made materials. However, many custom bootmakers still use leather, while the factories use plastic or man-made toe boxes.

Toe bug: also referred to as the "toe flower," "medallion," "fleur-de-lis," or just plain "toe stitch." Every boot maker has his favorite design. Many will only use one stitch pattern on the toe of their boots. It becomes their signature and can identify the boot to others. Usually only one or two rows of stitching are used to create a delicate and artful design. You seldom see cowboy boots without decorative toe stitching unless they are made from exotic skins, in which case the stitching would not be visible.

Tongue: the top part of the vamp, usually cut into a decorative shape. The tongue is sewn to the upper front portion of the boot. Because a cowboy's stirrup hits this area of the boot all day, it was originally reinforced by a third layer of leather inside or was cut extra wide to prevent wearing out.

Tools: the dozens of implements used in boot making. Most of these have their roots in Europe. Some have names and manufacturers; others do not. Most bootmakers hand-fashion many of their battery of tools—even today. To a bootmaker, tools are known by their functions rather than their names.

Triad: a type of boot with no counter. In a triad, the front of the boot extends all the way to the sole, and the vamp stops before the side seams and is stitched down. A regular cowboy boot has a four-piece construction: the shaft with two parts (front and back); the counter, or heel piece; and the vamp, which is the foot of the boot. A boot with a one-piece top has no side seams and is sewn or laced up the back.

Underslung: a descriptive word for the angle of the back of the heel. Underslung heels are also sometimes said to be "undershot." From 1880 to 1960, most cowboy boots had higher heels. To keep them from having a heavy, blocky shape, bootmakers hand-fashioned the backs of the heels to angle toward the foot. This style was taken to its extreme in the 1940s at the Leddy Boot Company in San Angelo, Texas, when bronc buster Alton Barnett had all of his boots so undershot that you could not squeeze a penny between where the heel and sole met. Other than those with a low, flat walking heel, most boots today have some undershot to them.

Vamp: the lower front portion of the cowboy boot that covers the foot. The vamp attaches to the counter in the back, and to the front parts of the boot shaft in the front.

Waist: the waist of the boot is at the bottom of the boot shaft where the ankle bends. The heel waist is the center circumference of the heel, sometimes angled or dipped in, especially noticeable in the Cuban heel.

Welt: a strip of heavy leather that is sewn around the lasting space of the upper and joins it to the insole. The sole is then stitched to the welt with a second seam. The welt is also known as the rand.

Wingtip: a fancy leather piece, which can be any shape and even have inlaid designs, that is stitched over the toe and a portion of the lower vamp area. In the 1940s, '50s and '60s, wingtips were usually associated with dress boots. Now wingtips are experiencing a revival and can be seen on everyday cowboy boots. A wingtip can be as simple as a small tip of exotic lizard or other skin sewn over the principal leather.

Wrinkles: the straight lines of stitching on a toe, usually located behind the toe flower.

RESOURCE GUIDE

The Cowboy Boot Web site www.dimlights.com/boots was the brainstorm of Jennifer June. In February 1977, shortly after buying her first pair of vintage peewees, this woman became smitten with boots and their makers. Her definitive site includes links to many of the custom bootmakers and information about boot-making schools, apprenticeships, collectors, special events, history, lore, legend, and a few myths. You might even catch a little boot gossip and "bootnik poetry."

The Bootmakers

Arizona

Chris Bennett Boot Company
1152-2 N. Hohokam Dr
Nogales, AZ 85621
(520) 287-6688

Paul Bond Boot Company
915 Paul Bond Dr
Nogales, AZ 85621
(520) 281-0512

Custom Footwear Inc.
835 E. Southern Ave #1
Mesa, AZ 85204
www.customfootwear.com
(602) 926-4130

Bootmaker David Espinoza
6042 N. 16th St
Phoenix, AZ 85016
(602) 263-8164

Herron's Custom Boot & Saddle Shop
PO Box 1207
Chino Valley, AZ 86323
(520) 636-5461

Bob McLean Custom Bootmakers
40 Soldiers Pass Rd
Sedona, AZ 86336
(520) 204-1211

Nevin's Custom Boots
1456 West Marguarite
Willcox, AZ 85643
(520) 384-2941

Stewart's Custom Boots
40 W. 78th St
S. Tucson, AZ 85713
(520) 622-2706

Arkansas

Jake's Custom Boots & Saddles
HC 72 Box 206-N
Mountain View, AR 72560
(870) 585-2337

Jim's Boot Shop
736 TJ King Rd
Lockesburg, AR 71846
(870) 289-5231

Bo Riddle Boots
963 St. Louis St
Batesville, AR 72501
(870) 612-8022

California

Michael Anthony
227 N. Main St
Sebastopol, CA 95472
(707) 823-7204

Kraig Jillson, Bootmaker
Alta Saddlery
3005 E. Center St
Anderson, CA 96007
(530) 378-2698

Luis' Custom Cowboy Bootmaking
4219 E. Shields
Fresno, CA 93726
(888) 894-0697
(209) 222-7091

Melody's Custom Boots
53430 Abenida Vallejo
La Quinta, CA
(706) 564-7759

Murga Boot Company
23382 Madero Rd, Suite G
Mission Viejo, CA 92691
www.murgaboot.com
(949) 206-9630

Jack Rowln-Bootmaker
21593 S. Powerhouse Rd
Manton, CA 96059
(530) 474-5146
Teaches bootmaking

R. Ty Skiver Custom Leather
21648 Flores Ave
Red Bluff, CA 96080
(530) 529-9310

Slickfork Boots
558 Printz Rd
Arroyo Grande, CA 93420
(805) 481-4944

Woodward Custom Boots
909 Prospect
La Jolla, CA 92037
www.woodwardboots.com
(619) 551-9595

Colorado

Jimmy Luke Covington
211 Main St
Elizabeth, CO 80107
(303) 646-0704

Dave J. Hutchings' Boots
8410 Garfield Way
Thornton, CO 80229
(303) 289-6726
Teaches boot making

KS Boots
#1 Lake of the Falls Parkway
Mosca, CO 81146
(719) 378-2320

LW Rooks Bootmaker
26688 County Rd 339
Buena Vista, CO 81211
(719) 395-9014

Rocking Z Custom Boots
PO Box 775443
Steamboat Springs, CO 80477
(970) 276-3160

Rusty's Boot Shop
10 East 4th St
La Junta, CO 81050
(719) 384-5760

Custom Boots by Larry Smith
655 Browning Ave
Ignacio, CO 81137
(970) 563-9510
Teaches boot making

Connecticut

Wild Bill's Boots
20 Lakeside Dr
Granby, CT 06035
(860) 844-8440

Florida

Legend Boots & Saddles
Trading Post Hwy 301 North
Waldo, FL 32694
(352) 468-2622

Idaho

Cowboy Boots by George
2792 Kelly-Toponce Rd
Bancroft, ID 83217
www.cowboybootsbygeorge.com
(208) 648-0800

G-D Custom Boots
229 Homer Dr
St. Maries, ID 83861
(208) 245-4142

Klemmer Boot
PO Box 122
Salmon, ID 83467
(208) 756-6444

Iowa

Boot Hill Custom Footwear
19263 Gilliat Ave
Council Bluffs, IA 51503
(712) 322-1789

Kansas

Franklin Custom Boot & Saddle
911 N. Tressin Rd
Salina, KS 67401
(785) 827-9277

Madison Valley Custom Leather
14960 Homestead Rd
Riley, KS 66531
(785) 485-2772

Louisiana

Royer Boot & Saddle Company
4803 Hwy 27
De Quincy, LA 70633
(318) 786-6670

Michigan

Richard N. Boehme
2721 Lorraine
Kalamazoo, MI 49008
(616) 382-6372

J. D. Custom Western Boots
1124 N. Pontiac Trail
Walled Lake, MI 48390
(248) 624-3220

Minnesota

Buster & Company
8285 68th St SW
Staples, MN 56479
(218) 397-2401

G. W. Custom Boots
39705 125th Ave
Holdingford, MN 56340
(320) 363-4605

Missouri

Cantrell & Clippard Custom Boots
209 Euclid
Poplar Bluff, MO 63901
(573) 686-4545

JP's Custom Handmade Boots
106 E. Hwy 54, Box 625
Camdenton, MO 65020
www.jpsboots.com
(573) 346-7711

Mississippi

David Gardner
PO Box 54202
Pearl, MS 39288
(601) 932-8101

Marlin Grisham Custom Boots
123 Wildwood Dr
Ripley, MS 38663
(601) 837-3688

Montana

Bowman's Wilson Boots
1014 West Park #5
Livingston, MT 59047
www.wilsonboots.com
(406) 222-3842

Custom Boot Shop
6 Maier Rd
Billings, MT 59101
(406) 252-0846

Eisele's Custom Boots
7 N. Cottage
Miles City, MT 59301
(406) 232-7172

Glenn's Shoe Repair
136 2nd St West
Kalispell, MT 59901
(406) 752-0079

Ryan's Boot & Shoe Repair, and Custom-made Boots
431 N. Last Chance Gulch
Helena, MT 59601
(406) 442-5215

Nebraska

Saunders Custom Boots/ Leather Shack
311 G St
Central City, NE 68826
(308) 946-3879

New Mexico

Bishop's Handmade Boots
PO Box 14
Tucumcari, NM 88401
(505) 461-1889

Burton's Boot & Saddlery
120 N. Main
Roswell, NM 88201
(505) 622-6424

Dean's Boot Shop
710 N. Turner
Hobbs, NM 88240
(505) 393-6583

J and M Custom Boots
107 Edgewood
Sunland Park, NM 88063
(505) 847-3020

Jacobs Shoe Repair
646 Old Santa Fe Trail
Santa Fe, NM 87501
(505) 982-9774

Liz's Custom Boots
82 Lopez Rd
Belen, NM 87002
(505) 864-7079

D. J. May Custom Boots
PO Box 854
Tijeras, NM 87059
(505) 281-2838

L. W. McGuffin Custom Boots
PO Box 480
McIntosh, NM 87032
(505) 384-3126

McGuffin Custom Boots
Hwy 41 & Otero Rd
McIntosh, NM 87032
www.mcguffinboots.com
(505) 384-3231
Teaches bootmaking

Pound's Custom Boots
PO Box 68
Corona, NM 88318
(505) 849-7744

Skinner's Western Wear
112 S. Ave A
Portales, NM 88130
(800) 321-5072
(505) 356-5072

Nevada

Jay Hightower Custom Boots
642 Idaho St
Elko, NV 89801
(702) 753-6338

Gary Tucker Custom Boots
4420 Arville #18
Las Vegas, NV 89103
www.tuckerboots.com
(702) 877-9777

Weinkauf Boots & Leatherworks
100 Landing Lane
Carson City, NV 89704
(702) 882-5900

New York

Jim Babchak, Bootmaker
313 E. 85th St
New York, NY 10028
(212) 861-1356

Oklahoma

Acox Custom Boots
Oswalt Rd
Overbrook, OK 73453
(580) 276-5678

Blucher Boot Company
Highway 75 North
Okmulgee, OK 74447
www.blucherboots.com
(800) 544-7830

Bond Custom Boot & Saddle
PO Box 112
Delaware, OK 74027
(918) 467-3659

C & J Custom Boots
Rt 1 (Box 222)
Temple, OK 73568
(580) 342-5570

Mike DeWitt
1801 E. 4th St
Okmulgee, OK 74447
(918) 756-6211
Teaches boot making

Dorwart Custom Cow-Boy Boots
117 South 2nd
Guthrie, OK 73044
(405) 282-1258

Fit Well Boot & Saddle Company
Hwy 48 & 48A
Coleman, OK 73432
(580) 937-4676

Hole in the Wall
619 7th St
Pawnee, OK 74058
(918) 762-4432

Loveless Custom Boots
2434 SW 29th
OK City, OK 73119
(405) 631-9731

Meanwhile . . . Back at the Ranch
710 East 146
Glenpool, OK 74033
(877) TO-RANCH
(918) 322-9808

Pony Tracks
PO Box 234
Medicine Park, OK 73557
(580) 521-3109

Sorrell Custom Boots
306 W. Industrial
Guthrie, OK 73044
www.customboots.net
(405) 282-5464

Tom Nix Custom Boots
Rt 2
Sayre, OK 73662
www.TomNix.com
(580) 928-3412

Oregon

Cal's Custom Boots
2 Northgate Plaza #2
Brookings, OR 97415
(541) 469-9845

Crary Shoe Manufacturing
8235 SE Stark St
Portland, OR 97216
(503) 253-8984

Frommer Boots
616 SW Evergreen
Redmond, OR 97756
www.bootmaker.com
(541) 923-3808
Teaches boot making

Mastercraft Shoe
1644 Ashland St, #4
Ashland, OR 97520
(541) 482-3531

John Newbury Boot Shop
1665 SE Bybee
Portland, OR 97202
(503) 235-7496

Matt Newberry Custom
Boots
46326 Lone Fir Rd
Halfway, OR 97834
(541) 742-4089

Dennis M. Wall, Bootmaker
175 S. Chase St
PO Box 683
Heppner, OR 97836
(541) 676-8735

South Dakota

MJN Boot & Leather Shop
27210 - 468th Ave
Tea, SD 57064
(605) 368-2922

Texas

Ammons Boots/West Star
1130 Rojos Ave
El Paso, TX 79935
(915) 595-2100
(214) 631-3640

Allen Boot Company
Rt. 1 (Box 52AA)
Bronte, TX 76933
(915) 786-4346

Amado Boot Company
734 - 2nd
Mercedes, TX 78570
(956) 565-9641

Don Atkinson Custom Boot
& Saddles
229C Old Ingram Loop
Ingram, TX 78025
(830) 367-5400

Austin-Hall Boot Company
230 Chelsea St
El Paso, TX 79905
(915) 771-6113

Jimmy Ayers Boot Company
1401 W. Levee Rd
Anthony, TX 79821
(915) 886-4903

B & D Custom Boots &
Leather
HCR 4 Box 1200
Burnet, TX 78611
(512) 756-1772

Barron's Boot Shop
125 N. Chadbourne
San Angelo, TX 76903
(915) 658-4701

Bell's Custom Boots
2118 N. Treadaway Blvd
Abilene, TX 79601
(915) 677-0632

Boot & Saddle Shop
102 - 3rd St
Whitesboro, TX 76273
(903) 564-5300

Boot Hill
1311 Live Oak
Commerce, TX 75428
(903) 886-0955

Boyd's Custom Boots
1242 N. 8th
Abilene, TX 79601
(915) 673-1656

Bramhall's Boot Company
128 E. Main
Grand Prairie, TX 75050
(972) 262-1994

A. W. Brookshire
1131 Live Oak St
Commerce, TX 75428
(903) 886-0955

Brookshire's Boot &
Saddlery
Rt 1 (Box 62A)
Bowie, TX 76230
(940) 872-4720

Brown's Boot & Saddle
Rt 1 (Box 441)
Paradise, TX 76073
(940) 433-9960

Buck's Boots
PO Box 701
Marble Falls, TX 78654
(830) 693-8486

C. T. Boot Shop
105 S. Main
Saint Jo, TX 76265
(940) 995-2901
Teaches boot making

Capitol Saddlery
1614 Lavaca
Austin, TX 78701
(512) 478-9309

Carmack's Custom Boots &
Shoes
1103 Big Bend Trail
Glenrose, TX 76043
(254) 897-2176

Carmargo's of Mercedes
710 Hwy 83
Mercedes, TX 78570
(956) 565-6457

Jason Carpenter Custom
Boots
200 E. Dickinson
Ft. Stockton, TX 79735
(915) 336-9141

Casa Linda Shoe Service
10211 Garland Rd
Dallas, TX 75218
(214) 321-0110

Champion Attitude Boots
505 S. Cotton
El Paso, TX 79901
www.championboot.com
(888) 547-7266
(915) 534-7783

Cottle's Boot & Shoe Repair
2803 Wolflin
Amarillo, TX 79109
(806) 352-8821

Double B Custom Boots &
Leatherworks
110 West Sealy
Monahans, TX 79756
(915) 943-3000

Stephanie Ferguson Custom
Boots
2112 Poe Prairie Rd
Millsap, TX 76066
www.StephanieFerguson.com
(817) 341-9700

Flint Boot & Hat Shop
3035 - 34th St
Lubbock, TX 79410
(806) 797-7060

Rusty Franklin Boot Co.
3275 Arden Rd
San Angelo, TX 76901
(915) 653-2668

Friday Boot Company
412 Andrews Hwy
Midland, TX 79701
(915) 682-2651

Leonard Green Custom
Boots
224 N. Main
Weatherford, TX 76086
(817) 594-5443

Higdon Boots
5605 W 41st
Amarillo, TX 79109
(806) 353-3951

J. B. Hill Boot Company
335 N. Clark Dr
El Paso, TX 79905
www.jbhill.com
(915) 599-1551

Holick's
106 College Main
College Station, TX 77040
www.holicks.com
(409) 846-6721

Jackson's Boot & Shoe
10733 Leopard
Corpus Christi, TX 78410
(361) 241-2628

James Boot & Shoe Repair
5106 S. Western
Amarillo, TX 79109
(806) 358-2701

Jass Boot Shop
110 N. Ave D.
Clifton, TX 76634
(254) 675-1232

John Jass Boot Shop
501B S. Key Ave
Lampasas, TX 76550
(512) 556-2729

Jass Boot Shop
803 E. Ave G
Lampasas, TX 76550
(888) 708-8122
(512) 556-3857

Jimmy's Boot Shop
211 E. Tyler St
Athens, TX 75751
(903) 675-5038

Jones Custom Boots
Hwy 290 Main St
Harper, TX 78631
(830) 864-4673

Kimmel Boot Company
Rt. 1 (Box 36)
Comanche, TX 76442
(915) 356-3197

James Leddy Boot Company
1602 N. Treadaway
Abilene, TX 79601
(915) 677-7811

M. L. Leddy Boot &
Saddlery
2200 Beauregard
San Angelo, TX 76901
(915) 942-7655

Leprechaun Shoe Shop
405-1/2 TX Ave
Mart, TX 76664
(254) 876-9148

Little's Boots
110 Division Ave
San Antonio, TX 78214
www.DaveLittleBoots.com
(210) 923-2221

Lonesome Dove Saddlery &
Boot Company
324 Callowhill
Baird, TX 79504
(915) 854-1265

Maida's Black Jack Boot
Company
3948 Westheimer
Houston, TX 77027
www.maidas.com
(713) 961-4538

McKown Boots
4266 Cottonbelt Parkway
McGregor, TX 76657
(254) 857-3892

Terry McLaury Custom
Boots
PO Box 547
Aspermont, TX 79502
(940) 989-2897

Medicine Show Boot
Company
816 S. Fleishel St
Tyler, TX 75701
(903) 597-2828

Mingo Boot Company
6966 Alameda
El Paso, TX 79915
(915) 779-7681

Morado Boots
402 Frisco St
Houston, TX 77022
(713) 694-7571

Mull's Custom Boots
901 - 3rd St
Marble Falls, TX 78654
(830) 693-2724

My Boot Shop
205 CR 321
Gatesville, TX 76528
(254) 865-9312

Overton Boot and Saddle
PO Box 507
Albany, TX 76430
(915) 762-9007

Preston Boot & Saddlery
Rt 3 (Box 214P)
Stephenville, TX 76401
(254) 965-5000

Ramirez & Sons Boot
Manufacturing
804 N. Hancock Ave
Odessa, TX 79761
(915) 332-3923

Jack Reed Boots
HCR 4 Box123
Burnet, TX 78611
(512) 756-7047
Teaches boot making

Rios of Mercedes Boot
Company
105 S. Vermont
Mercedes, TX 78570
(956) 565-2634

RJ's Boot Company
3321 Ella Blvd
Houston, TX 77018
(888) RJ-BOOTS
(713) 682-1650

Rocketbuster Boot Company
115 S. Anthony
El Paso, TX 79901
www.rocketbuster.com
(915) 541-1300

ROC'N' WT Boot Company
306 E. Main St
Hamilton, TX 76531
(254) 386-8881

Rowell's Boot Shop
500 Park Blvd
Austin, TX 787514315
(512) 454-8829

Tom Smith Custom Boots
PO Box 482
Aspermont, TX 79502
(940) 989-3385

Spikes Custom Boots
1202 E. Spring
Henrietta, TX 76365
(940) 538-4864

Stallion Boot Company
100 N. Cotton St
El Paso, TX 79901
(915) 532-6268

Taylor's Custom Boots
1406 Early Blvd
Early, TX 76802
(915) 646-7752

Tex Robin Boots
115 W. 8th St
Coleman, TX 76834
(915) 625-5556
Teaches boot making

Texas Custom Boots
2525 S. Lamar Blvd
Austin, TX 78704
(512) 442-0926

Texas Traditions
2222 College Ave
Austin, TX 78704
(512) 443-4447

Tomlinson's Boot Shop
111 E. Main
Llano, TX 78643
(915) 247-5441

Tres Outlaws Boot Company
421 S. Cotton St
El Paso, TX 79901
(915) 544-2727

Western Leather Craft Boot
Shop
1950 Civic Circle
Amarillo, TX 79109
(806) 355-0174

Wheeler Boot Company
4115 Willowbend
Houston, TX 77025
(713) 665-0224

Wright's Boots
5258 Louetta #175
Spring, TX 77379
(281) 251-6060

Ye Olde Leather Boot
Worth St
Hemphill, TX 75948
(409) 787-1233

Young's Custom Boots
808 Backus
Paducah, TX 79248
(806) 492-3103

Utah

Merrell Institute
3400 N. 3500 W.
Vernal, UT 84078
(435) 789-3079
Teaches boot making

Vermont

Dan Freeman's Leatherworks
2 Park St
Middlebury, VT 05753
(802) 388-2515

Virginia

Gum's Boot & Saddlery
3170 Draper Dr Bay #7
Fairfax, VA 22031
(703) 691-9111

Washington

Gjelstein Boots
10 S. Bridge St
Brewster, WA 98812
(509) 689-2838

Outside United States

Liberty Boot Company
224 Shaw St
Toronto, Ontario M6J 2W8
CANADA
(416) 588-5013

Tony Leather
34 Suriwong Rd
Bangkok, Thailand 10500
2342343-4

Vintage Boot Dealers

Tyler Beard
(915) 948-3768

Hopalong Boot Company
(505) 471-5570

Mark Hooper
(505) 256-0321

Tyler Beard
(915) 948-3768
Hopalong Boot Company
(505) 471-5570
Mark Hooper
(505) 256-0321
Wendy Lane, Back at the Ranch
(505) 989-8110
Eddy Liptrott
(416) 252-0785
Nathalie's
(505) 982-1021
Prairie Rose
(817) 332-4369
Jack Pressler
(505) 983-3547
Rustic Styles
(830) 997-6219
Caroline Shapiro
(847) 317-9767
Gary van der Meer
(914) 332-6460
Claudia Voyles
(503) 234-4022
Evan Voyles, Neon Jungle
(512) 448-2787

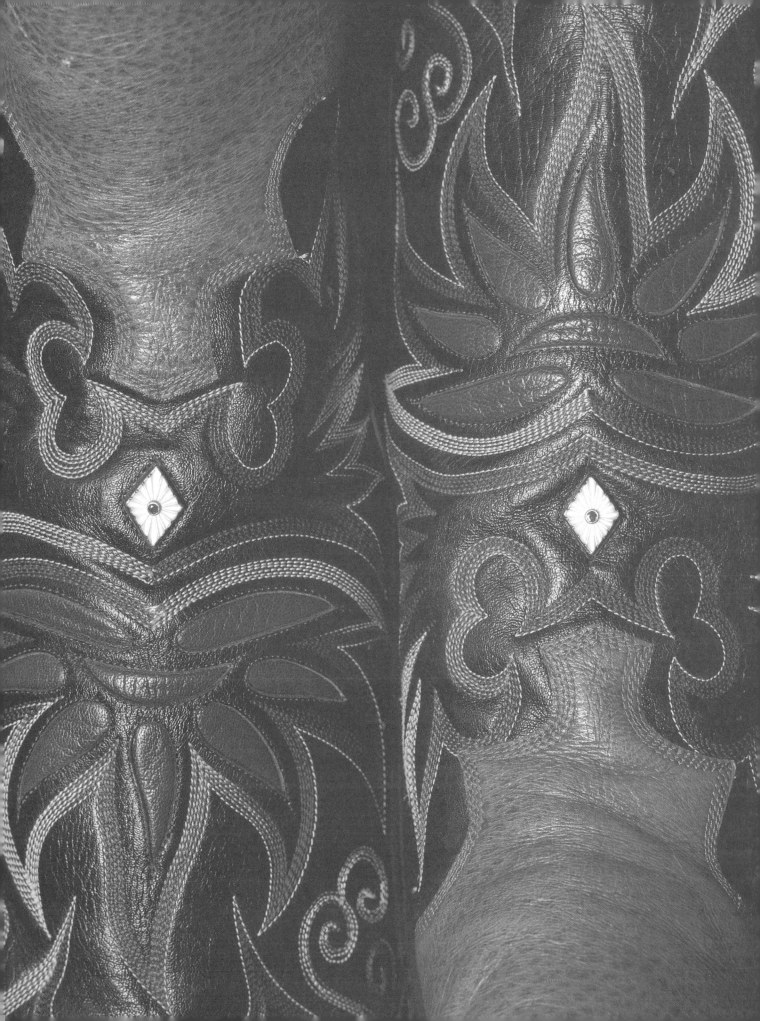